How I Draw
SCOTT McKOWEN
SKETCHBOOKS

DEDICATED TO THE MEMORY OF
TONY URQUHART (1934–2022),
WHOSE DRAWINGS WILL ALWAYS
INSPIRE AND DELIGHT.

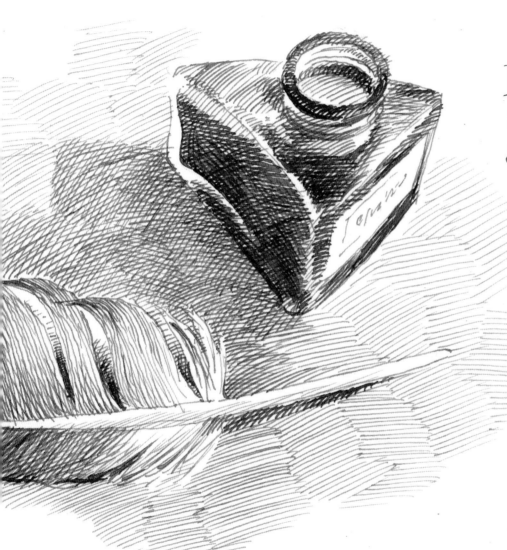

How I Draw
Scott McKowen
SKETCHBOOKS

FIREFLY BOOKS

A FIREFLY BOOK

Published by Firefly Books Ltd. 2022

First printing

Library of Congress Control Number: 2022934053

Library and Archives Canada Cataloguing in Publication
Title: How I draw : Scott McKowen sketchbooks.
Other titles: Scott McKowen sketchbooks
Names: McKowen, Scott, artist, author.
Description: Includes bibliographical references and index.
Identifiers: Canadiana 20220188114 | ISBN 9780228103660 (hardcover)
Subjects: LCSH: McKowen, Scott—Notebooks, sketchbooks, etc. |
 LCSH: Drawing—Technique.
Classification: LCC NC143.M42 A4 2022 | DDC 741.971—dc23

Published in the United States by
Firefly Books (U.S.) Inc.
P.O. Box 1338, Ellicott Station
Buffalo, New York 14205

Published in Canada by
Firefly Books Ltd.
50 Staples Avenue, Unit 1
Richmond Hill, Ontario L4B 0A7

Cover and interior design: Scott McKowen

Printed in China

Canada ▮◆▮ We acknowledge the financial support
of the Government of Canada.

FSC
www.fsc.org MIX
Paper from
responsible sources
FSC® C111080

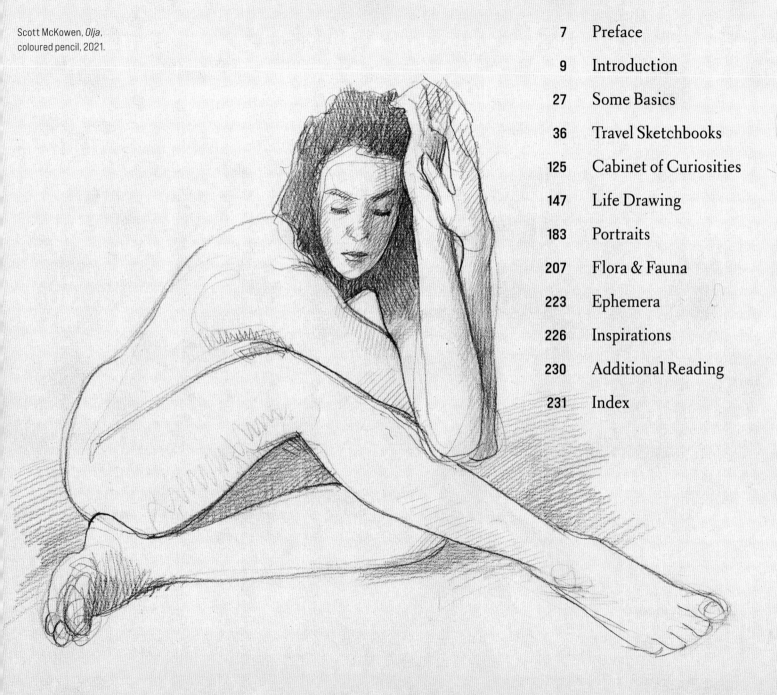

Scott McKowen, *Olja*, coloured pencil, 2021.

CONTENTS

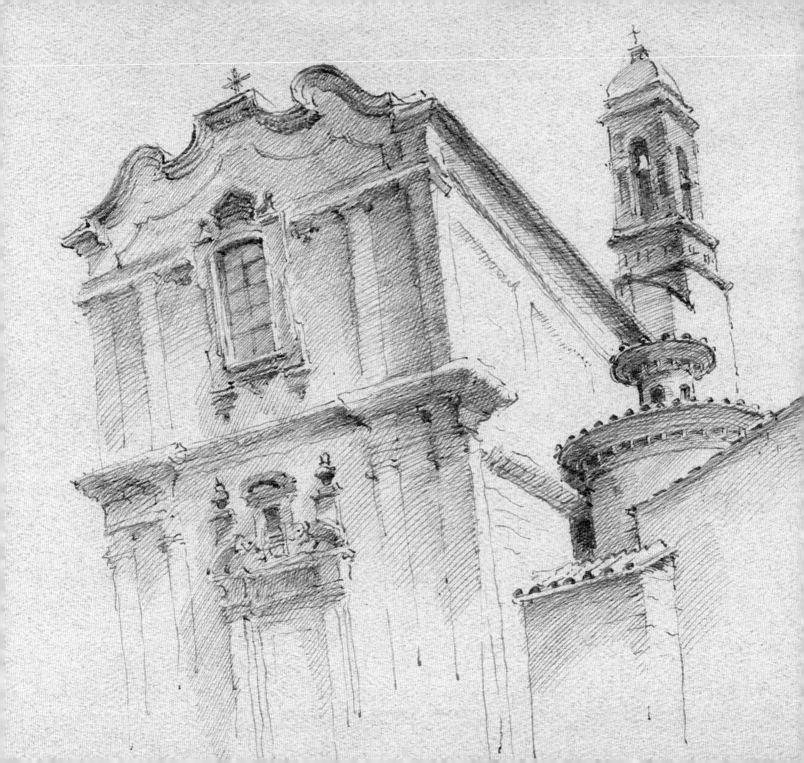

PREFACE

Fair warning: a refrain throughout this book is "the more you draw, the better you'll draw." I relearned this maxim during the pandemic — with no work in the studio for almost two years (and no opportunity to travel), I found myself with more time to focus on drawing than I normally have.

There's a plethora of "how to draw" books out there — I'm not primarily a teacher, and this is not a step-by-step guide for beginners, although I hope it will prove useful to anyone interested in drawing, at any level of skill or experience. As signalled by the title, this is more of a "how *I* draw" book — which underscores that there are many ways to approach the subject and no single right way or wrong way to do it.

My wife, Christina Poddubiuk, is a costume and set designer in theatre and opera. She is a superb draughtswoman, conveying through her costume sketches concise and accurate information about historical period garments along with a vivid sense of character. Christina is my best (which is to say harshest) critic. As she was looking through my selection of life drawings for this book, her only comment was "wow, your drawing has *really* improved."

I draw mainly from direct observation. I try to make drawings that are clearly expressed — with intelligible, cogent lines. It's a lifelong study, and I'm still very much trying to figure it out. The more you draw, the easier it becomes. You can trust me on that.

Scott McKowen, *Chiesa di Santa Croce, Umbertide*, ink, 1991.

8

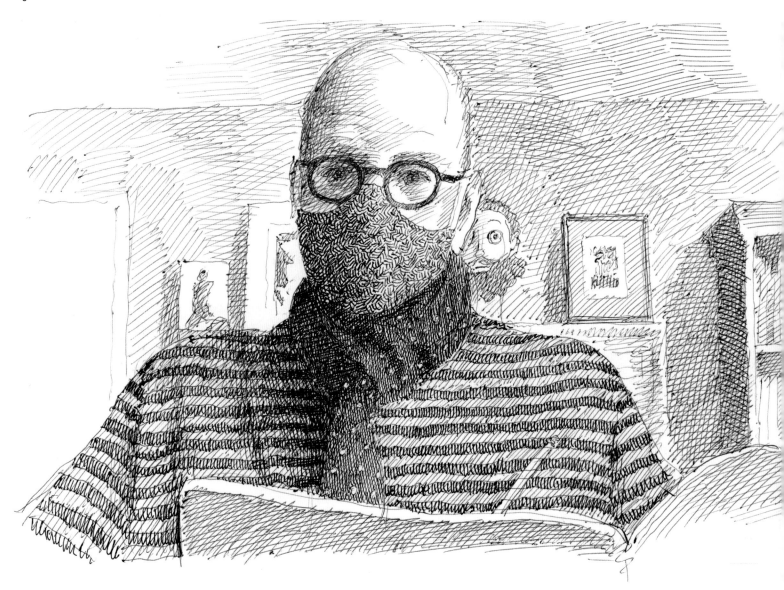

Scott McKowen, *Pandemic self-portrait*, gel pen, 2020.

Christina had made facemasks shortly after the COVID pandemic broke out. I love the Japanese fabric she picked for mine, and I wanted to try to capture it in a sketch. I set up an 8 x 10 mirror on my drawing table. The light source is a window off to the right. I used different line weights and hatching patterns to render the fabrics of the mask, the striped shirt and the polka-dotted scarf. The objects behind me are resting on the Victorian moulding of a double-door frame — they are across the room from me so I kept the background hatching lines as light as possible in order to add a sense of depth to the drawing.

INTRODUCTION

A wonderful short video of Milton Glaser was circulating on social media shortly after he died in June 2020, at age 91. We never see his face; we watch over his shoulder as he draws, with quick, confident lines, a portrait of William Shakespeare. "Curiously, people think that the difficulty of drawing is in making things look accurate," he observes. "But accuracy is the least significant part of drawing. *But* — you have to learn how to draw accurately before you can do anything else. Then, you can begin to think about drawing *expressively* — and that's another game entirely."

That other "game" is the visual language that every artist develops in order to express, through their work, what they have to say to the world. Every artist has to discover and develop their own individual voice, of course, but Glaser is saying that we must to learn to draw what is outside of ourselves before we can draw what is inside.

Drawing is my way of seeing and understanding the world. We communicate increasingly through visual images, but many of these are fleeting encounters on screens. I find that it's only when I draw something — when I actually take the time to sit down and study something carefully enough to draw it — that I can really begin to understand it.

My working title for this book was *Lucid Drawing*. The intentional reference to lucid *dreaming* was deemed a too-clever play on words. But "lucid" means "clear and easy to understand," "able to think clearly," intelligible and having full use of one's faculties. These are precisely my goals when I draw and when I talk about drawing.

I don't recall that I have ever had a lucid dream — being consciously aware that I'm dreaming, without waking up. The experience is sometimes described as a personal virtual reality world created out of some combination of your own memory and imagination. It sounds completely amazing.

Drawing is perhaps a little like dreaming while awake — maybe that's a stretch, but hear me out. You are in control of drawings as you create them. You start with a blank sheet of paper, memory, imagination and a sense of exploration. You probably have a subject or an idea, but there's no way to predict where a drawing will end up. You immerse yourself in a drawing, constantly evaluating it. Drawing takes complete focus. I like to have music playing, which is relaxing and helps block out distractions so I can engage completely with my subject. Because of the concentration required, I don't even notice the time going by — a three-hour drawing session goes by in a flash. The end of a session feels like waking up and returning to the real world — but with a record on paper of where I've been.

Neuroscientists suggest that lucid dreams may offer benefits to our waking life including lowering anxiety and improving problem-solving and creativity — plenty of overlap with drawing there! But science can't begin to explain why we dream or what our dreams might mean. The mystery of dreams is similar to the mystery of art.

What makes a drawing successful or not is highly subjective. In a 2021 interview, the great South African artist William Kentridge reminds us that "The question of uncertainty, ambiguity and doubt is the bedrock of what happens in the studio whether you're a writer, a singer, or a visual artist." Many times I have thought to myself during a life drawing pose, "this is going really well…" — only to reassess the next day and realize that it's not even a drawing I want to save. (I always try to remember to date my drawings so that I can look back years later and see how far I have come.) For every drawing I selected for this book, there are hundreds that nobody ever needs to see.

Drawing is fundamental to the work of fine artists. Painters and sculptors work out ideas for a compositions through preliminary drawings. Because drawings function as studies for paintings, they are sometimes regarded as a lesser art form. This is unfortunate and unfair because there is no form of creative expression more personal and more spontaneous than drawing. In *The Art of Drawing*, a 1972 book produced to accompany an exhibition of the British Museum's unrivalled collection of drawings, Richard Kenin observes, "the innermost visions of the mind flow clearly and directly through the hands of the draughtsman, and all that the imagination can conjure is represented in this most fragile and transitory of artistic media. In a great drawing one can

see the creative process at work." Kenin notes that some styles of painting intentionally conceal how certain effects are produced — but drawings have no such artifice. Drawings stand on their own as a record of an artist's exploration of ideas and experiences. In fact, they show us how an artist's mind works.

In the wider, more practical world, drawing is an essential service in the communication of information. If you want to give someone directions, sketching a map is far more efficient than a verbal description. Any man-made object you can think of started out as a drawing. Building a house requires hundreds of architectural and engineering drawings. Simple or complex, the common denominator here is that if you can draw clearly and with confidence, you are able to communicate your ideas more accurately and more fluently.

Anyone can learn to draw — if they want to. Like any skill, the longer you practise it the more proficient you will become. It's like learning a new language. At first your drawings will be awkward and unsure — you will stumble over making lines on the page as you might struggle with unfamiliar vocabulary and grammar. But the more you practise, the more articulate and comfortable you will become. It requires motivation and a big commitment of time. But the effort is worth it because eventually you attain fluency, and new worlds will open up to you.

Drawing trains your eye and your hand. Like physical exercise, it's a workout for your muscles and for your mind simultaneously. The effects are cumulative — drawing trains your perception and your imagination. It makes you more observant. It makes you pay closer attention to whatever you are looking at.

There's a lovely anecdote about the legendary Spanish cellist Pablo Casals (1876–1973), who was asked why, in his eighties, he continued to practise four and five hours every day. He answered, "because I think I am making progress." Casals' philosophy, apocryphal or not, also applies to drawing, which is a lifelong study.

A selection of Scott McKowen's sketchbooks.

Scott McKowen, full page chapter opener for *The Brides of Maracoor* by Gregory Maguire, scratchboard, published by HarperCollins, 2021.

The difference between a fine artist and an illustrator is nothing to do with level of skill. Choice of subject matter for the artist is self-motivated. My subject matter as an illustrator is assigned — my "finished" work is commissioned art for reproduction. My work has been featured in several art gallery exhibitions, but you're more likely to see it on book covers or theatre posters.

Drawings are my everyday tools. I brainstorm ideas with quick, rough concept sketches. Once a concept is approved, I work out the details of figures, perspective and lighting in highly detailed studies before sitting down to start working on the final art. I enjoy this process because every new assignment brings a fresh problem to solve — new territory to explore.

As an illustrator, I'm best known for working in scratchboard — an engraving medium in which you draw white lines into an all-black surface with an x-acto knife blade. When you draw black lines on white paper, you're rendering shadows; scratchboard is the opposite — when you draw white lines on black, you're rendering highlights.

Gregory Maguire's fantasy fiction novels are great fun to illustrate — the drawing at left was inspired by an old deck of tarot cards with gigantic hands holding swords or crowns, materializing out of the clouds. Gregory loved my preliminary concept sketches for the chapter openers and promptly added a deck of tarot cards into his manuscript! The hand-drawn calligraphy helped support the historical setting of the story.

I had the great fortune to illustrate 38 classics of literature over 15 years for Sterling Publishing in New York. Daniel Defoe's *Robinson Crusoe* was the oldest in the series, published in 1719. Crusoe is shipwrecked and spends 27 years alone on an island in the Pacific. It's one of the most famous adventure stories ever written, but it also has an introspective side — this solitude gives Crusoe plenty of opportunity to contemplate life, philosophy, theology and what he believes in. The only "voice" he hears during these long years is Poll, a parrot, whom he teaches to speak. They form a close bond and Crusoe takes her with him when he finally leaves the island. I proposed a cover with the parrot as the colourful focal point, contrasted against the title character in shadowy silhouette. The pencil sketches show the development of this idea from rough concept sketch to working drawing with a model (Stratford Festival actor Michael Spencer Davis). The black and white scratchboard engraving was colourized digitally.

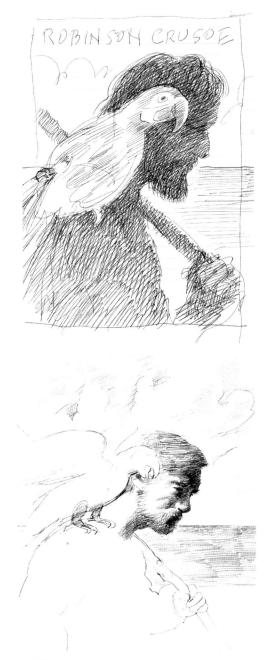

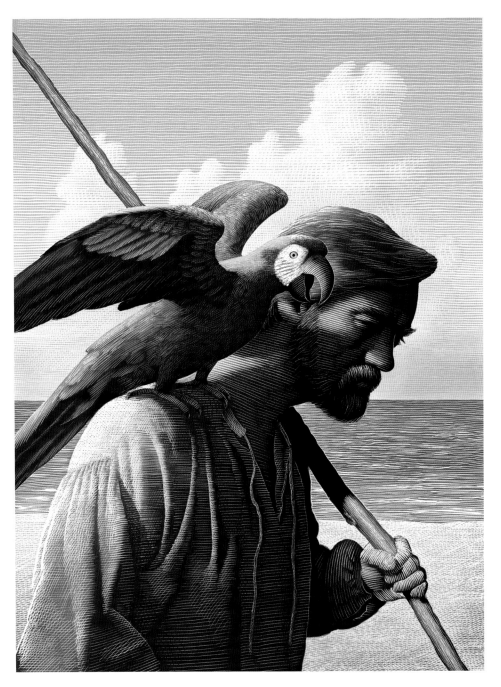

Scott McKowen, *Robinson Crusoe*, pencil sketches and final art for the cover of the Sterling Classics Edition, 2010.

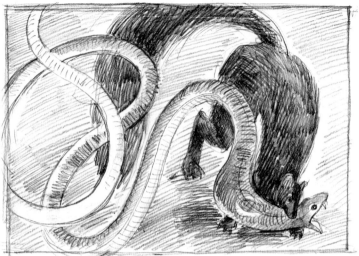

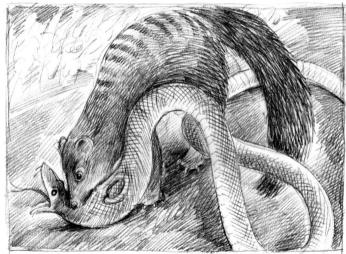

Scott McKowen, rough pencil sketches, used to develop concepts for illustration assignments. Clockwise from left: theatre poster for Eugene Ionesco's *Rhinoceros*; two compostions for "Rikki–Tikki–Tavi" in Rudyard Kipling's *The Jungle Book*.

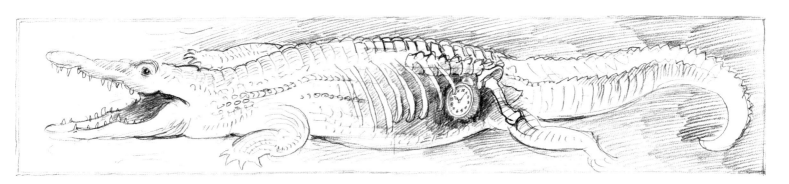

Scott McKowen, concept pencil sketches for the Crocodile in J.M. Barrie's *Peter Pan*; a wedding portrait in Lucy Maud Montgomery's *Anne of Avonlea*; cover for Mark Twain's *The Adventures of Tom Sawyer*.

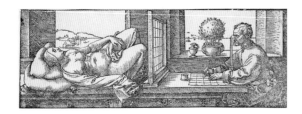

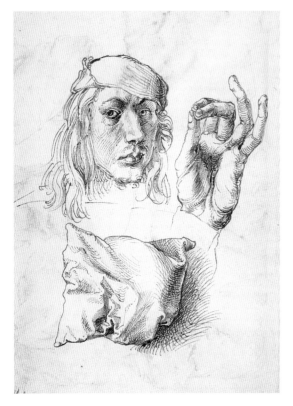

Albrecht Dürer, *Draughtsman Making a Perspective Drawing of a Reclining Woman*, woodcut, c.1600 (Metropolitan Museum of Art, New York).

Albrecht Dürer, *Self-Portrait at Age Twenty-Two*, 1493 (Metropolitan Museum of Art, New York). Notice that the scale of his hand is larger than the head — exactly what you would see if your hand was closer to a mirror. This is the same kind of distortion you might see today, drawing a model in an online Zoom session if a head or a foot is positioned close to the camera.

Ken Nutt, my friend and colleague who runs our weekly Open Studio life drawing sessions in Stratford, wrote a thoughtful essay in 2018 titled "Why Draw from Life?" Why bother to draw someone or something when it's so much easier to grab a photo with your iPhone camera? Ken gives us lots of reasons: the investment of time on the part of both the artist and the sitter are more profound. A lens records everything it sees but drawing requires a process of selection and distillation — decisions about what to include and what to omit. Ken reminds us that "for even the very greatest of artists, the act of drawing — observing, measuring, making the right marks — has never been easy. That it is a hard task to master only increases the enjoyment of those who persist. Making the calculated look easy, capturing the effects of a moment through hours of concealed effort, delivers the same satisfaction as having pulled off an elaborate piece of stage magic."

But where to begin? With a complex subject, how do you start a drawing? The first line is always the hardest. Artists have a name for the moment of indecision as you start a drawing or painting: Brush Terror. The most common wisdom is not to panic: "in order to make the right line, you must first make a wrong line." With experience, you learn to spot the difference.

There have always been shortcuts claiming to sidestep making that wrong line. At the back of the comic books I read as a kid were ads claiming I could DRAW ANY PERSON IN ONE MINUTE! NO LESSONS! NO TALENT! ONLY $1.98. The offer was for a crude image projection device. Pop-up ads on Facebook today pedal the same shortcut but the price has gone up substantially. This is nothing new. Vermeer and Canaletto employed a *camera obscura* to capture images. Albrecht Dürer (1471–1528) experimented with a drawing machine designed to plot out perspective points — he made engravings of how it works (a 16th-century version of those comic book ads).

In the end, Dürer didn't need any drawing machines. His 500-year-old self-portrait drawing, at the tender age of 22, is one of the earliest self-portraits in Western art. The calligraphic precision and expressiveness of the lines are breathtaking. The study of a pillow on the same sheet is purely practical — he was economizing on paper (the *verso* side of this sheet contains six more studies of that same pillow) — but the unexpected juxtaposition of images gives the drawing a fresh, completely modern feel.

I had always thought of Vincent van Gogh (1853–1890) as a painter, but an exhibition of his drawings at the Metropolitan Museum of Art in the fall of 2005 was a revelation. On a visit to Provence, Van Gogh discovered a local hollow-barrelled grass that could be sharpened with a penknife, "the way you would a goose quill," he wrote in 1888. The reed pen allowed Van Gogh to express himself rapidly, with a bold immediacy. His ink drawings with this new tool are a dazzling fireworks display of lines, hatches and dots that describe the textures and surfaces of the French countryside. You can almost feel the warmth and energy of the sunshine. Guy Noble points out

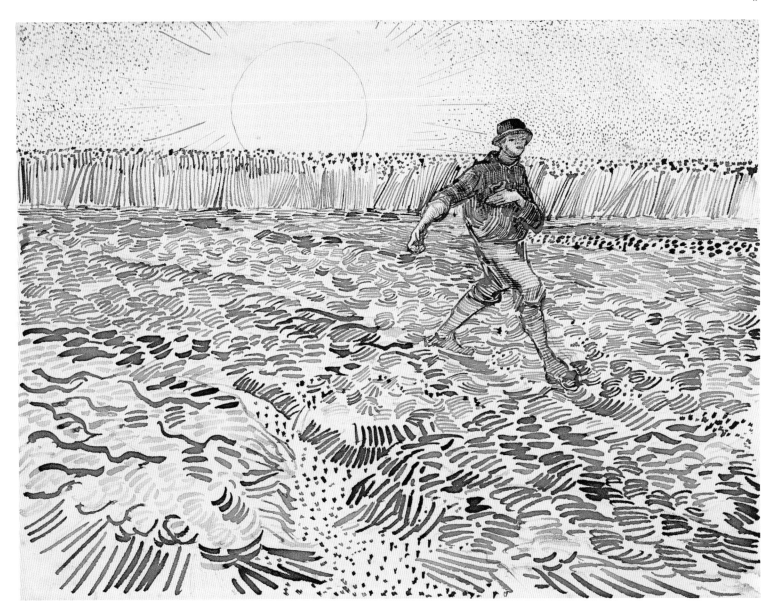

Vincent van Gogh, *The Sower*, 1888, reed pen, quill and ink over graphite on wove paper (Van Gogh Museum, Amsterdam).

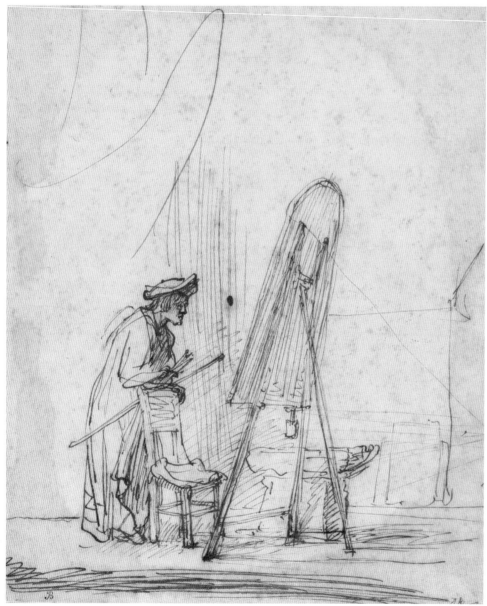

Clockwise: Rembrandt Hamensz van Rijn, *An Artist in his Studio*, c.1630, brown ink (The J. Paul Getty Museum); Augustus John, *Henry Lamb*, c.1908, pencil on paper (Bridgeman Images); James Montgomery Flagg, illustration for *Good Housekeeping*, 1923, ink.

in his book *Drawing Masterclass: 100 Creative Techniques of Great Artists* that "Van Gogh's reed pen drawings are completely original... He provides yet another example of an artist adapting drawing to fit their needs."

The Old Masters are always teaching us new lessons from across the centuries. I have a huge book of Rembrandt's drawings, large enough itself to function as a coffee table. Rembrandt Harmensz van Rijn (1606–1669) experimented with a wide range of materials and techniques. Using pen and ink, silverpoint, charcoal and coloured chalk, he drew with extreme precision but at the same time with loose, sketch-like lines. I marvel at the liveliness and spontaneity in his drawings. The jacket flap quotation on the book is by Vincent van Gogh: "Rembrandt goes so deep into the mysterious that he says things for which there are no words in any language."

Closer to our own time, I love the superb drawings of Welsh artist Augustus John (1878–1961). John's drawing was extraordinary "for the firm, fluent, lyrical line, for vigour and spontaneity," to quote his biographer Michael Holroyd. John's domestic life was complicated and chaotic, but he was completely clear and concise the moment he picked up a pencil.

Eric Gill (1882–1940) was a sculptor, one of the great typeface designers of the 20th century and a superlative draughtsman. He wrote in the introduction to his 1938 book *25 Nudes*, "Good drawing means good lines — clean lines, clear lines, firm lines, lines you intend and not mere accidents." A lofty goal for any artist, but Gill's elegant drawings here are woodcuts — the lines are V-shaped grooves carved with a chisel or a burin, producing a white line on black background in the finished print. Gill adjusts the width of his lines by varying the pressure on the engraving tool — his control over this medium is astonishing. I can correct my scratchboard engravings with a black pen, but wood engraving demands incredible confidence to place the lines where you want them — you don't get a second chance.

Gill's description of clean, clear, intentional linework makes me think of the drawings of James Montgomery Flagg (1877–1960), one of the "Golden Age" American illustrators. Flagg's paintings are great — everyone knows the famous recruiting poster with Uncle Sam pointing his finger at you — but his drawings are even more impressive. Flagg had an uncanny ability to indicate form and colour with an interweaving of swift pen strokes, his confident lines effortlessly describing the textures of skin tones and fabrics.

Eric Gill, woodcut from *25 Nudes*, 1938.

Georges Seurat, *Aman-Jean*, 1882–83, conté crayon on Michallet paper (Metropolitan Museum of Art, New York). Incidentally, Seurat's paper was white — the creamy warm tone is from the paper's natural aging process over more than a century.

Lines are the fundamental building blocks of a drawing. We use lines to describe the edges of forms — but they don't really exist in nature. Lines are a two-dimensional fiction we use to define a three-dimensional figure from the background behind it. We see form, on the other hand, through the tonal values created by light falling across the surfaces of objects. Highlights, midtones and shadows generate the illusion of volume and dimension; these dynamics can be rendered on paper by building up layers of crosshatched lines or with chalk or pastel, which can be blended into a range of "continuous tone" — like we are used to seeing in photographs.

Georges Seurat (1859–1891) recorded scenes of Parisian entertainment — parades, café concerts and circuses — and leisure, most famously in his monumental painting *Un Dimanche à la Grande Jatte*. I saw the MoMA's exhibition of Seurat's atmospheric drawings in 2007. He worked with conté crayon, manufactured from a mixture of pulverized graphite and clay, pressed into soft sticks producing a rich, velvety black line on the page. Lots of artists used this medium, but Seurat worked on a handmade paper made by pressing wet pulp into a mould — a rectangular frame with a wire mesh frame — and letting it dry. The surface of the sheet retained the corrugated texture of the wire mesh — a pattern of tiny hills and valleys running the length of the sheet, known as a "chain laid" finish. When the black conté rubs across the paper, the pigment catches on the raised areas of the sheet, skipping over the lower areas. The resulting grid of texture creates a soft luminous glow around Seurat's figures (this effect in his drawings has been compared to that of the "pointillist" dots in his paintings). Seurat placed darks and lights in relationships of "mutual exaltation" — his term for this was "irradiation."

John Singer Sargent (1856–1925) was the greatest portrait painter of his generation. His clients were the rich and powerful — the elite of society. His work dominated exhibitions on both sides of the Atlantic. But in 1907, at the height of his fame, he quit. He had tired of the time-consuming process of oil painting, so he switched mediums. He began fulfilling portrait commissions with charcoal drawings, which took less time to complete. There are 750 of them from his late career. The Morgan Library's 2019 exhibition of 53 of them showed off Sargent's astonishing drawing skill. A detail I learned from the excellent catalogue is that Sargent used pellets of bread, as tiny erasers, to create highlights — commercial erasers risked abrading the surface of the paper.

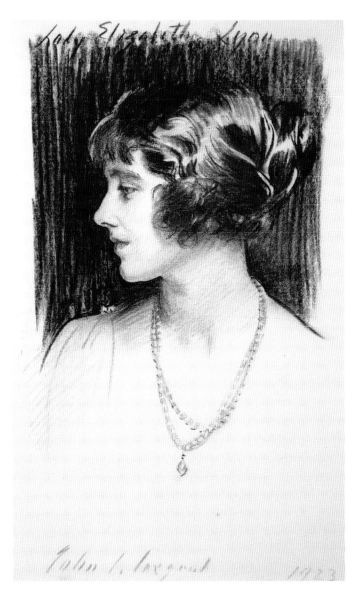

John Singer Sargent, *Lady Elizabeth Bowes-Lyon, later Queen Elizabeth, The Queen Mother*, 1923, charcoal (The Royal Collection).

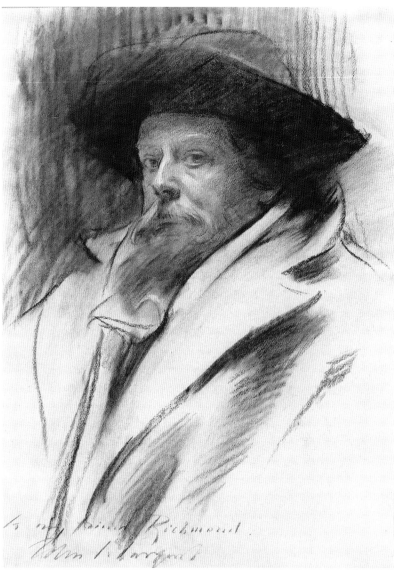

John Singer Sargent, *Sir William Blake Richmond*, c.1910, charcoal (National Portrait Gallery, London). William Blake Richmond (1842–1921) was a successful artist and portrait painter himself, and a friend of Sargent.

LOOKING BACK TO LOOK FORWARD

I signed up for Art History 101 in my freshman year at the University of Michigan. My professor was the great Rudolph Arnheim, (1904–2007); I had no idea, at the time, that Arnheim was one of the preeminent thinkers of the 20th century on Art and Visual Perception. To this day, I'm surprised that such a distinguished faculty member would be teaching an introductory survey course. Arnheim's insightful lectures were a highlight of my university years and led to much (informal) further study over the ensuing decades. A working knowledge of how artistic styles and tastes changed through history is indispensable in understanding how observational drawing has evolved to where it is today.

Virtually all of the important artists of the 19th century trained in Paris, in the Academic tradition. This highminded style was characterized by idealized figures in classical, religious, mythological, allegorical or historical scenes and subjects. Exhibitions attracted huge crowds — 50,000 people might visit the Paris Salon in a single day. A successful showing in the Salon was an official seal of approval for an artist, making his work marketable to the growing number of private collectors. William Bouguereau, Alexandre Cabanel and Jean-Léon Gérôme were the leading painters of the day.

Young artists were accepted into the École des Beaux-Arts and private ateliers only with a letter of recommendation from a notable professor of art and after passing an examination. Training was rigorous — learning to draw was at the heart of the curriculum. First, students copied printed images of classical sculptures to learn the principles of light and shadow, contour, value and volumetric shape. They would then graduate to three dimensions — drawing from plaster casts of classical sculptures. Only after a year of this basic training were students permitted to draw from a live model. Their skills were perfected over a four-year course of study. Drawing was considered the foundation of Academic training — you could advance to painting only when you had acquired mastery of draughtsmanship.

The Academic training system was so successful that there were soon more trained artists than commissions to be fulfilled. The market became

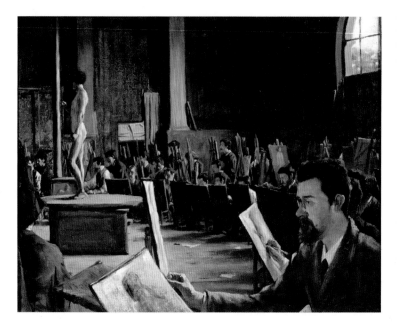

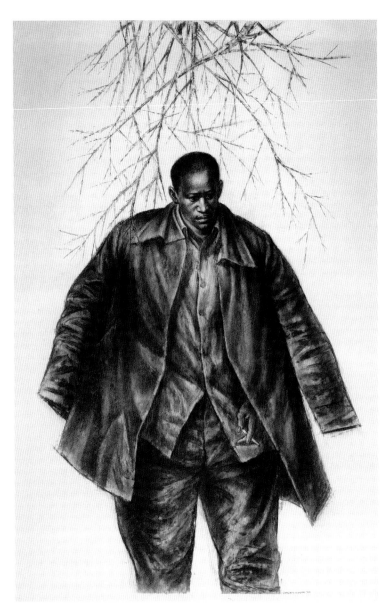

Charles White, *J'Accuse! No.5*, 1966, wolff crayon and charcoal on paper (Michael Rosenfeld Gallery). Opposite: Tancrede Bastet, *Life Class at the Ecole des Beaux Arts*, 1883 (Musee des Beaux-Arts, Grenoble/Bridgeman Images); "An Alcove in the Preparatory Class," *Harper's Magazine*, 1891.

saturated. Artists like Claude Monet, Gustave Courbet, Édouard Manet and Georges Seurat all received Academic training but, like teenagers rebelling against their parents, were pushing towards new forms of "modern" art.

The Impressionists tried to capture "exactly what the eye sees and the hand puts down," and criticized the slick, idealized style of Academic teaching. Eventually, Academic art came to be seen as conservative and sentimental. Tastes moved on to the "Modern" innovators at the end of the 19th century — Vincent van Gogh, Paul Cézanne, Paul Gaugin, Henri de Toulouse-Lautrec and Henri Matisse — and on towards the avant-garde forms of the 20th century — Fauvism, Cubism, Dadaism, Surrealism, Abstract Expressionism and, eventually, Conceptual and Performance Art.

There were artists in the mid-20th century who continued working in a realistic style — I had Andrew Wyeth (1917–2009) poster reproductions on the walls of my first apartment. Edward Hopper (1882–1967) went to Paris to study in 1906, then returned home to paint lonely, isolated individuals in diners or apartments well into the 1950s. Charles White (1918–1979), a magnificent draughtsman, created powerful images of working-class African Americans.

But these artists were swimming upstream against a tide of abstraction. Art schools had little use for those life-size plaster casts of classical statuary left over from the days of traditional Academic training. When I was a student at the University of Michigan School of Art, the huge plaster *Laocoön* was gathering dust in a back corridor. There are many accounts from art school students — contemporaries of mine — who wanted to work figuratively but ran into systematic academic prejudice against learning traditional skills. One Abstract Expressionist professor told his students that Sargent was a bad artist, calling his paintings superficial and facile, with no soul. Some students, who went on to successful careers as fine artists, enrolled in illustration classes in order to learn skills in anatomy, perspective and painting technique.

But sometime before the turn of the millennium, the pendulum of public taste started to swing back towards realism and representational art. Pop Art had already embraced working with images and objects. In his book *The Undressed Art: Why We Draw*, Peter Steinhart observes that "abstract expressionism soon enough proved to have limits. Without the ability to look

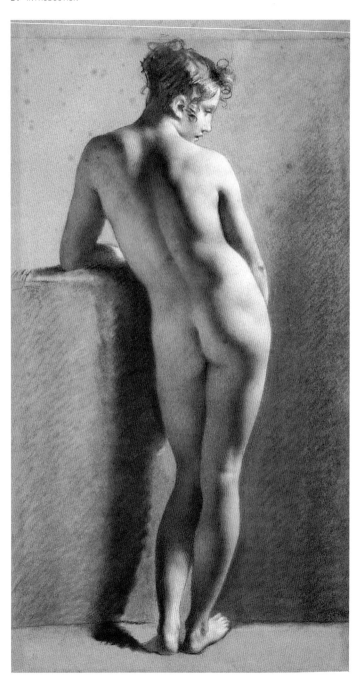

to nature for subjects, artists felt constrained. The promise, believed in by many artists, that abstract expressionism would lead to a universal language of pure form communicating feelings unadulterated by ideology or intellect was never fulfilled. Abstract artists began to sneak back to nature." Steinhart relates a story about Richard Diebenkorn, who was starting to gain fame as an abstract artist in the 1950s. Diebenkorn quietly started painting landscapes — "abstractly enough to deny that he was painting landscapes." He joined life drawing groups and eventually started one of his own, ignoring collectors who discouraged him from working from the figure because it might tarnish his reputation and lower the value of his abstract paintings.

A new atelier movement has sprung up — small studios run by practising artists, dedicated to reviving traditional methodology that has been lost or discarded over a century of neglect. There's a school in Toronto where you can actually learn Fresco — the technique of painting murals into wet plaster that Michelangelo used in the Sistine Chapel.

Atelier students study the works of masters such as Pierre-Paul Prud'hon (1758–1823), who worked with powdery applications of black and white chalk on mid-toned paper. Prud'hon articulated light and shadow by stumping — seamless blending of chalk with little wands made of tightly wound paper. He captures the feeling of light and shadow wrapping around the figure, down to the luminous quality of reflected light bouncing into the shadows.

Atelier students go through four to five years of rigorous drawing and painting curriculum, copying old masterworks, drawing from casts and studying anatomy. There are no shortcuts to mastering these skills — it requires sustained effort, self-discipline and great focus. In these ateliers, the models sit for ten-hour poses (with appropriate breaks, of course). Juliette Aristides, who runs her own atelier and has written several excellent books introducing her curriculum, writes "the Atelier education movement seeks to revive the discoveries of the past while giving students the skills to move forward with their own vision. Ateliers take students out of the classroom and place them back in the studio where they can learn their craft under the watchful guidance of a mentor artist, as so many great artists have done before them."

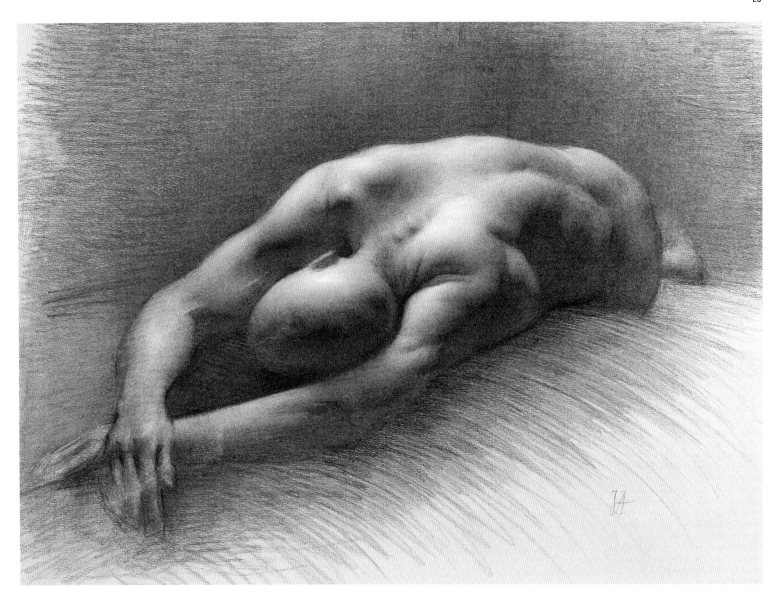

Opposite: Pierre-Paul Prud'hon, *Standing Female Nude, Seen from Behind*, 1785–90, charcoal heightened with white chalk on paper (Museum of Fine Arts, Boston).

Juliette Aristides, *Sutherland at Rest*, 2021 (courtesy of the artist).

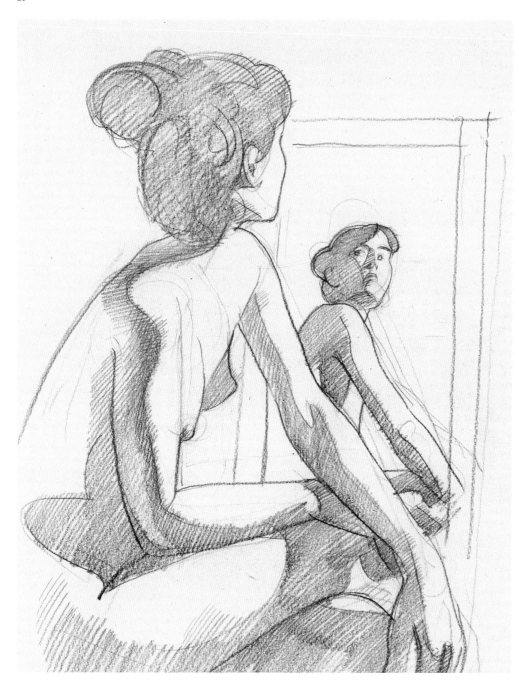

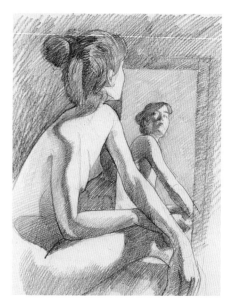

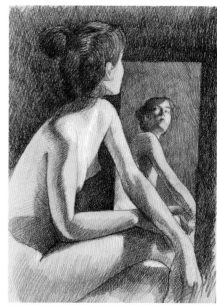

Scott McKowen, *Vilidian*, coloured pencil, 2021. The large image is the block-in stage, before continuing on to develop and finish the drawing.

SOME BASICS

Most problems in observational drawing come from shortcomings in observation, not drawing. Someone once said that your vision needs to be sharper than your pencil — look before you draw! A few minutes spent studying your subject before you pick up a pencil allows you to analyze the key elements of your composition. Before I begin any drawing, I try to think about what's important to include and what can be omitted.

When starting a drawing, the first few lines that establish the placement and scale of the image are called the block-in. Always keep the block-in light so that you can make corrections as you proceed. I kick myself sometimes when I lock myself too quickly into decisions by making dark "finished" lines, then get frustrated when the drawing is not accurate. Keeping the drawing pliable for as long as possible keeps you from going too far, too quickly.

A good rule of thumb is to work from the general to the specific — sketch in simple basic shapes to capture essential angles and proportions of the large masses. I often start a figure drawing with a very light oval that looks like an egg, knowing that a head is not remotely shaped like an egg. But it gives me an armature to flesh out the details as I start to develop the drawing. Look for the overall structure and relationships between elements.

You never know when you start a drawing how it's going to turn out. Sometimes you will be happy with a result; sometimes not. As an illustrator, my drawings are commissioned by a client and I know the steps necessary to develop a drawing to "final art" stage, ready for print reproduction. The drawings in this book are my personal work when I don't have illustration deadlines. Most of them could be considered mere exercises — I never intended that they would be finished works. But sometimes an intangible phenomenon takes place on the page and a few simple, eloquent lines express something in a way that transforms a drawing into a work of art. How this works is a mystery — and very much in the eye of the beholder, as the old cliché goes — but all artists have had this experience. A successful drawing builds your confidence, which is important. A drawing that you're not happy with provides a learning opportunity — which is equally valuable.

On the next eight pages are some "basic training" skills that I wish somebody had drilled into me in my formative years. In retrospect, the art classes at my high school were painfully mediocre, with an emphasis on craft projects. This was the 1970s and curriculum was designed to be fun. What I needed was a teacher to recognize that I had motivation and potential — someone to sit me down and work me twice as hard as the other students. I knew I was sadly lacking in fundamental skills and felt for years that I was behind, trying to catch up. Thank goodness it's never too late to learn.

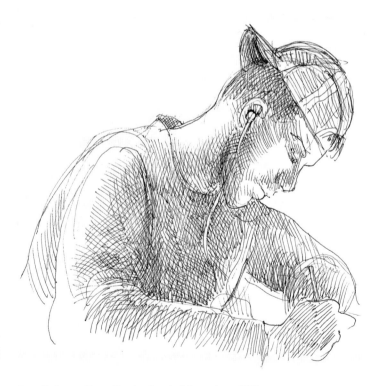

Scott McKowen, *Young Man in a Baseball Cap*, gel pen, 2021.

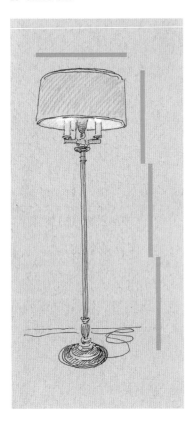

There's an old cliché image of an artist wearing a beret and holding up his thumb at arm's length in front of his canvas. Maybe it comes from those LEARN TO DRAW magazine ads I grew up with in the 1960s. I don't think the beret will improve your drawing, but the raised thumb makes reference to something that will. Measuring is one of the most important techniques for ensuring accuracy in a drawing, no matter the subject or style.

Your thumb is too clunky to be effective as a measuring stick. A pencil works. I use a knitting needle — the thinner and straighter the better. For consistency, hold the stick at arm's length, with your elbow locked.

Hold your stick up to your subject and use your thumb to mark off a unit of measurement. If you're drawing a figure, it's typical to use the height of the head as the unit of measurement. You can use doors, arches or windows as your unit if you're drawing architecture. You can use the width or height of any element in your subject.

Here's a sketch of a floor lamp to demonstrate the method. I used the width of the shade as my unit of measurement and discovered that the lamp is exactly three units in height. Presto, I've got the correct proportions.

A deer skull that I have in my studio provides a more complex example. I found that the height of the skull is the same as the inside distance between the uppermost points of the antlers (shown in light blue). The tip of the nasal bone down to the bottom of the incisive bone (shown in pink) is exactly one quarter of the overall height of the skull; measuring up from the bottom, the third quarter falls at the top of the eyesocket. The width of the skull just below the eye sockets (green) is equal to the distance between several of the antler points, and I found that if I extend that measurement up from the bottom tip of the incisive bone four times, it hits the tip of two of the antler points. The base to the tip of the antlers (purple) is the same length as the base of the antler to the broken incisive bone.

To start the actual drawing, I made a series of very light hatch-marks indicating the units of measurement (like those indicated in pink on the mockup). These serve as guideposts as I block in the initial light lines of my drawing. You can use the same scale (your thumb marking the unit of measurement on your knitting needle) — but it's easy to change the scale if, for example, you want a larger-than-lifesize drawing that fills the page. I invested 15 minutes measuring and plotting out those key hatch-mark points, and double-checking them — this exercise will give you the confidence that the antler points (in this case) are accurately placed.

You have to get used to closing one eye while measuring — binocular vision defeats the purpose. I never consciously think about this because I happen to have vision in only one eye. I was diagnosed in infancy with a rare and aggressive cancer called retinoblastoma. I was born at the University of Michigan hospital in Ann Arbor — it was one of the first hospitals in the country experimenting with cobalt radiation as a treatment for localized cancers. I was a guinea pig in the right place at the right time. I lost the left eye but they saved the right one — which has been working fine for more than six decades. With a career in design and illustration, there is not a single day that I take for granted how lucky I am.

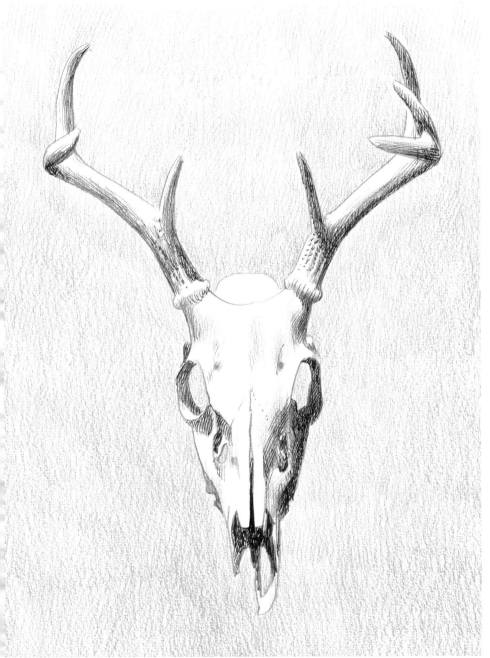

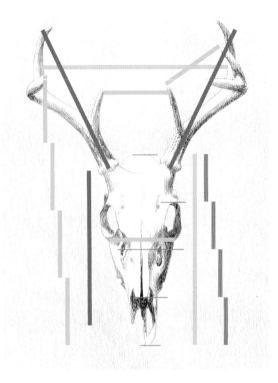

Scott McKowen, *Deer Skull*, coloured pencil, 2021, with inset above showing units of measurement; ink sketches of the same skull from different angles, as drawing exercises, 2020.

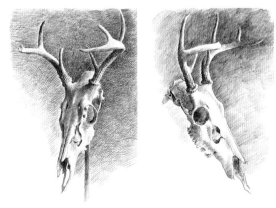

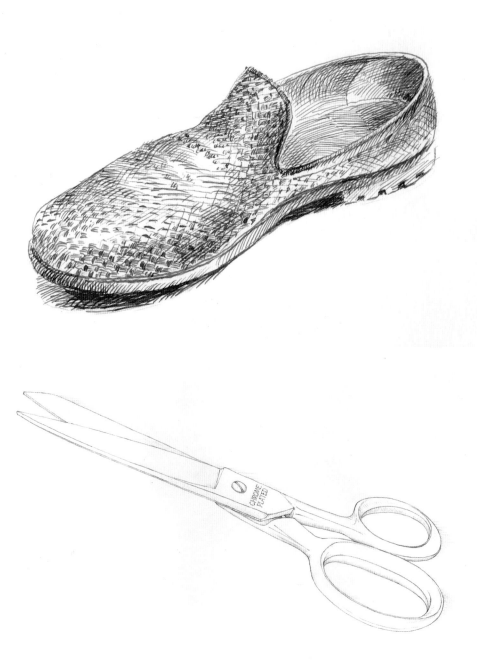

I remember the first day of my first drawing class at the University of Michigan School of Art. The teacher asked everyone to remove one shoe, put it on the desk and draw it. It was a kind of self-portrait — the choice of Doc Martins or beat-up Nikes or sandals makes a statement about personal taste and style — but the exercise was about looking at shape and proportion and the lines that define edges. I don't have my shoe drawing from all those years ago, so I recreated that assignment in pen and ink.

I pulled the rest of these pencil drawings out of a dusty student portfolio that I haven't opened in 50 years — but it is instructive to revisit them as teaching tools. The scissors is a large drawing (18 x 24 inches) — the assignment was to fill the page with a hard-edged metal tool, so we had to enlarge the scale of the object while learning to make smooth, confident lines.

We had to draw paper shopping bags, for weeks, as exercises in monochromatic tonal shading.

The X-ACTO knife with a plastic glove inflated like a balloon was an exercise in rendering reflections and transparency.

M.C. Escher was a favourite artist among university students in those days, including myself. There's a famous Escher self-portrait holding a reflecting sphere that showed the entire room, so I did a little homage, using a Christmas ornament, for a self-portrait assignment.

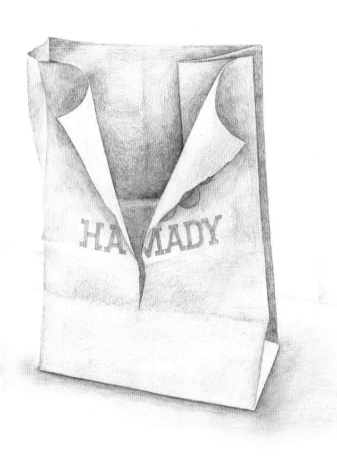

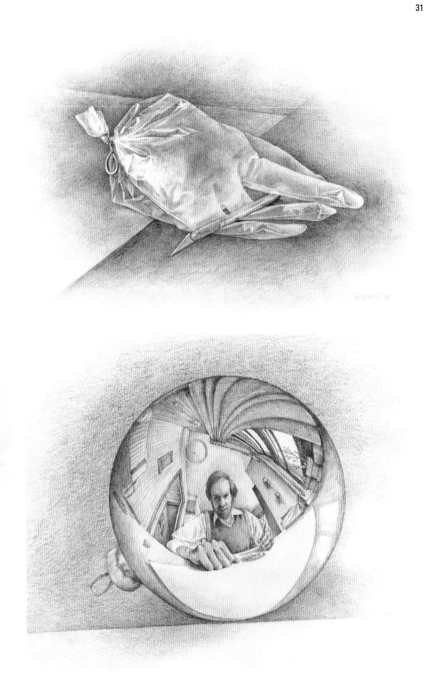

Scott McKowen, student pencil drawing exercises from the University of Michigan School of Art, 1975–76. Opposite: *Venetian Loafer*, ink, 2020.

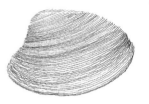

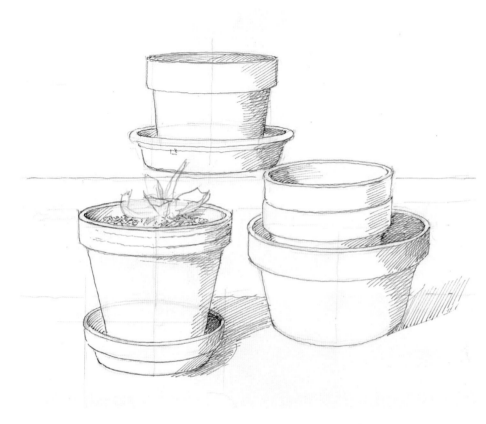

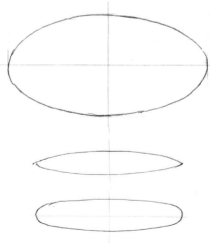

Every ellipse — no matter how steep the angle — is always symmetrical vertically and horizontally. A pencil construction with the two axis lines is a useful way to visualize this — you can see some of mine in the drawing above. Each of the four quadrants formed by the perpendicular axis lines should be identical.

A common pitfall to avoid is a pinched ellipse that look like a cigar or a football; or a squashed ellipse that looks like sausage.

The lowest grade I ever received in my academic career was one C — from Vincent Castagnacci in a drawing class at the University of Michigan School of Art. He was a rigorous taskmaster — he's the only teacher I've ever encountered who would actually step in to correct your drawing (in red pen!) as you were working on it. He could spot a misplaced line with deadly accuracy, leading regularly to students leaving the room in tears of frustration. In retrospect, that class provided the best basic training I ever received. We were assigned fundamental drawing exercises designed to connect the hand firmly with the eye. To practise contour lines, for example, we had to draw the closely spaced growth rings on clam shells.

We spent an entire semester drawing flower pots in order to master ellipses. An ellipse is simply a circle on a tipped plane — hold a coin so that you are looking at it straight on, as a circle. Rotate it slowly and watch the shape change into an ellipse that gets narrower until it morphs into a line when you are looking straight across at the edge of the coin. Many objects are cylindrical, so there's no escaping ellipses in drawings. There is a mathematical formula for constructing an ellipse, but it's far more practical to learn to freehand them accurately. Facility with drawing ellipses comes in handy almost every time I pick up a pencil.

Set up a still life with a stack of flower pots and try drawing them. You'll notice that the ellipses get wider as the plane drops farther below your eye line.

TART 16.06.20.

Scott McKowen, casual studies of various round and cylindrical everyday objects, clockwise from top left: a large potted callalily in my studio; a drawing made at a local garage; a bicycle in Amsterdam; a rhubarb tart on a springform pan.

VANISHING TRACE

TIPPED PLANES

V.T.

V.T.

V.T.

H.L. V.T.

HL. V.P.

V.P. HL.

HL. V.P.

MR. MORTON · RM. 2 · WED. AM

This page: Marjorie Kurta, perspective assignments from the
Meinzinger School of Art in Detroit, in the late 1940s.

VIA BOCCARDI TRIESTE

Scott McKowen, two one-point perspective sketches, 2003. The *Passage des Panoramas* opened in the 2nd *arrondissement* in Paris in 1800; Via Boccardi, Trieste.

Linear perspective is the method of representing objects in space with their natural sense of three-dimensionality. An object that's farther away from us appears smaller than one that is closer. You can't avoid thinking about perspective if you're drawing architecture, for example — the horizontal lines of a streetscape appear to converge at a horizon line (even if you can't see the horizon) at a precise vanishing point.

Here are two urban sketches demonstrating one-point perspective. All the elements of the composition converge at a single vanishing point on the horizon line. I freehanded the perspective here so they are a little fast and loose; the perspective exercises on the facing page to show the complexity of a proper exploration of objects in space. On the facing page are two student drawings by my mother, Marjorie Kurta, who trained at the Meinzinger School of Art in Detroit in the late 1940s. I still have her school portfolio and I have to admit that she received better basic training than I did. You can see from her drawings how two-point perspective works, with vanishing points at the outside edges of the composition. There's three-point perspective as well, when you're looking up at a tall tower, for example.

Aerial perspective is another way of creating an illusion of depth through changes in value and line weight, which I'll mention elsewhere.

Travel Sketchbooks

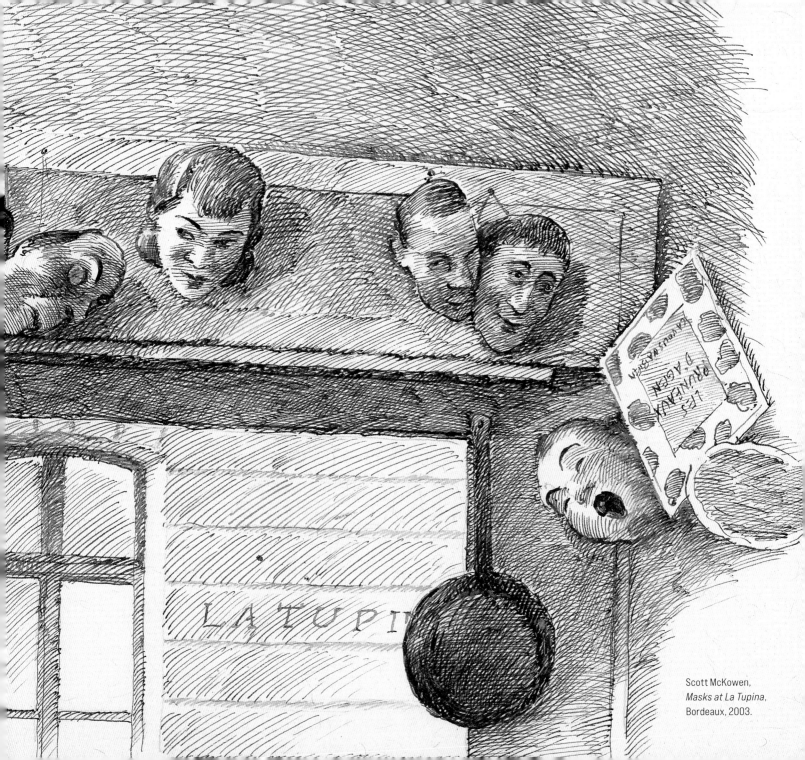

Scott McKowen,
Masks at La Tupina,
Bordeaux, 2003.

Scott McKowen, *Venice Windows*, ink and white gel pen, 2012.

When I travel, I always take a sketchbook with me. Sitting in front of a landmark for an hour and trying to capture its proportions and perspectives and character on paper gives me a more meaningful connection than I could ever get from a cell phone photo. (And I don't even *have* a cell phone!) When I am walking the streets of a new city, or returning to a familiar one, I'm constantly watching out for interesting places to draw. Sometimes this rubs off — Christina often comes back from her own rambles and announces, "I spotted a drawing for you." I have accumulated drawers full of sketchbooks over the years — leafing through any of them, years later, immediately takes me back to the time and place. The drawing becomes an evocative record of the experience.

David Gillett echoed this in his article "Why I prefer to travel with a sketchbook instead of a camera," published in *The Globe and Mail* in 2016. Gillett observed, "Drawing is to photography what walking is to driving: it's more work, it's slower, it demands patience and it's something we've increasingly forgotten how to do. And yet, it pays dividends: The work is a rewarding pleasure, the pace allows a scene to sink in and be appreciated, concentration breeds a contemplative mind-set."

A few years ago I joined Urban Sketches, an informal global community of artists who practise on-location drawing. Their pragmatic mission statement is "see the world, one drawing at a time." Founded in 2007 by Seattle journalist and illustrator Gabriel Campanario, Urban Sketchers promotes drawing in parks, in cafés, on the street, from the window of your house — indoors or out — but always on location from direct observation, never from photos or memory. To clarify, "We don't draw from photographs because that would be reproducing someone else's vision." Urban Sketchers has an excellent website with a network of blogs where members share drawings and stories.

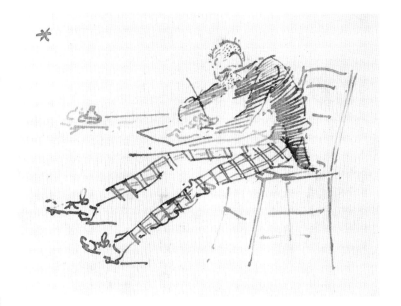

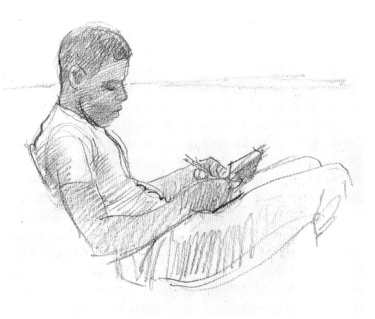

James Abbott McNeill Whistler, *Walter Sickert sketching*, ink, 1885 (Bridgeman Images); Scott McKowen, *Sketch Night at Society of Illustrators*, 2012.

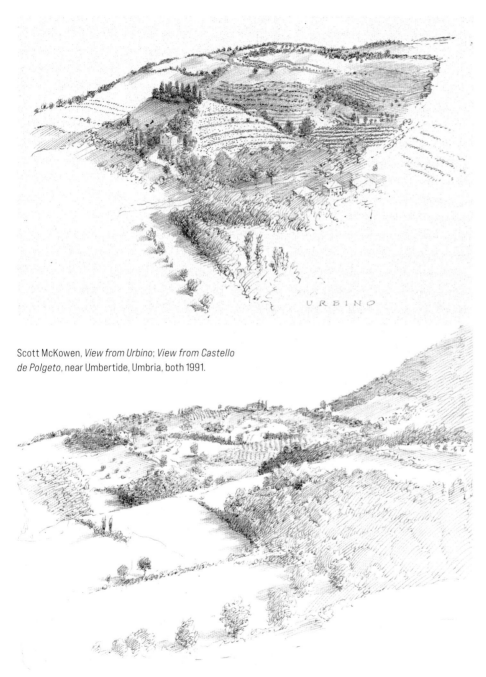

Scott McKowen, *View from Urbino*; *View from Castello de Polgeto*, near Umbertide, Umbria, both 1991.

Before starting any drawing, you have to spend a lot of time looking. There's as much art to selecting an interesting subject as in the drawing of it. I am always taken with the textures of the Italian countryside — shadows falling across rows of vineyards create distinctive stripe patterns, undulating across hillsides with trees and fields of other crops.

Landscapes are a good place to start thinking about composition — the layout and design of the page that invites the viewer's eye into the sketch. A drawing is a two-dimensional slice of the wide world around us — a "cropping." How much of a scene do you want to include? It can be useful to make quick thumbnail sketches, to compare different versions of the composition, before starting the actual drawing. These small practice sketches help you visualize the scene at a smaller scale and get you thinking about how to simplify the shapes.

Cinematographers often use an eyepiece to select the framing of a movie shot. I sometimes use a viewfinder frame to help isolate the area that I want to focus on. I found this ViewCatcher gadget online — a plastic frame with a sliding panel that adjusts to any horizontal, vertical or square proportion — but you can just as easily make your own cardboard version.

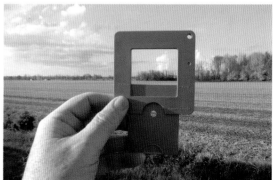

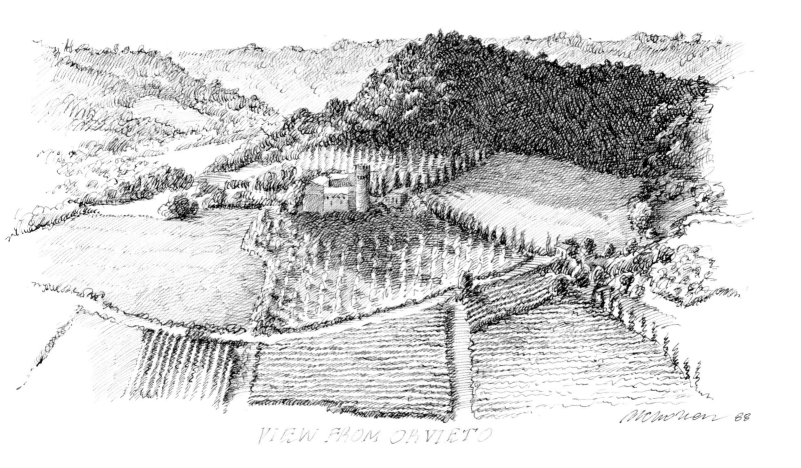

VIEW FROM ORVIETO

Scott McKowen, *View from Orvieto*, 1988.

Notice that the most distant hills in this drawing are rendered with lighter lines than those in the middle distance and foreground. The phenomenon of aerial perspective makes objects farther away appear to have less contrast and less detail than those closer to the viewer — the increasing amount of atmosphere acts like a filter to create this effect. Using lighter tones to render distant features (and a shift towards blue, if you are working in colour) enhances the illusion of depth in a landscape.

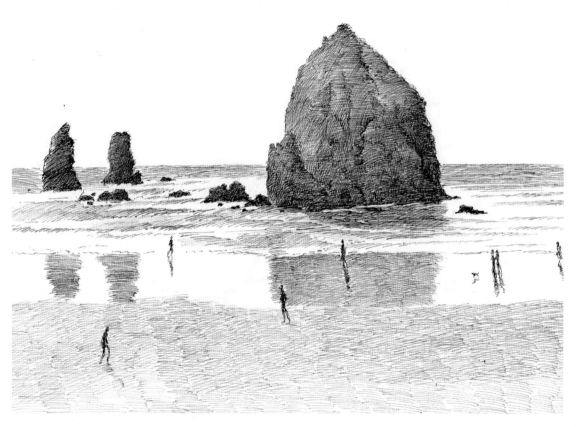

Scott McKowen,
Haystack Rock,
ink, 2001.

I think a lot about how pen lines can render the contrasting natural textures in landscapes. Here are two views of rocks and water. I visited Cannon Beach in Oregon, looking out over the Pacific, on a day when the waves breaking onto the sand created glassy reflections, which helped tie together the foreground and the background of my sketch.

I brought my drawing kit (in a waterproof bag) on a canoe trip in Killarney Provincial Park on the rugged north shore of Georgian Bay. This region was made famous by the Group of Seven — the white quartzite and pink granite mountains, dotted with pine trees, are part of the ancient Canadian Shield stretching from the middle of North America across to Greenland. I hadn't really planned it but the paper I was using (a 9 x 12 pad from Bandelier Environmental Papers) had a fibre texture that seemed to enhance that of the distant rocks.

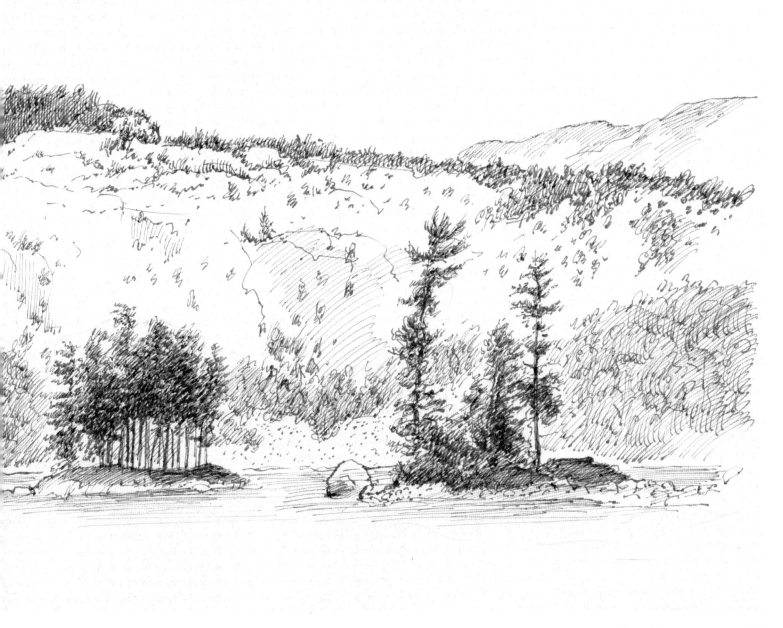

Scott McKowen, *Killarney*, ink, 1997.

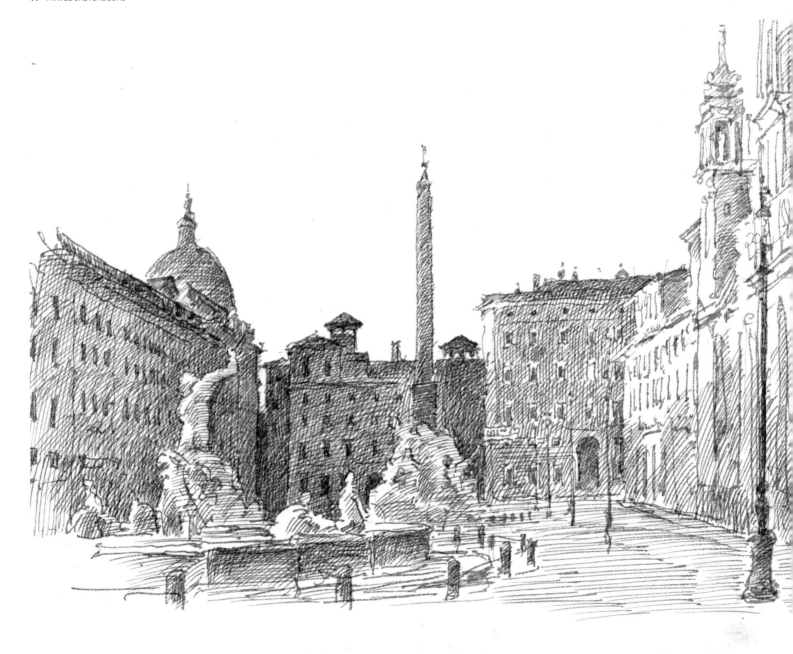

The only way to get a drawing of Rome's Piazza Navona without hordes of tourists is to get up at 6 AM before they descend. The facades on the right, catching the early morning sun, were the brightest surfaces so I left them the white of the page, with hatching lines indicating the soft cast shadow of the roofline on the left side. The far end of the piazza was in deep shadow — the darker hatching there helps to highlight the white marble statuary under the obelisk. I didn't take the time to construct the one-point perspective lines radiating from a precise vanishing point, but eyeballed them as accurately as I could.

Fontana dei Quattro Fiumi, the exuberant centrepiece of Piazza Navona, is a fountain that personifies rivers. Gian Lorenzo Bernini's 1651 masterwork unites the four continents of the world (known at the time) under a giant obelisk. My 2012 drawing reduced the gigantic marble figures to a compact grouping in the distance — so I explored close-up studies on a subsequent visit. The Danube represents Europe.

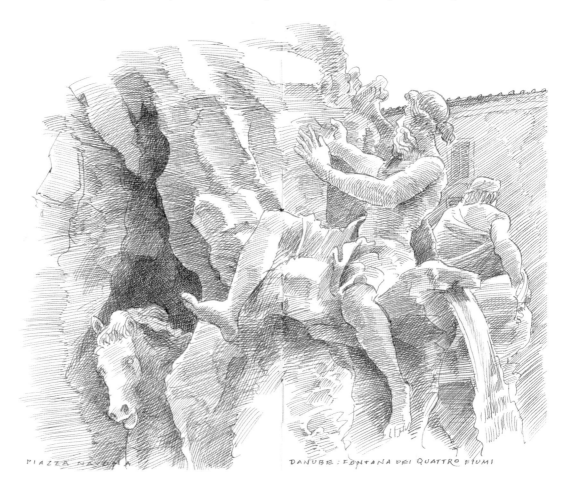

Scott McKowen, *Piazza Navona*, ink, 2012; *Danube*, ink, 2015.

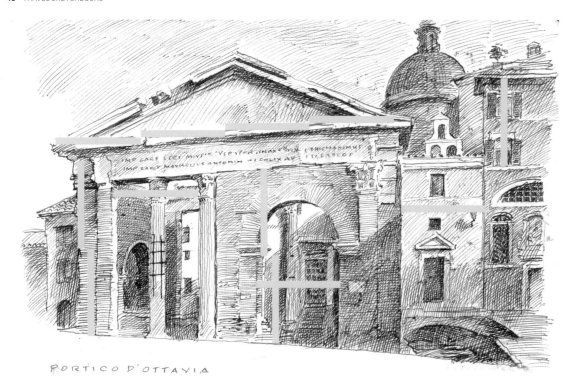

PORTICO D'OTTAVIA

Scott McKowen, *Portico d'Ottavia*, ink, 2017.

The Portico d'Ottavia is a landmark in the Jewish Ghetto neighbourhood in Rome. I have already introduced the important practice of measuring, but here's an example of how it can work with architecture. To start this drawing, I pulled out my trusty knitting needle and, holding it at arm's length, looked for a convenient unit of measurement.

I selected the width of the arch in the main facade. I have superimposed light blue rulers, above, to show how that unit repeats through the drawing. The distance from the ground to the bottom of the entablature is exactly twice the unit. Perspective makes the left-hand side of the facade appear smaller than the right — ground to the top of the entablature measures two units here. The pediment is not quite four units in width. The width of the light-coloured house to the right of the portico is exactly one unit; the height of the top two storeys on the building beside that is another one unit.

I blocked in the drawing with light pencil lines, using hatch-marks to locate these landmarks. I checked and rechecked my measurements, so I was confident that the proportions of the finished drawing were accurate. Only then did I pull out my pen and a bottle of ink and start thinking about the contrasting textures of brick, marble, stucco and tile, and cast shadows falling at a 45-degree angle across the facades.

PORTIC

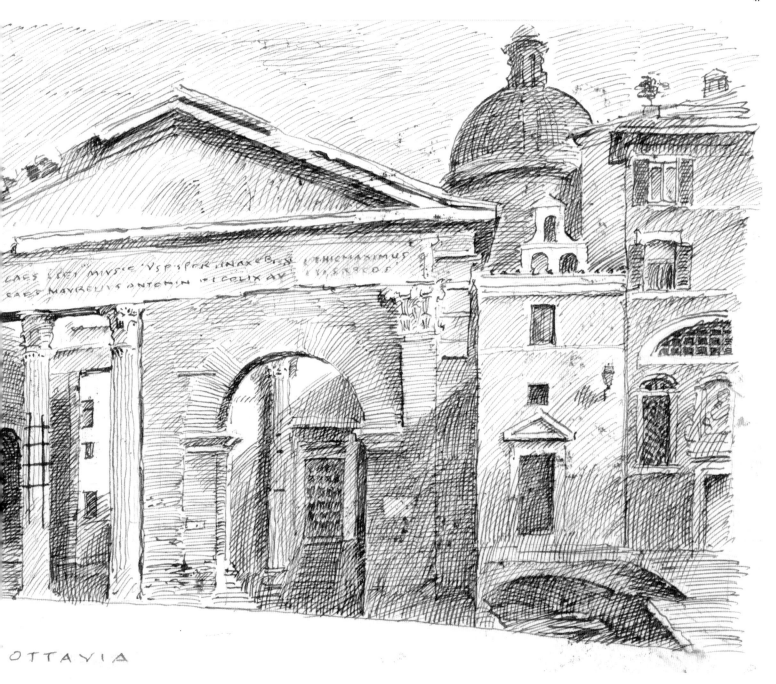

OTTAVIA

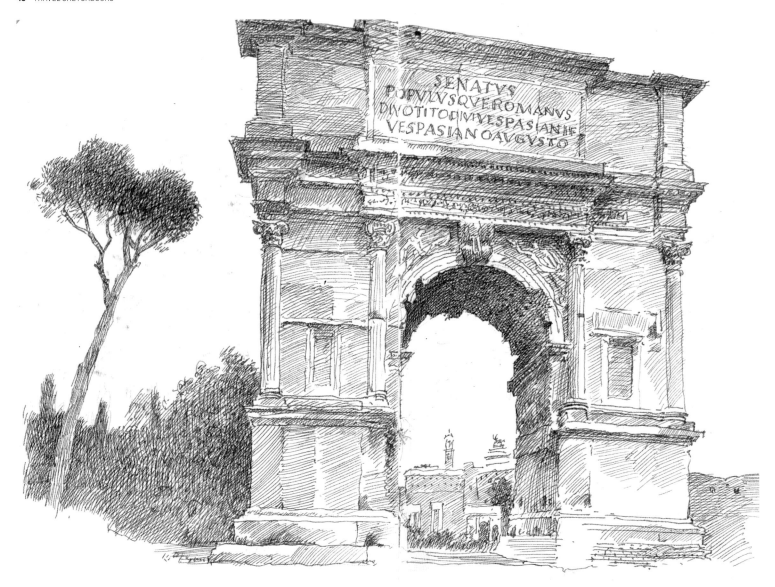

Scott McKowen,
Arco di Tito, ink,
2015.

You can retrace my measuring steps on this drawing of the Arch of Titus at the top of the Roman Forum. The overall height is exactly three times the width of the main arch, and you can extend that unit out from there. This drawing took about an hour, and at least the first half of that time was spent measuring and constructing in light pencil lines before I was ready to start drawing in ink.

Scott McKowen, *Piazza d'Aracoeli*, 2017.

The iconic "umbrella pines" of Rome (*Pinus Pinea*) resemble something that Dr. Seuss might have dreamed up. A dense, dark green canopy of needles undulates high above the ground across the city, providing a wonderful visual counterpoint to the classical architecture, ancient and modern. This tiny plaza, adjacent to the Campidoglio and the Vittorio Emanuele Monument, is an oasis of calm in the middle of the crazy traffic surging through the centre of the city.

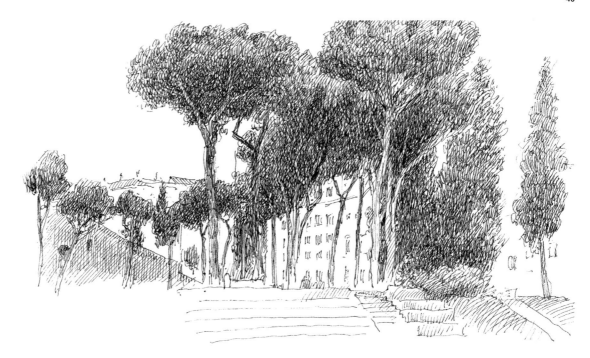

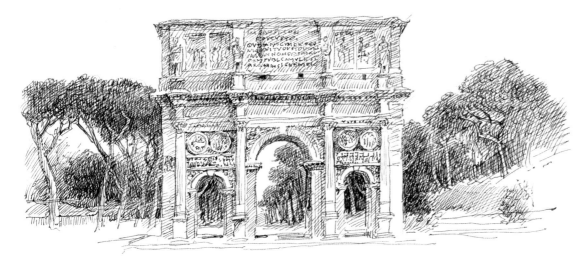

Scott McKowen, *Arco di Constantino*, 2015.

This triumphal arch was dedicated in 315 to commemorate Emperor Constantine the Great. The vertical and horizontal divisions of the marble facade gave me plenty of landmarks to measure from. I love the perspective through the centre arch of the pines stretching along Via di San Gregorio. This is the ancient *Via Triumphalis* — the route taken by emperors returning to the city in triumph.

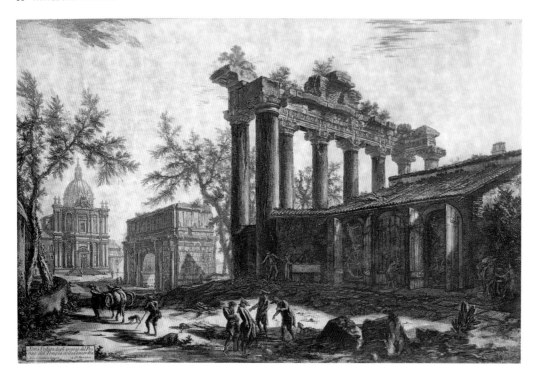

Many years ago, I acquired an original engraving by Giovanni Battista Piranesi (1720–1778). It was a gift from Elizabeth Lawry, born in 1914 in Ishpeming, Michigan. She earned her Bachelor of Arts degree at the University of Michigan, graduating *magna cum laude* with honours in Latin in 1935; returning to earn her Master's degree in 1938. She taught for 40 years in the Lansing school system, serving for 33 years as Assistant Principal at J.W. Sexton High School (where my father taught vocal music for 25 years, and I was a frustrated art student for three). Elizabeth lived to age 97; my mother kept in close touch with her, driving to the Upper Peninsula to visit her in a retirement home. Forgive the backstory but "Miss Lawry" was unforgettable, and I treasure her memory and her generosity.

The Piranesi is one of his fabulous "views" of the ruins of the Roman Forum. I love the layering of history here — it's a snapshot of the ancient monuments from around 1770. The Arch of Septimius Severus is half-buried, and 18th-century horse barns share space with the Temple of Saturn. I wanted to try to make a sketch from the same vantage point, 240 years on. I got pretty close — the landmarks lined up reasonably well from the Portico dii Consentes, just behind the Capitol. The Baroque facade of the Chiesa Santi Luca e Martina looks very much the same today. Piranesi must have been sitting a bit lower to get his exact perspective — perhaps on the roof of an ancient temple immediately below where I was standing. Hatching lines in the sky have to be quiet enough to hint at the soft texture of clouds without competing with the architectural detail.

ALTRA VEDVTA degli avar
del Tempio della Concordi

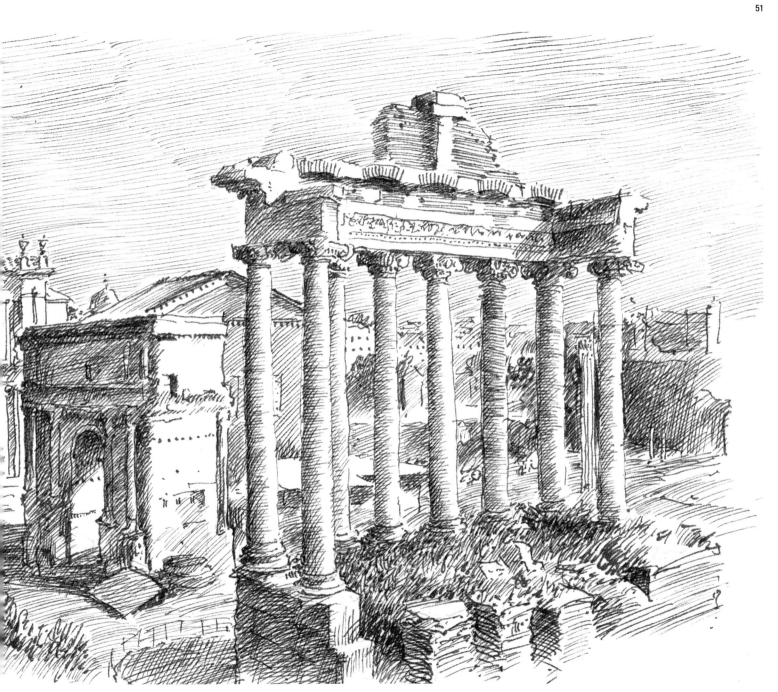

I couldn't decide between a vertical and a horizontal cropping of this facade in Rome's Jewish Ghetto, half a block down the street from the Portico d'Ottavia, — so I drew both. What caught my eye was the layering of history over history — Latin inscriptions carved into ancient stone above the ghost of an Art Deco "Drogheria" sign (a grocery store from the 1930s?), overlaid with plumbing pipes and a spaghetti of electrical wires. Oddly, there are carved stone fragments of two unrelated hunting scenes — a lion attacking a gazelle and a dog hunting a rabbit. The premises is now a café — the tacky Cinzano umbrellas over the sidewalk tables obscure much of the detail I wanted to draw, so I made sure to get there well before they opened for the day.

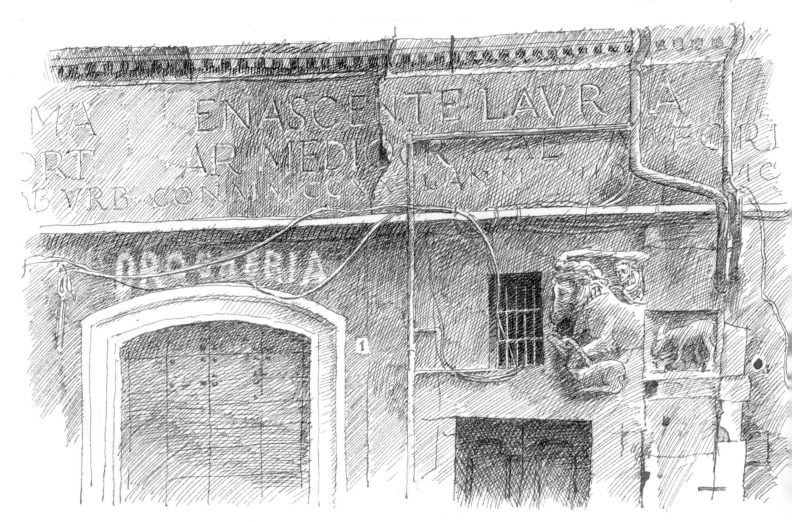

Scott McKowen, two views of a facade on the Via del Portico d'Ottavia, Rome, ink, 2015.

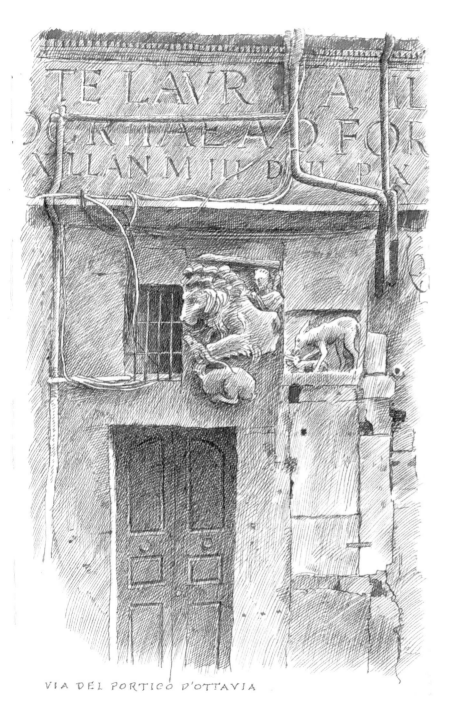

VIA DEL PORTICO D'OTTAVIA

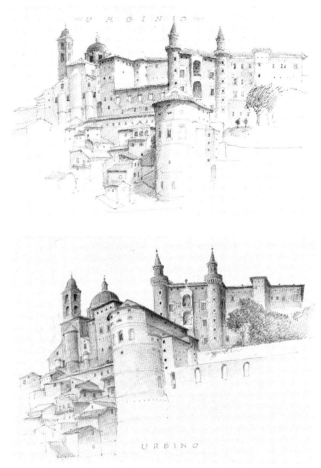

Scott McKowen, two views of Urbino, ink, 1991.

The most impressive view of Urbino is from the municipal parking lot at the base of the hill town. Urbino is a UNESCO World Heritage Site; Raphael was born here. The tallest structures in both drawings are the twin towers of the Palazzo Ducale, from the mid-15th century, which we explored the next day. The buildings are not as precarious as my sketches suggest — but this slight vertical wonkiness feels somehow appropriate for the perspective looking up at the architecture.

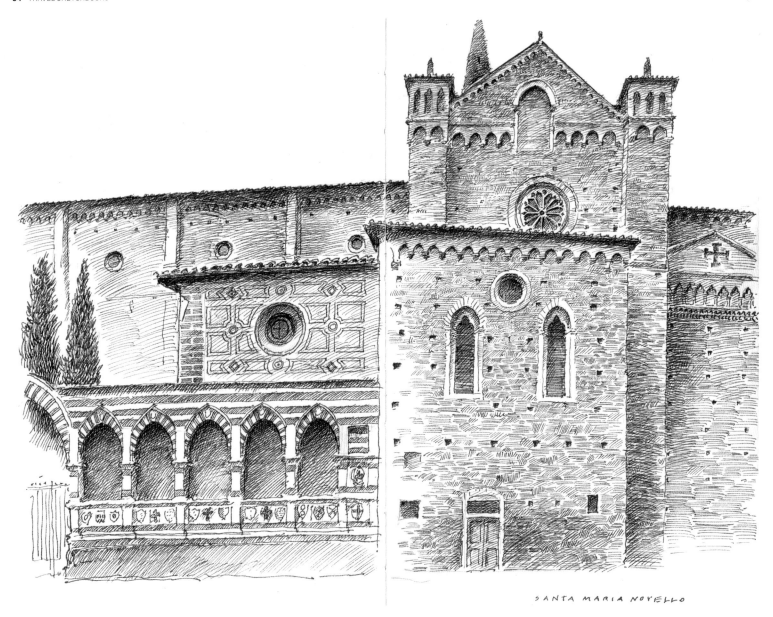

SANTA MARIA NOVELLO

Scott McKowen, *Santa Maria Novello*, Florence, ink, 2012.

It was raining when I made this drawing of Santa Maria Novello — this is the view from a bus shelter across the street where I sat to keep my sketchpad dry. I love the shapes of the various chapels, from different eras, projecting along the side of the church. The square holes in the stone supported wooden scaffolding as the church was being built.

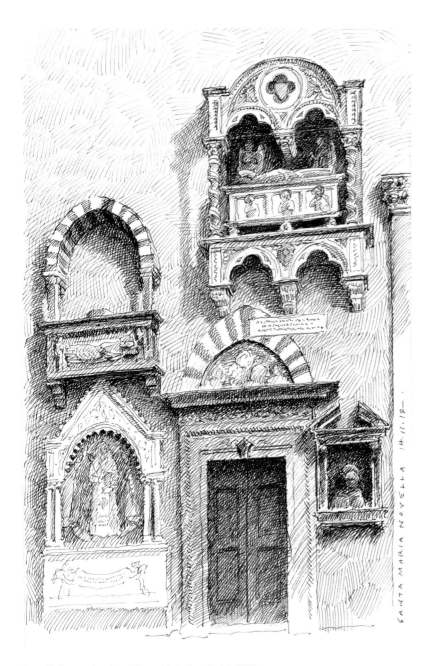

Scott McKowen, *Interior of Santa Maria Novella*, ink, 2012.

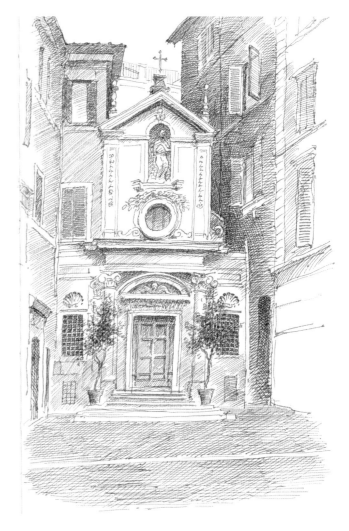

Scott McKowen, *Santa Barbara dei Librai*, Rome, ink, 2015.

Santa Barbara is a tiny church squeezed into a handkerchief of a piazza near the Campo de' Fiori. A café had set up outdoor tables in the square — ordering some wine gave me a perfect angle and provided refreshment while drawing.

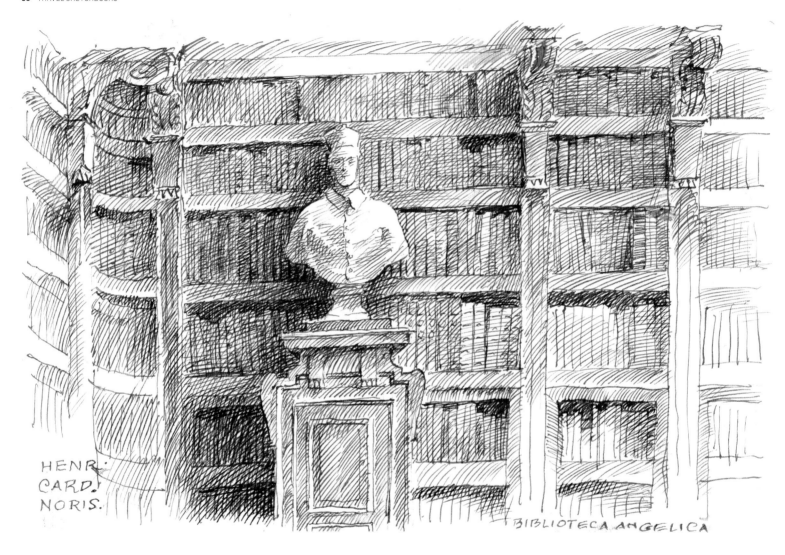

HENR.
CARD.
NORIS.

BIBLIOTECA ANGELICA

Scott McKowen, two views of the Biblioteca Angelica, Rome, ink, 2017.

The Biblioteca Angelica takes your breath away. It claims to be the oldest public library in Europe. It was started by a 17th-century cardinal who owned 200,000 books and took the enlightened view that they should be accessible to anyone who wanted to read them — not hoarded by rich people. We learned of it in a *New York Times* travel article on ancient libraries in Rome, and by complete coincidence, this one was half a block around the corner from our hotel near Piazza Navona. Tourists are allowed to gawk from one end of the room, but we were granted entry permits — temporary library cards for visitors that allowed us to work at the long tables with other researchers. We were here

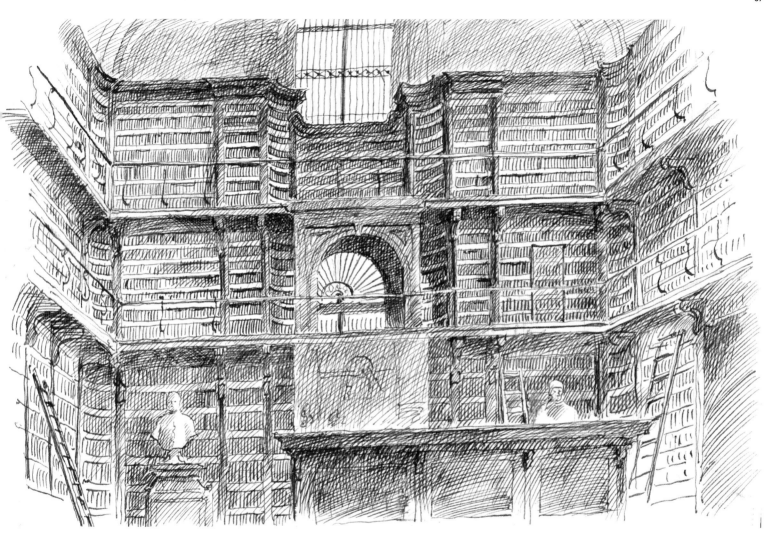

in November 2017, when Christina was designing sets and costumes for a 2018 Stratford Festival production of
Shakespeare's *Julius Caesar*. She had planned to devote some time on our holiday to that project — could there be a
more inspiring setting to work on that particular text? I settled in with my sketchbook to draw this incredible room.
I chose an ink colour similar to the tones of the wooden shelves, columns and corbels. Doors beneath marble portrait
busts in the four corners of the room conceal staircases leading to the upper balconies. I asked if it would be possible
to go up, but was politely informed that this was for library staff only.

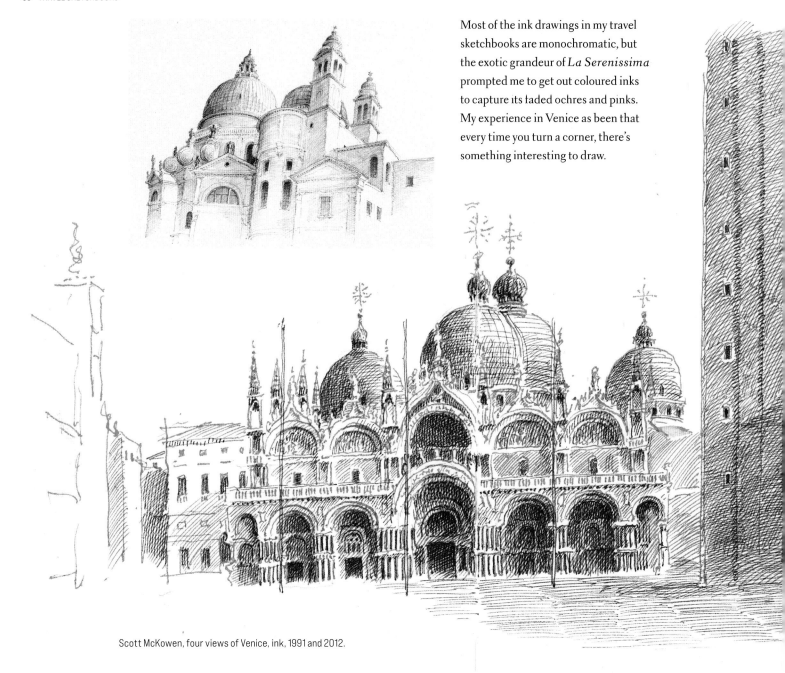

Most of the ink drawings in my travel sketchbooks are monochromatic, but the exotic grandeur of *La Serenissima* prompted me to get out coloured inks to capture its faded ochres and pinks. My experience in Venice as been that every time you turn a corner, there's something interesting to draw.

Scott McKowen, four views of Venice, ink, 1991 and 2012.

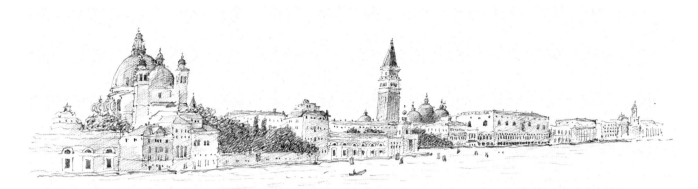

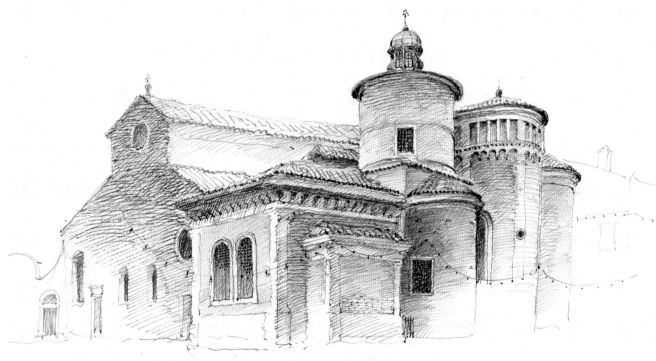

SAN GIACOMO DELL'ORIO = VENEZIA

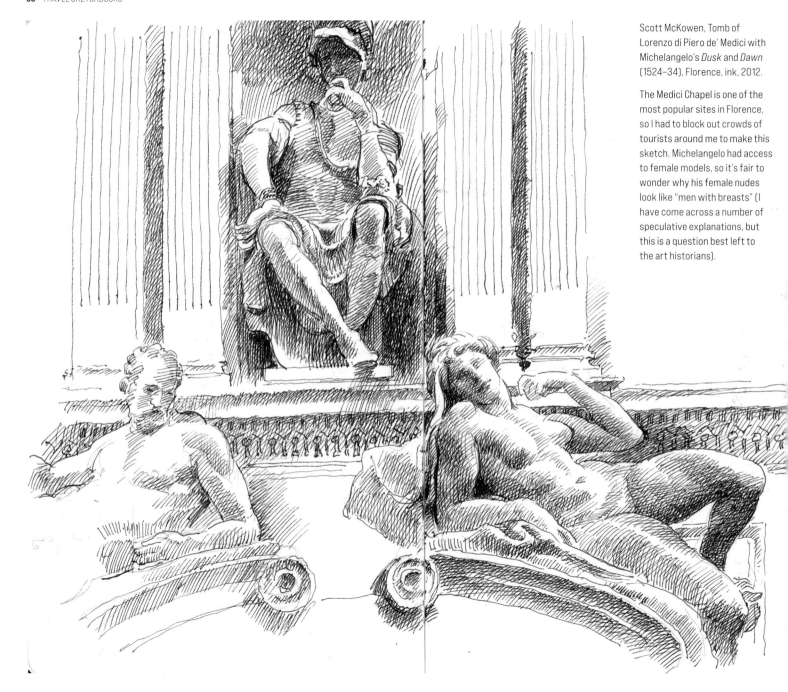

Scott McKowen, Tomb of Lorenzo di Piero de' Medici with Michelangelo's *Dusk* and *Dawn* (1524–34), Florence, ink, 2012.

The Medici Chapel is one of the most popular sites in Florence, so I had to block out crowds of tourists around me to make this sketch. Michelangelo had access to female models, so it's fair to wonder why his female nudes look like "men with breasts" (I have come across a number of speculative explanations, but this is a question best left to the art historians).

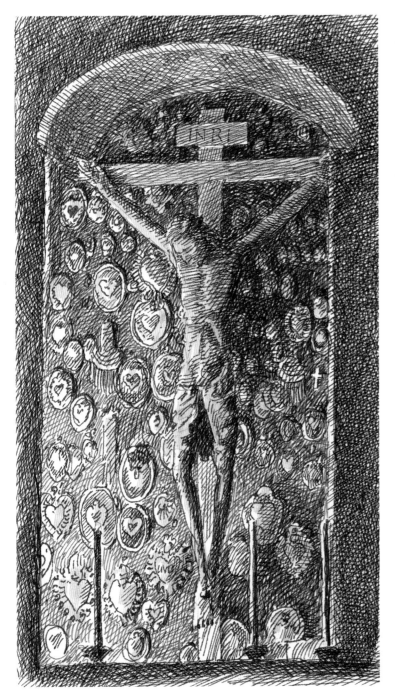

A detail drawing can sometimes tell a better story than a wide-angle view. I was unfamiliar with the old Italian Catholic tradition of ex-voto tokens. These are votive offerings to a saint or divinity, left by worshipers as tokens of thanksgiving for prayers answered — miracles received. This small side chapel in Santa Trinita contains hundreds of tokens, each with its own story. They are usually heart-shaped, but I have seen variations that relate to specific professions or even healed body parts. The initials GR stand for *per grazia ricevuta* — "for grace received." I have started a small collection of these tiny ecclesiastical relics — you can still find them tucked away in antique shops in smaller towns across Italy.

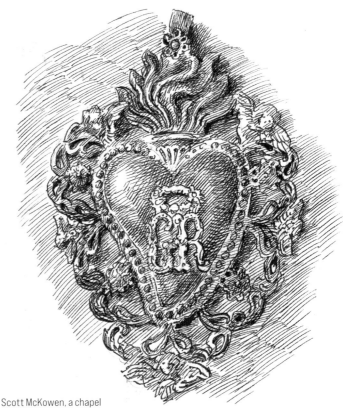

Scott McKowen, a chapel in Santa Trinita, Florence, ink, 2012; *Per Grazia Ricevuta*, ink, 2016.

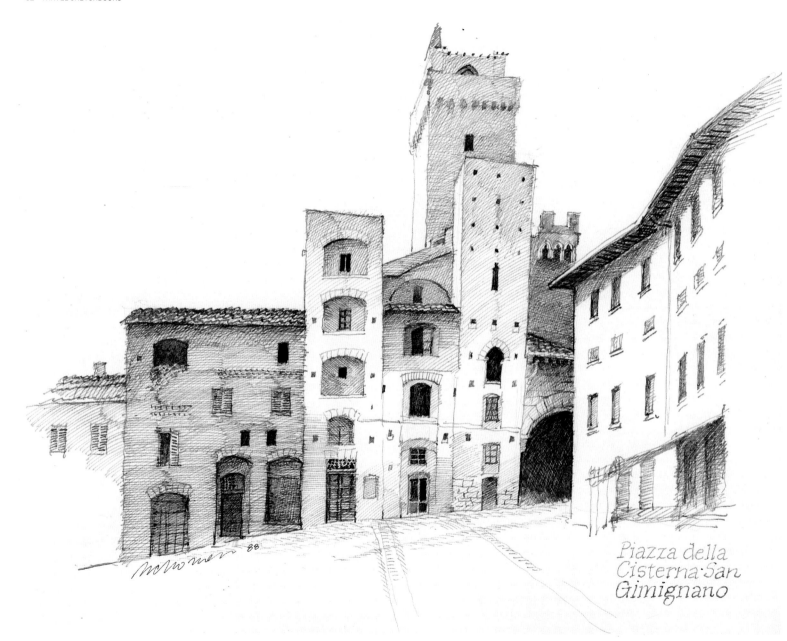

Piazza della Cisterna·San Gimignano

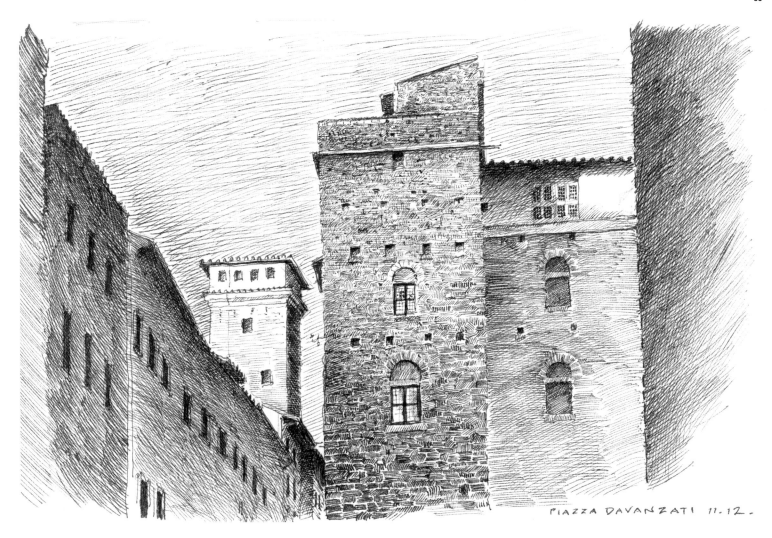

Piazza della Cisterna, San Gimignano, ink, 1988.

San Gimignano is an older drawing, from our first visit to Tuscany. The city is a UNESCO World Heritage Site, celebrated for its 14 ancient towers (there were 72 in the medieval period) — from a distance they have an uncanny resemblance to the skyscrapers of the New York City skyline (exactly as all the guidebooks point out).

Piazza Davanzati, Florence, ink, 2012.

Palazzo Davanzati in Florence, built in the second half of the 14th century, is now open as a museum. It's not every day you get to walk through a medieval tower house. This view presented itself as I came out onto the street and turned left. The stones of that central tower stood out in sharp detail, in contrast with the softer textures of the stucco walls on either side. The square holes, visible in both drawings, are called "putlog" holes — they held wooden beams supporting exterior scaffolding as the towers were under construction.

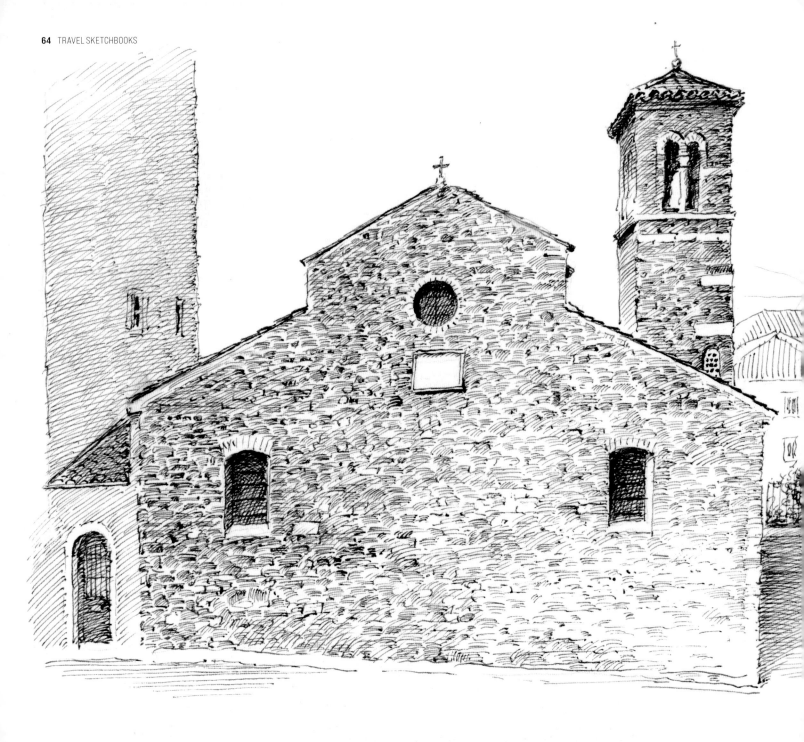

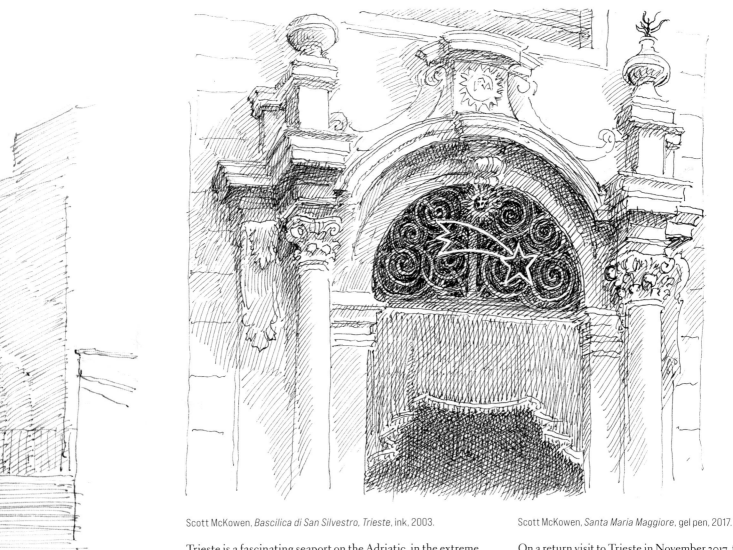

Scott McKowen, *Bascilica di San Silvestro, Trieste*, ink, 2003.

Scott McKowen, *Santa Maria Maggiore*, gel pen, 2017.

Trieste is a fascinating seaport on the Adriatic, in the extreme northeast corner of Italy. It was part of the Venetian empire, but only five miles from the border with Slovenia so there's a fusion of Italian ambiance with the flavours of the Austro-Hungarian Empire. I tried to capture the austere Romanesque stone textures on the back wall of the 11th-century Bascilica di San Silvestro.

On a return visit to Trieste in November 2017, the city was decked out for the holidays. Next door to San Silvestro, the exuberant Baroque grillwork above the main entrance of the 17th-century Chiesa de Santa Maria Maggiore was upstaged by a slightly tacky modern Christmas decoration.

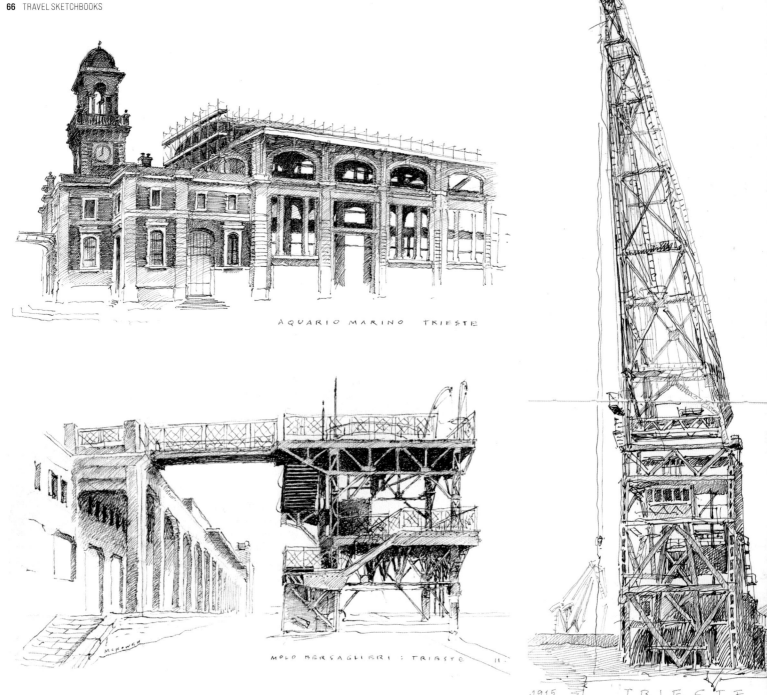

AQUARIO MARINO · TRIESTE

MOLO BERSAGLIERI · TRIESTE · 11 ·

1915 · TRIESTE

VIA BECCHERIE : TRIESTE

Scott McKowen, four drawings of old ironwork in Trieste, ink, 2003 and 2017.

It turns out that I have a tenuous family connection to Trieste. Both my mother's parents immigrated to the United States from Hungary — separately, in 1907 and 1913, at ages 16 and 13. They met only after they both ended up in Detroit. They both sailed from Trieste, the nearest port city, bound for Ellis Island. Walking the Trieste waterfront, I could imagine those kids lining up on these same piers, wondering what their future might hold.

James Joyce lived and worked here, in self-imposed exile from 1904 to 1920 (he wrote *Ulysses* here), which means he could have crossed paths with either of my young Hungarian ancestors.

The ancient ironwork on the waterfront is seized with rust and decay. I rotated my sketchbook vertically to draw this massive crane from around 1915. The bridge structure, for loading and unloading ships, had not moved an inch for decades.

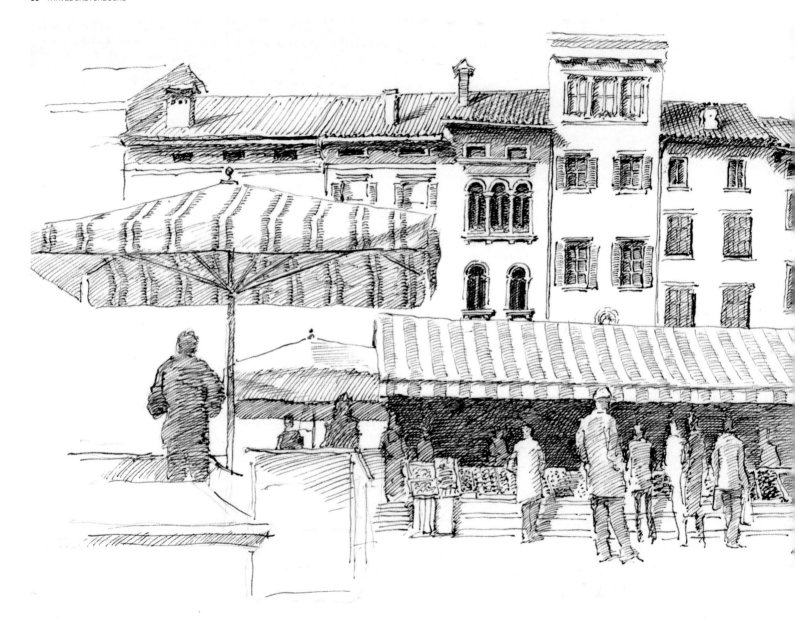

Scott McKowen, *Market Day, Udine*, ink, 2003.

Scott McKowen, *La Gazzettino, Udine*, ink, 2003.

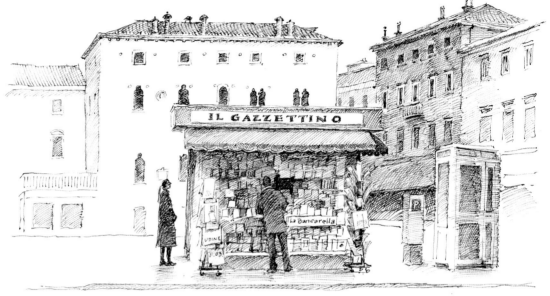

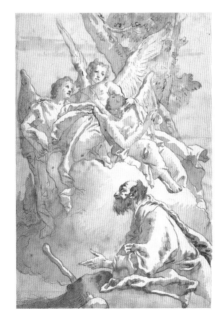

Giandomenico Tiepolo, *The Three Angels Appearing to Abraham by the Oaks of Mamre*, ink over black chalk, Metropolitan Museum of Art.

Udine, "the City of Tiepolo" in Northern Italy, is famous for the Baroque frescos created by father-and-son artists Giambattista, 1696–1770, and Giandomenico, 1727–1804, at the Palazzo Patriarchale and several churches. The art exceeded all expectations — Christina wrote in her travel diary "stupefied with wonder," a phrase she would not use lightly. When you buy your admission ticket to see the frescos, they give you a pillow for your head — it's more comfortable to lie on the floor to study ceilings than to crane your neck.

We spent a couple of days exploring the city — lovely piazzas and wonderful cafés; prosciutto, cheese, local honey and excellent wine for dinner. I drew the busy Saturday market which featured an unbelievable variety and quantity of beautiful fresh fish. And, above, the layers of magazines displayed at a newsstand.

Scott McKowen, *Ljubljana*, 2003.

Scott McKowen, *Madonna and Child with Television Antenna*; *Gresham Palace Grillwork*, Budapest, 2017.

I visited Budapest in 2017 — this Madonna was sandwiched into a tiny square in a residential neighbourhood. The impressive peacock grillwork commands the main entrance to the Gresham Palace, which opened in 1907 as a glorious Art Nouveau office building. It fell into disrepair during World War II, then decrepitude during the Communist era; it was rebuilt and restored by Four Seasons and reopened as their flagship luxury hotel in 2004.

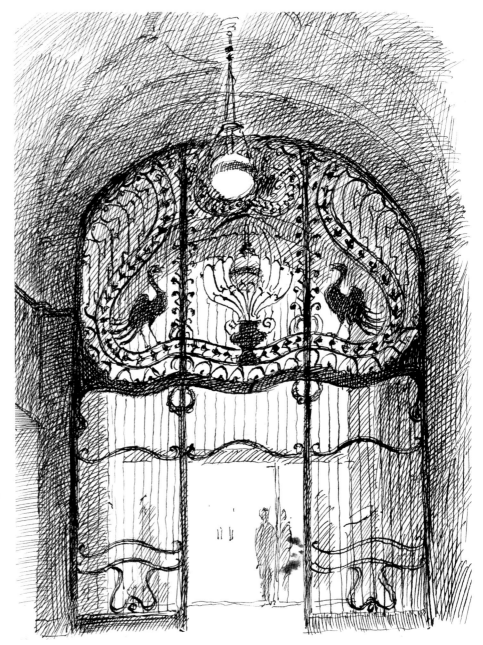

WAWEL CATHEDRAL KRAKÓW

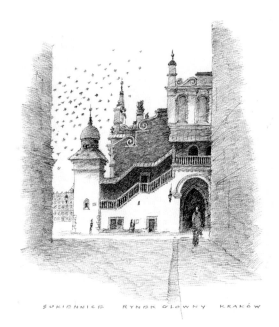

SUKIENNICE RYNEK GLOWNY KRAKÓW

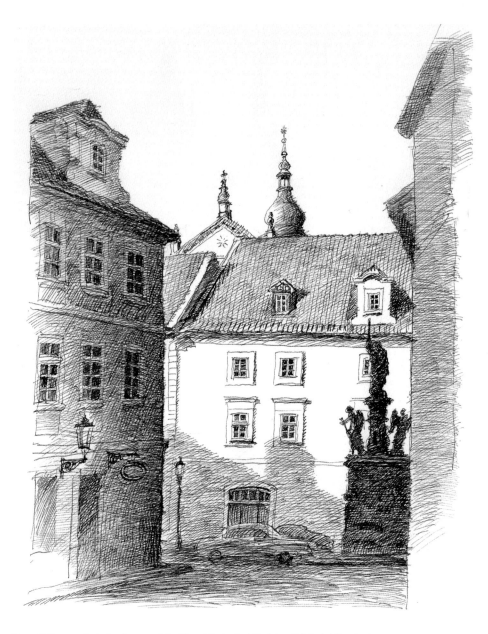

Scott McKowen, clockwise from top left: *Wawel Cathedral, Kraków*; *Maltézské Naměsti*, Prague; *Sukiennice, Rynek Glowny*, the Cloth Hall in the main square in Kraków, all 1999.

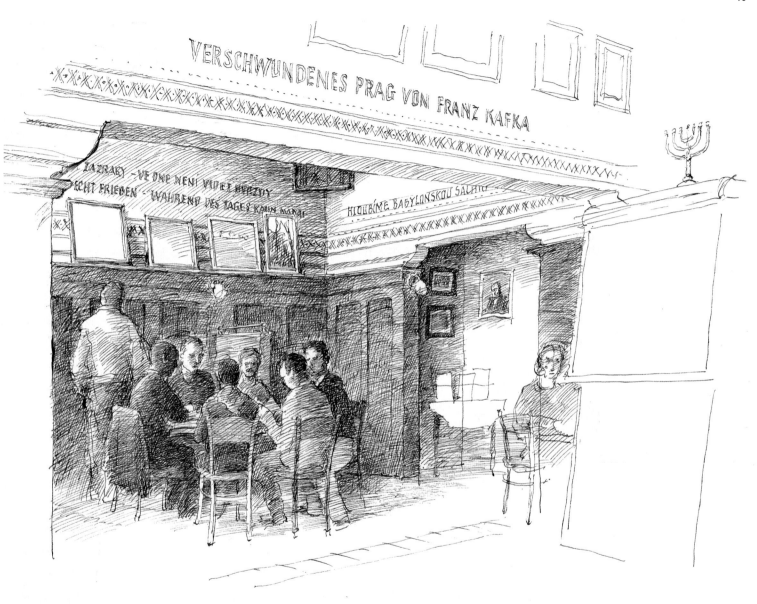

Scott McKowen,
Franz Kafka Café,
Prague, ink, 1999.

Franz Kafka (1883–1924) still has a strong presence in Prague, especially in the Jewish Quarter where he lived and worked. His face is everywhere — on signage, t-shirts and the sugar packets at the Franz Kafka Café, which felt less like a tourist attraction and more like a faded working-class hangout.

I was taken by the exuberant display of topiary and *espalier* crowding the sidewalk in front of this Left Bank *fleuriste* shop in Paris. This drawing was never finished, so you can see how I block in a sketch with light pencil lines. That block-in allows me to work out scale, proportion, composition and cropping while it's still easy to make corrections. Once the structure of the drawing is in place, I can shift my focus to the ink lines and concentrate on shading, tones and textures. Normally I would erase all the pencil lines once the drawing is finished and the ink is dry.

I had a vague plan to spend a day drawing at the Carnavalet Museum — but arrived to find it closed for renovations. Annoyed, I wandered the *Marais* looking for something else to draw. A few of blocks away I stumbled upon the Hôtel de Lamoignon and my mood improved like magic. The building is open to the public — home to the city's municipal archives and historical library. It's the best-preserved grand townhouse from the late 16th century in all of Paris. I used a double-page spread in my sketchbook (the gutter between the pages runs vertically through the centre of the drawing).

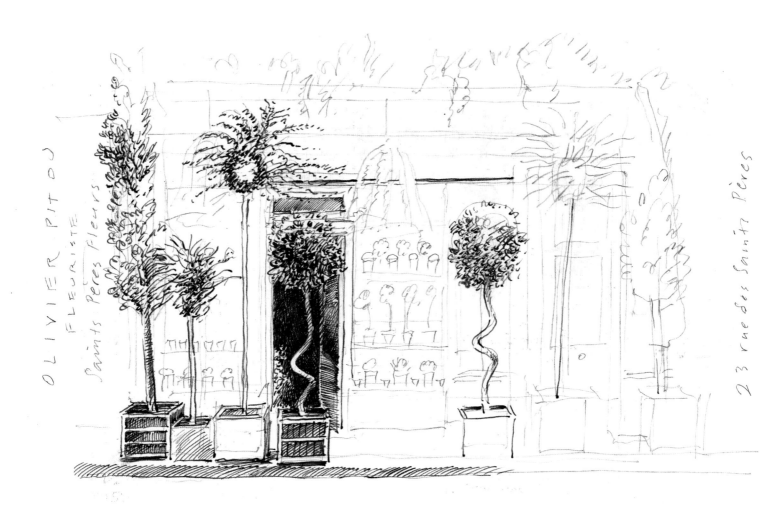

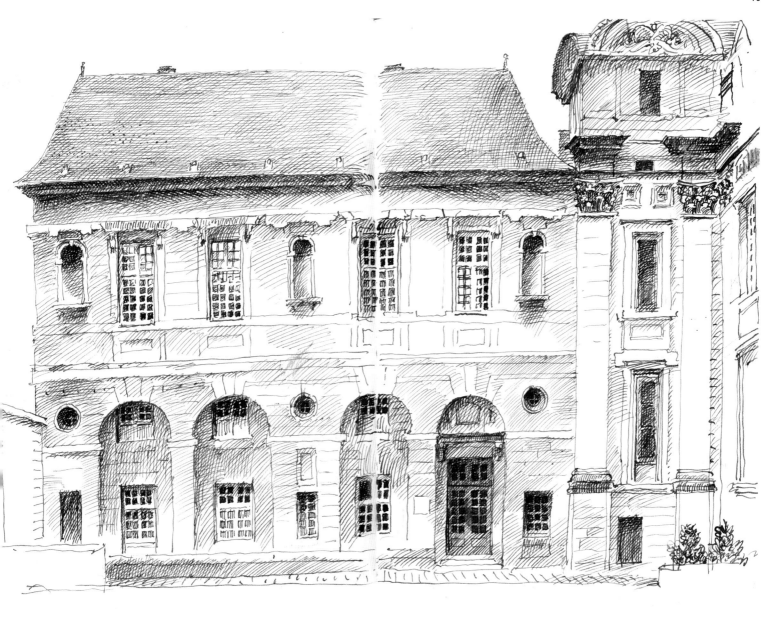

Scott McKowen, *Olivier Pitou Fleuriste,*
rue des Saints-Pères, pencil and ink, 2004.

Scott McKowen, *Hôtel de*
Lamoignon, ink, 2018.

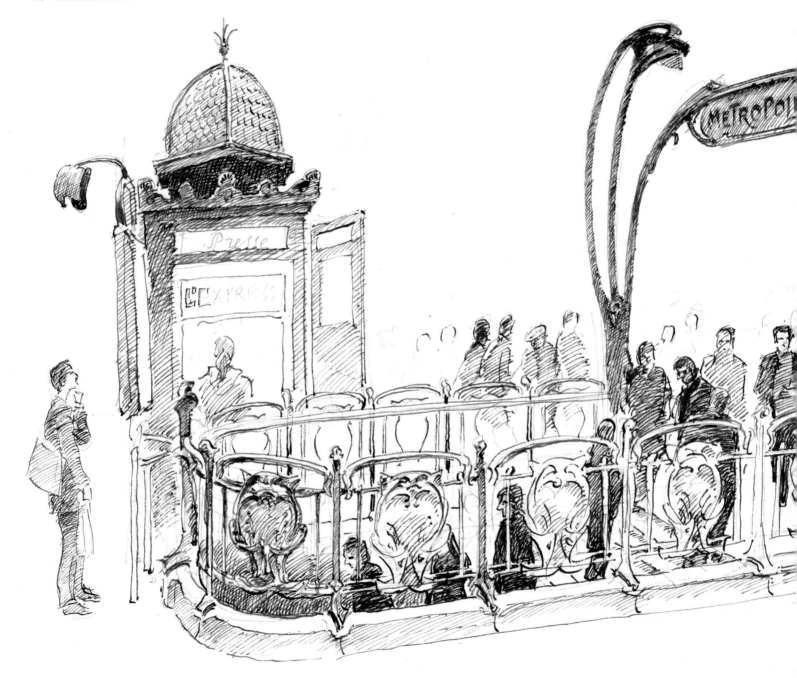

Scott McKowen, *Metropolitain*, ink, 2003;
Saint-Sulpice, gel pen, 2018.

On a 2003 trip to Paris, I decided to draw as
many of the Art Nouveau Metro stations as
I could find. I came upon this one at rush
hour — to get the angle I wanted, I had to
stand on a traffic island, much too close to
speeding cars. The intricate railings shift
from dark to light (in reverse against the
shapes of the dark figures on the staircase),
which helps create the illusion of depth.
The crowd was constantly moving but I
find, glancing back and forth from the
paper, you can freeze individuals, plotting
them in where you observed them for a split
second. I built the crowd this way (except I
left it unfinished — you can still see pencil
underdrawing that I never bothered to erase).

Église Saint-Sulpice, a block from the
Luxembourg Gardens in the 6th *arrondis-
sement*, is the second-largest church in Paris.
I have drawn Saint-Sulpice many times, inside
and out; this 2018 sketch is the back end of the
church, on Rue Garancière. I liked the play of
light and shadow across the curves and angles
of the architecture. The finial on the dome in
the foreground is a statue of a pelican feeding
her young. Ancient legend has it that in time
of famine, the pelican would wound herself in
the breast in order to feed her chicks with her
own blood — as a result, the pelican became
a symbol of the Passion of Jesus.

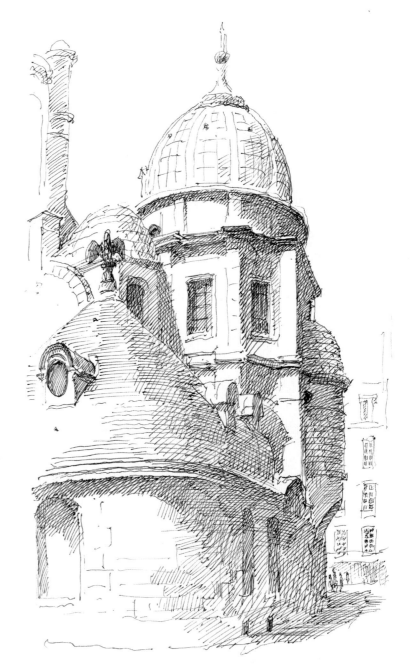

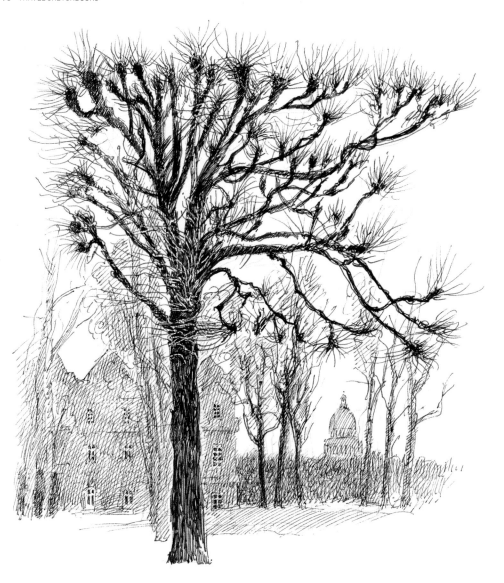

Scott McKowen, Winter in Paris, 2007.

Winter is the best time of year to see the stubby, gnarled architectural shapes of the *pollarded* trees in the Jardin du Luxembourg — this is the view looking east, from the Orangerie, towards the dome of the Panthéon in the distance.

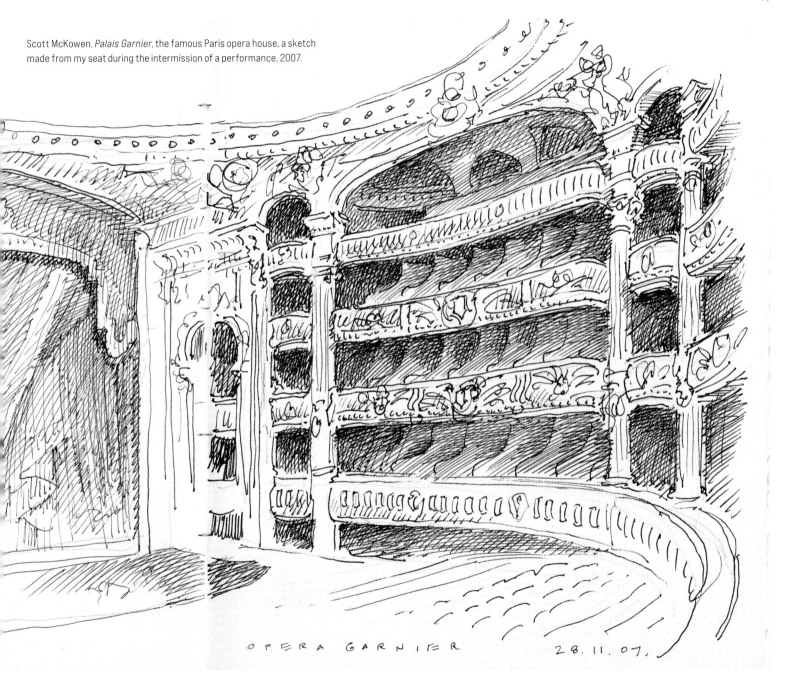

Scott McKowen, *Palais Garnier*, the famous Paris opera house, a sketch
made from my seat during the intermission of a performance, 2007.

OPERA GARNIER 28.11.07.

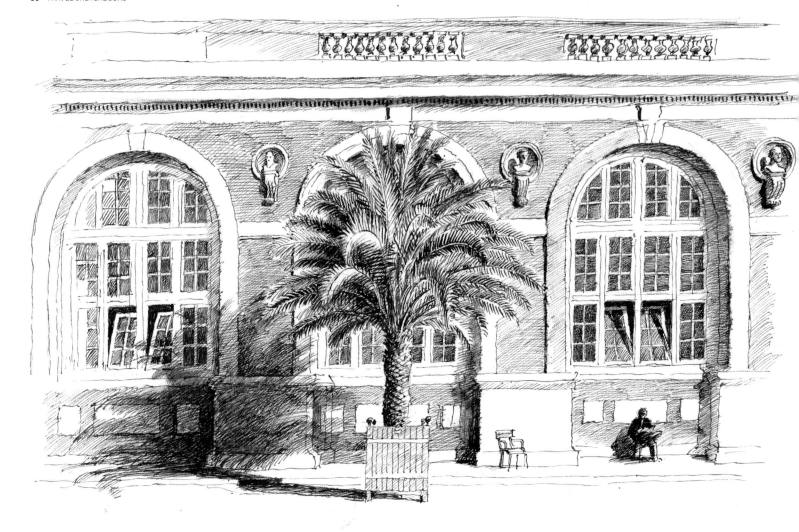

Scott McKowen,
Orangerie, Jardin du Luxembourg, ink, 1999.

I made this drawing on a visit to Paris in November, at the end of the season. The large, potted palm trees in their Versailles planter boxes were being moved inside the Orangerie for the winter. It was a cool, clear day and I loved how the hard shadows falling across the sidewalk and the building added the illusion of depth. I was almost done with the drawing when a forklift drove up and carried off my palm tree — finished or not, time's up!

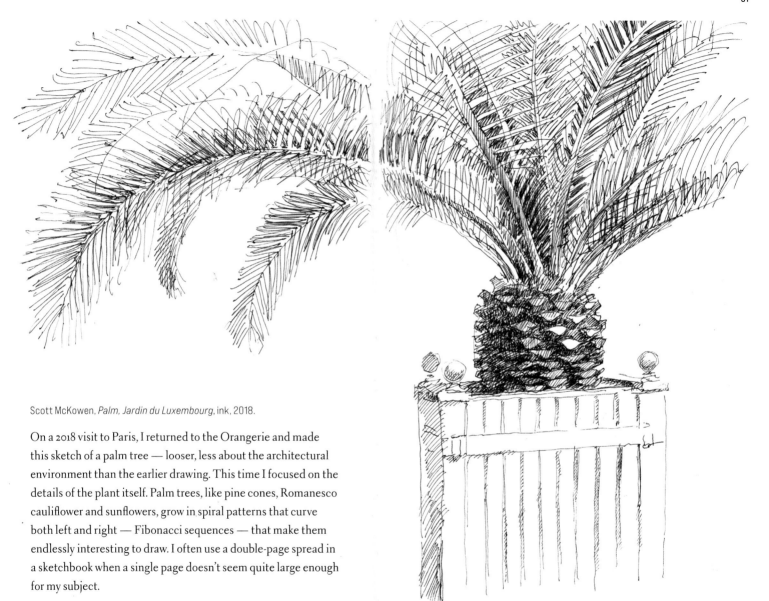

Scott McKowen, *Palm, Jardin du Luxembourg*, ink, 2018.

On a 2018 visit to Paris, I returned to the Orangerie and made this sketch of a palm tree — looser, less about the architectural environment than the earlier drawing. This time I focused on the details of the plant itself. Palm trees, like pine cones, Romanesco cauliflower and sunflowers, grow in spiral patterns that curve both left and right — Fibonacci sequences — that make them endlessly interesting to draw. I often use a double-page spread in a sketchbook when a single page doesn't seem quite large enough for my subject.

The studio of Gustave Moreau and the Jardin des plantes would not seem to have any connection to each other, but I placed these drawings side by side because I found out about the one while visiting the other. I spent a fascinating morning at the Moreau museum — the home and studio of the Symbolist artist, essentially unchanged since the day he died in 1898. That graceful staircase leads to an upper studio where dozens of Moreau's drawings are exhibited in rows of frames you can pull out from the wall, one at a time. There was a drawing of an elephant at the Ménagerie du Jardin des plantes — which we had never heard of. We looked it up — it's the second-oldest zoo in the world (1793), and only a couple of Metro stops across town. We went directly there after lunch — if Moreau found inspiration there, then I would too! We visit the Jardin every time we return to Paris.

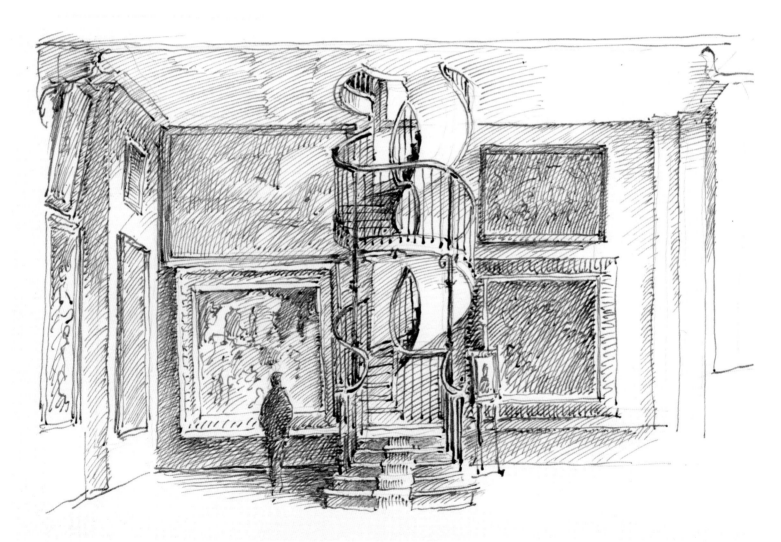

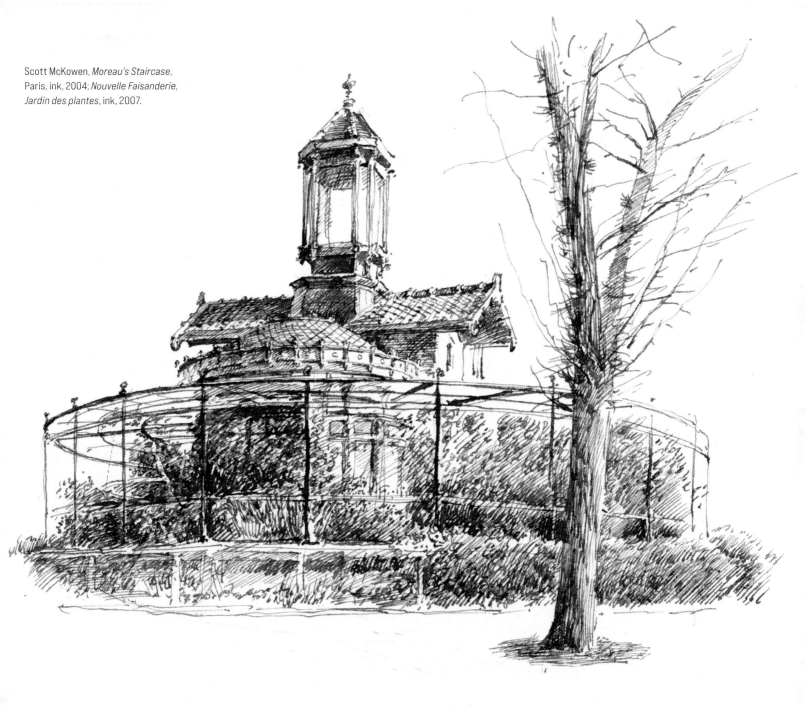

Scott McKowen, *Moreau's Staircase,*
Paris, ink, 2004; *Nouvelle Faisanderie,*
Jardin des plantes, ink, 2007.

NOUVELLE FAISANDERIE JARDIN DES PLANTES

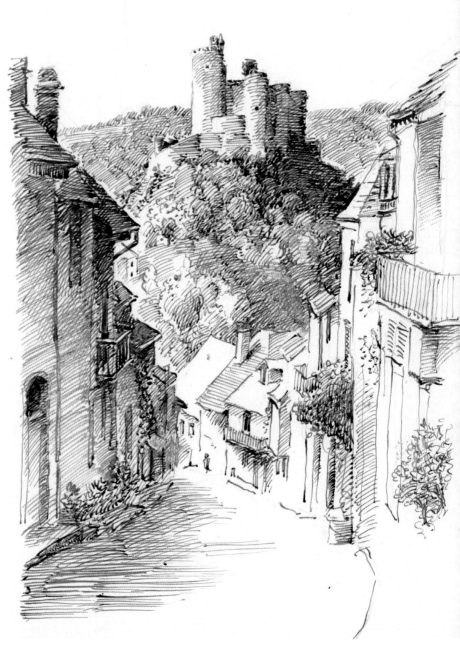

Scott McKowen, drawings from Tremolat and Najac, ink, 2004.

In 2004, Christina and I drove from Toulouse to the hill towns of Cordes-sur-Ciel, Najac and Rocamadour, then west along the Dordogne, ending up in Bordeaux. Walking in the tiny village of Tremolat, I noticed a half-demolished house with the floors long since rotted away in what must have been a kitchen — because hanging, inexplicably, from a nail over the fireplace was a frying pan.

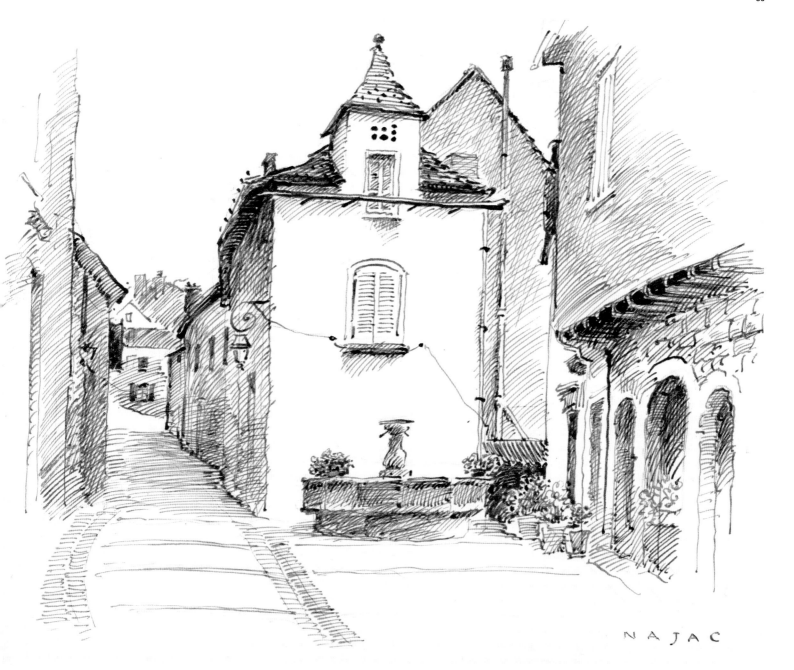

NAJAC

Scott McKowen, *Chez Allard, Front Room*, Paris, gel pen, 2003; *La Tupina*, Bordeaux, ink, 2004; *Caffé Tommaseo*, Trieste, ink, 2003; *Chez Allard, Back Room*, Paris, ink, 2002.

My travel plans revolve, more than perhaps they should, around restaurant reservations. Convivial bistros are more sketchbook-friendly than Michelin-starred temples of gastronomy.

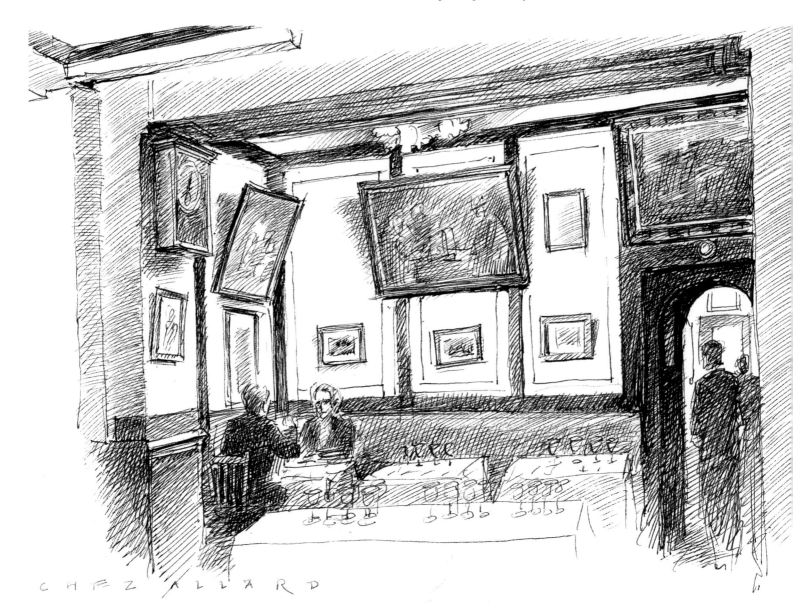

CHEZ ALLARD

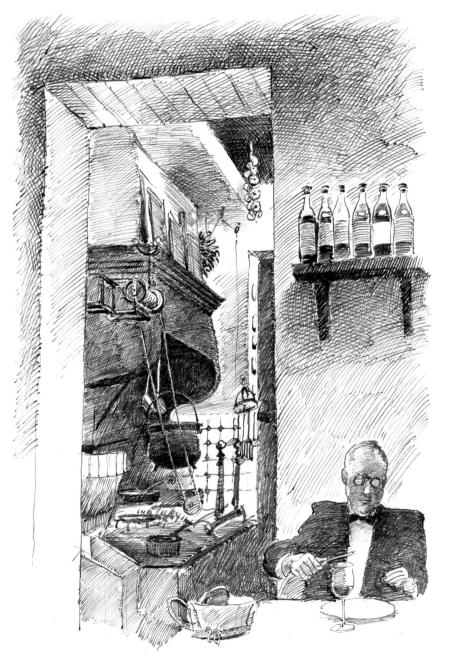

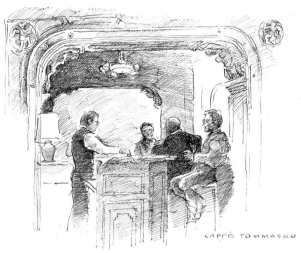

CAFFÈ TOMMASEO

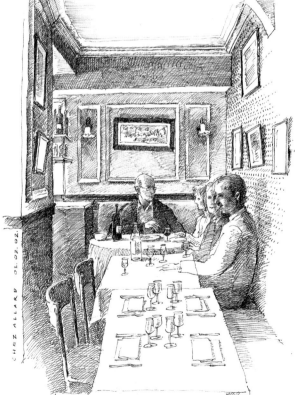

CHEZ ALLARD 01.02.02.

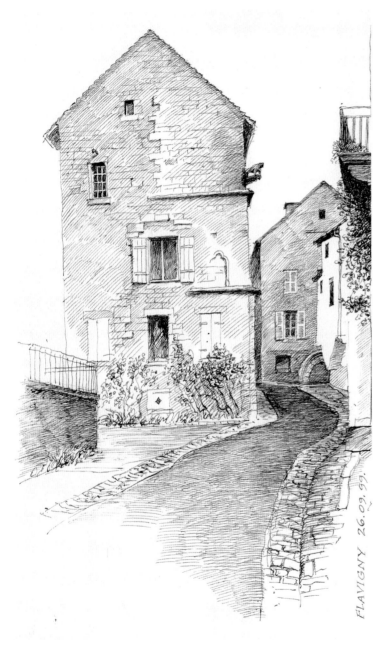

FLAVIGNY 26.09.99.

Scott McKowen, *Flavigny*, ink, 1999.

Scott McKowen, *Grand Escalier, Rocamadour*, ink, 2004.

Drawings by Tony Urquhart and Virgil Burnett, artist friends who lived and worked in Stratford, have been a personal inspiration for several decades. Burnett also owned a house in Flavigny-sur-Ozerain, a medieval village an hour north of Dijon. We have visited Flavigny several times — population is fewer than 400, half of them farm families, the rest Benedictine monks.

We have drawings by Tony Urquhart framed in virtually every room of our house. He combined meticulous classical draughtsmanship (his cal-ligraphic precision makes me think of Dürer) with the abstract sensibility he brought to his paintings. Urqhuart's drawings of Najac and Rocamadour inspired our visits there and my drawing of the *Grand Escalier* with its stations of the cross along a path of steep switchbacks, climbed by religious pilgrims on their knees. Tony made art out of subjects he found in French churches, graveyards, museums, zoos and gardens and forests. I have learned so much following, however tentatively, in his footsteps.

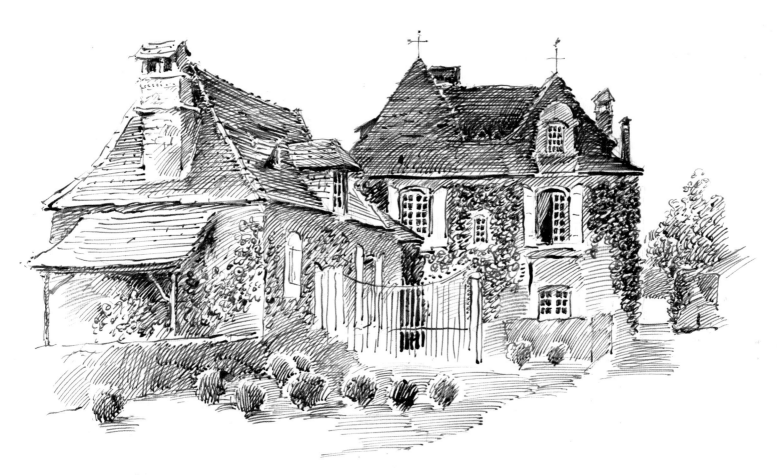

Scott McKowen, *Le Vieux Logis, Trémolat*, ink, 2004.

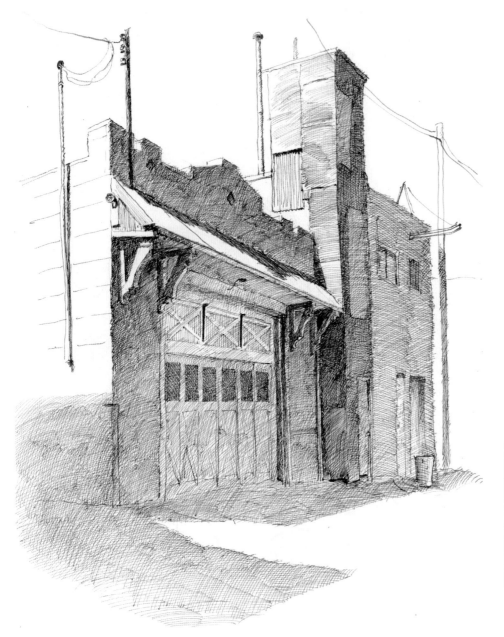

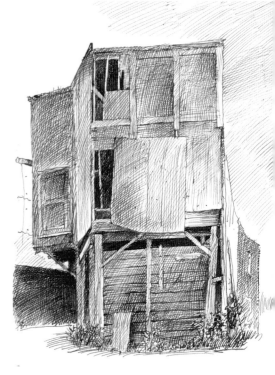

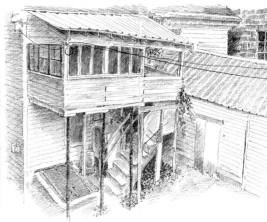

Scott McKowen, "back alley" drawings from Outremont in Montreal; a boarded up lumberyard near my house in Stratford; and a fire escape view in Cooperstown, New York.

91

Scott McKowen, *Stoney Street, Borough Market, Southwark*, ink, 2003.

I noticed several of Banksy's stencilled wall paintings in the neighbourhood, including his famous invitation for a selfie, "This is not a photo opportunity" — so I have to assume the inscription under the bridge was a real one.

STONEY STREET
BOROUGH MARKET
SOUTHWARK
03. 03. 03.

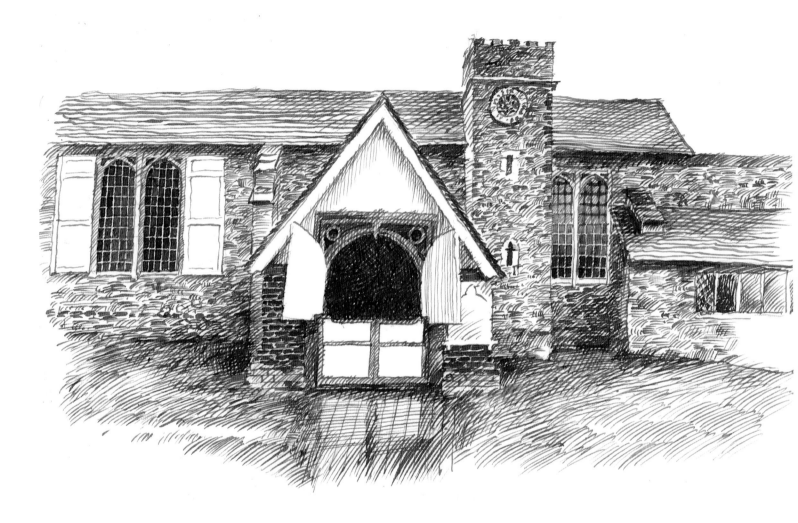

Scott McKowen,
*Saint Augustines
Church, Brookland,
Kent*, ink, 2019.

I mostly use pen and ink for travel sketches — the line weight is variable depending on how much pressure you put on the pen nib, so it's possible to get a dynamic range from rich, dark shadows to delicate highlight detail. Saint Augustines in Brookland, Kent, was built in 1250. It was a wet, windy day so I was trying to catch the reflections on the wet pavement, the textures of the wet grass, the ancient stone walls, the brick porch, the wood shingled roof and the translucent quality of the leaded glass windows. I could easily have done three or four more drawings in order to feel I had really explored the possibilities — but I was a passenger in the car and there was an agenda for the rest of the day.

WINDY DRIVE TO DUNGENESS

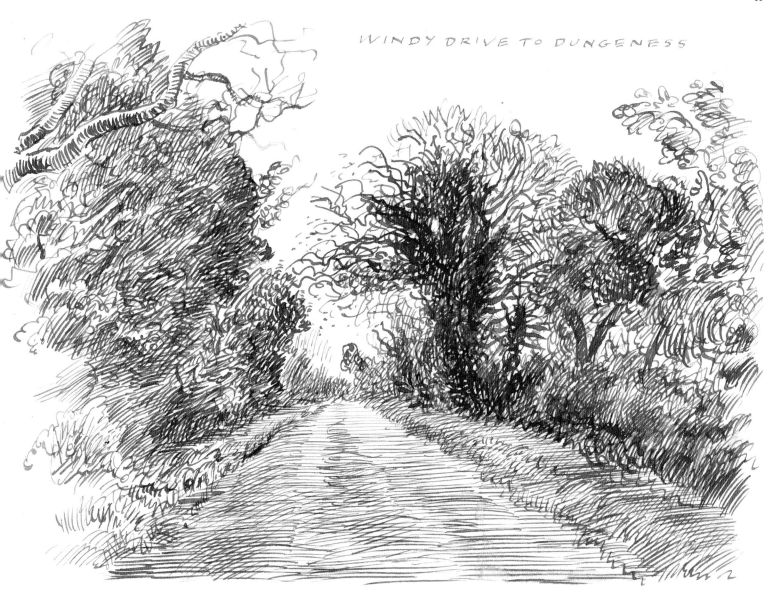

Scott McKowen, *Windy Drive to Dungeness*, ink, 2019.

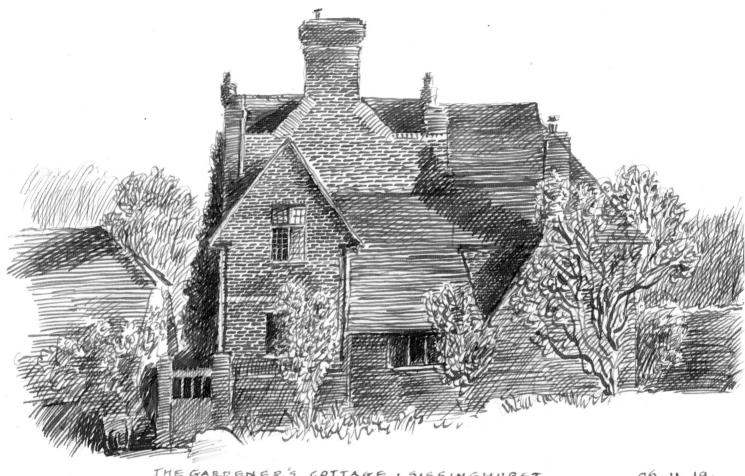

THE GARDENER'S COTTAGE · SISSINGHURST 06.11.19.

Scott McKowen, *The Gardener's Cottage, Sissinghurst*, ink, 2019.

Sissinghurst is one of the National Trust's most popular historic sites — the main house with the arched gateway was built in the 1530s. The bottle of ink I brought with me on this trip happened to be exactly the right colour for the Tudor bricks — and I realized that, on a drawing this scale, my pen nib was the right width to render them with a single stroke. It was a sunny day (never a sure bet anywhere in the U.K.) so the finishing touch on both drawings was a heavier layer of hatching lines to define the cast shadows falling across the slate roofs. The rather palatial Gardener's Cottage was built in the 1930s by Vita Sackville-West.

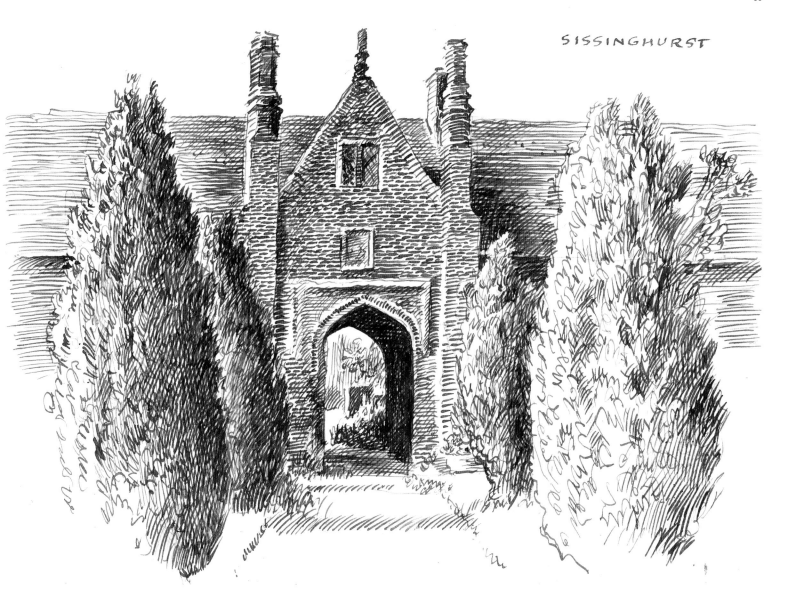

Scott McKowen, *Sissinghurst*, ink, 2019.

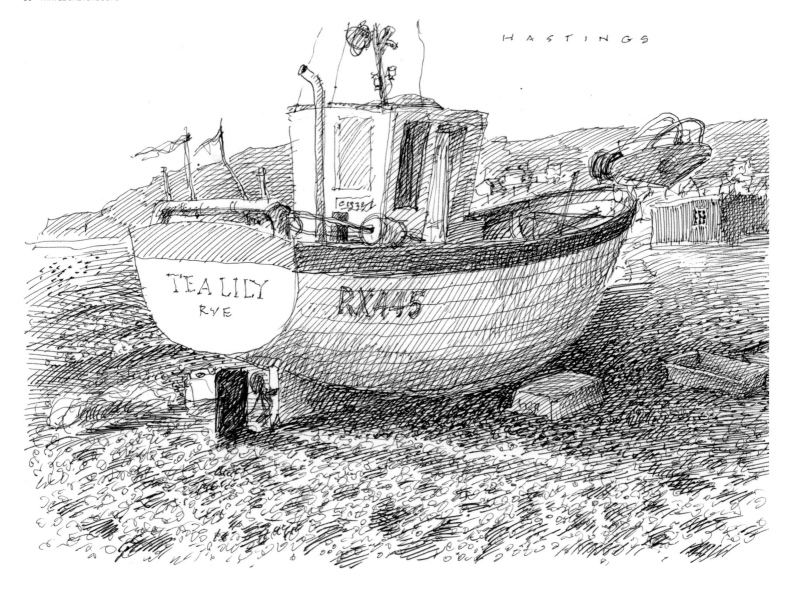

HASTINGS

TEA LILY
RYE

RX445

Scott McKowen, fishing boats on the
shingle at Hastings, gel pen, 2019.

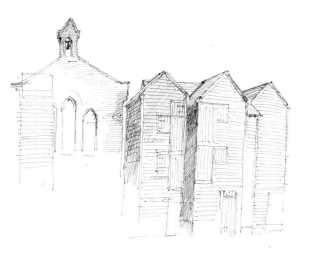

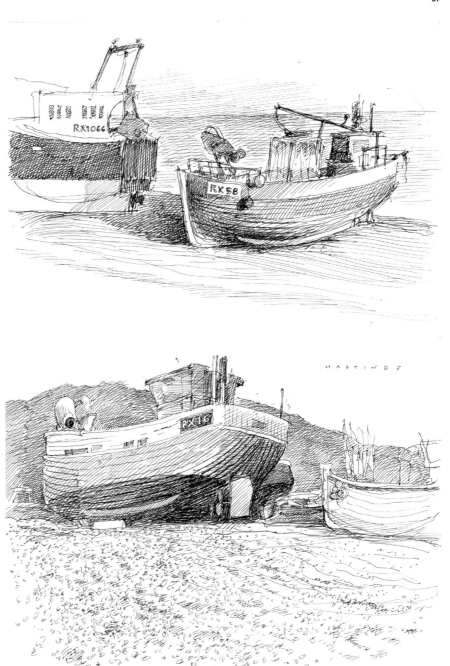

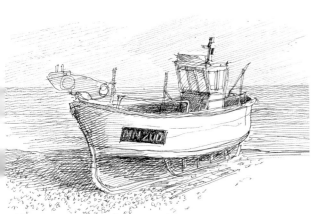

I happened to visit Hastings, the seaport town on the
English Channel, at low tide — and found the fleet of
dozens of fishing boats pulled up on the shingle beach.
There was not a soul around — that would change in
a few hours when the tide came back in, but it was a great
opportunity to draw these hard-working vessels, oddly
out of their natural element. The tall wooden structures
in the sketch at the top of the page are net-drying sheds.

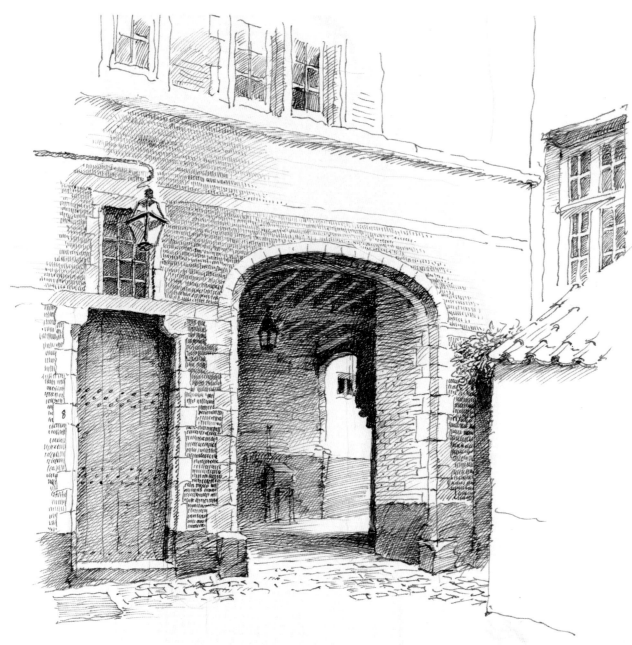

Scott McKowen,
Courtyard, Antwerp,
ink, 2001.

Scott McKowen,
*The Begijnhof,
Amsterdam*, ink,
2001. A *hofje* is a
courtyard surround-
ed by alms-houses —
this one dates to
the Middle Ages .

ANTWERP 23.11.01.

Scott McKowen, *Vieux Montreal*, ink, 2001.

My wife, Christina, grew up in Montreal so I have had the great fortune to get to know the city from countless family visits over 35 years. Mark Poddubiuk, her brother, is an architect and professor at Université du Québec à Montréal, and an authority on the city's architectural history and urban planning — accompanying Mark on a hour-long dog walk through Griffintown is an educational opportunity. The stone walls of this inner courtyard in Old Montreal are covered with ivy, so the already interesting configuration of the architectural shapes is further enlivened by hatching lines describing a range of natural textures.

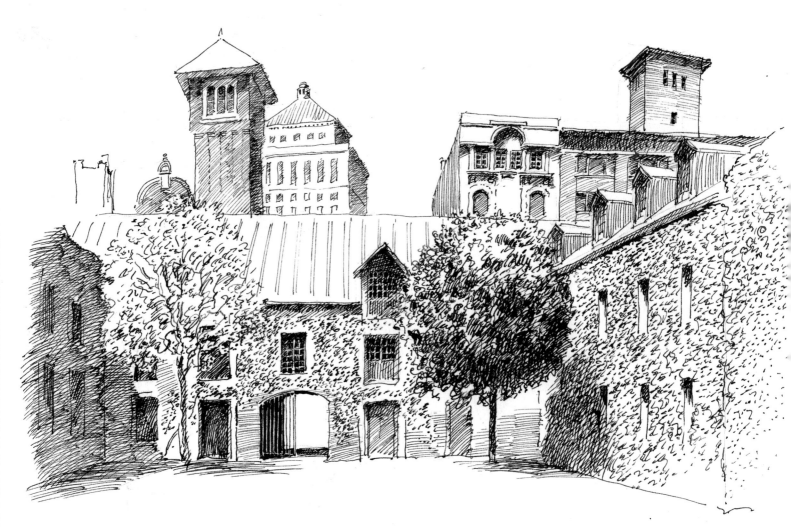

VIEUX MONTRÉAL

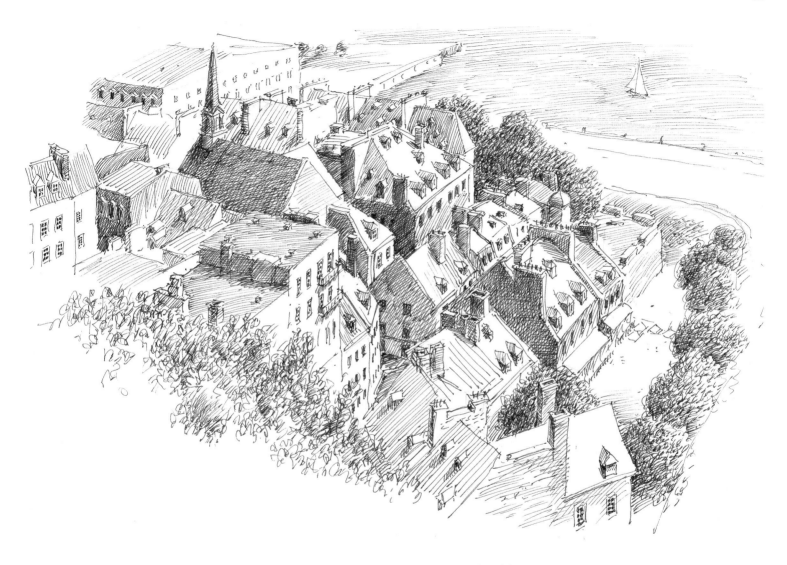

Scott McKowen,
Vieux Québec,
ink, 2012.

I visited Québec City in 2012, a great opportunity to draw the distinctive roofs and dormers of the historic Lower Town from various angles — in this case from Dufferin Terrace, the famous wooden boardwalk overlooking Île d'Orléans and the St. Lawrence River.

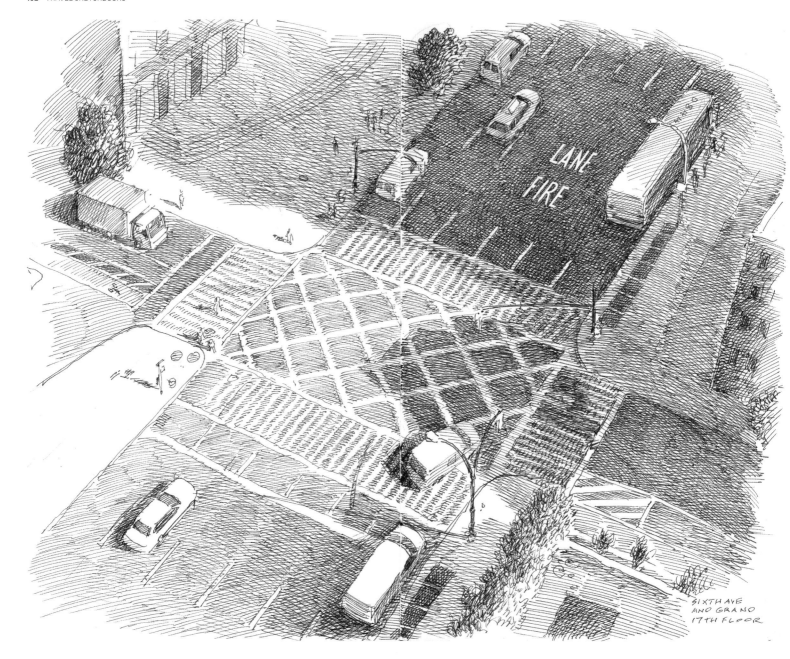

SIXTH AVE
AND GRAND
17TH FLOOR

These two drawings were made on a 2011 visit to New York City. We had a posh room at The James Hotel on Sixth Avenue at Canal Street. I happened to wake up an hour before Christina and, not wanting to disturb her, I quietly opened my sketchbook. I let the white paper become the white bed-linens with minimal, judicious shading.

The drawing on the facing page is the view from the hotel's rooftop.

Scott McKowen, *Sixth Avenue and Grand*, and *Room 406*, Micron pen, 2011.

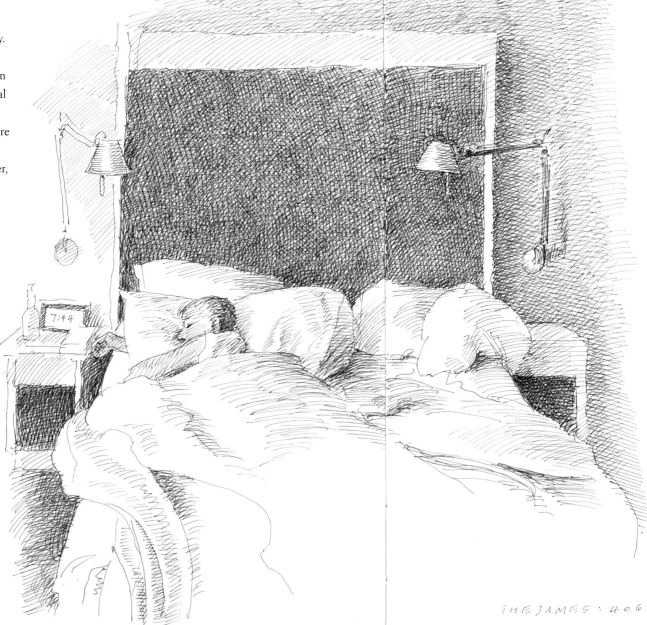

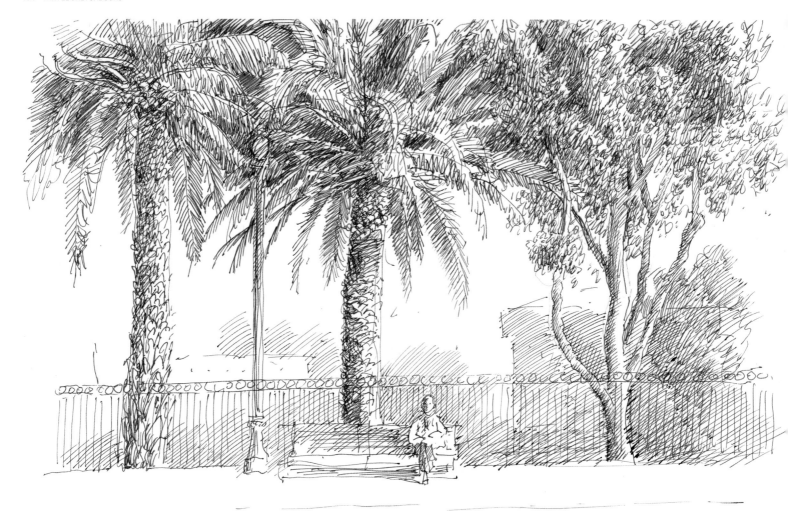

Scott McKowen, *Palo Alto Train Station*, gel pen, 2012.

Palm trees always seem, to me, exotic and luxuriant — but I grew up in a snowy Northern climate where they were nonexistent. *Communication Arts* in Palo Alto, California, invited me to be one of the jurors for their prestigious Illustration Annual competition in 2012. Palms were everywhere; when I wasn't working, I was out drawing their frond-shaped leaves and the Fibonacci sequence spiral growth patterns on the trunks. This sketch was made at the Palo Alto rail station while waiting for a commuter train to San Francisco.

South Carolina's nickname is the Palmetto State, honouring the iconic native palm tree (the state flag is the silhouette of a palmetto palm). Charleston in December feels like May or June in Stratford — we rode bicycles everywhere, ate oysters and I quickly filled a sketchbook.

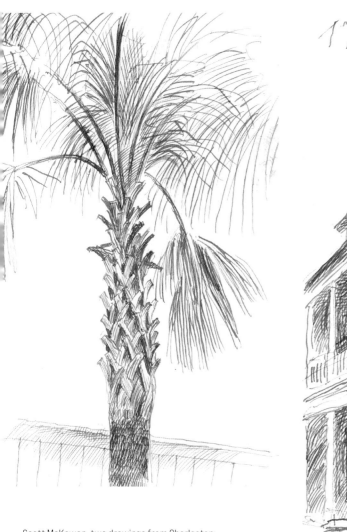

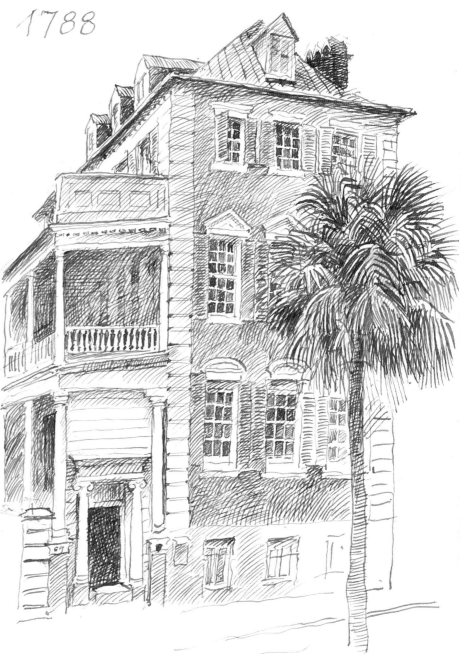

1788

Scott McKowen, two drawings from Charleston:
Palmetto Palm; *Poyas-Mordecai House*, built in 1788;
both pen and ink, 2018.

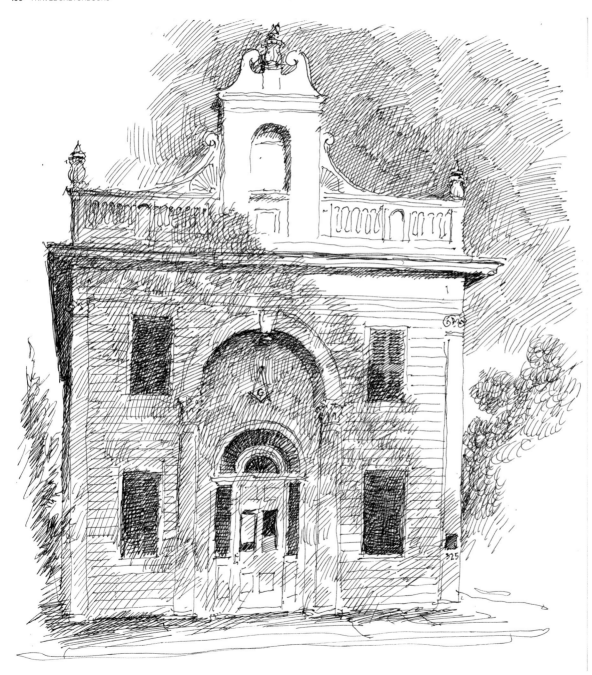

Scott McKowen, Masonic
Halls in rural New York
state, ink, 2017 and 2012.

Driving through Aurora,
in the Finger Lakes region
of New York state, I was
stopped by the timeworn
neo-classical facade of this
little hall. Hatching lines
darkening the sky and
representing the shadow
cast by a tree highlight the
area of bright sunshine on
the upper corner of the
building.

The house on the
facing page, built in 1826,
was once a Masonic
Lodge in the village of
Cooperstown.

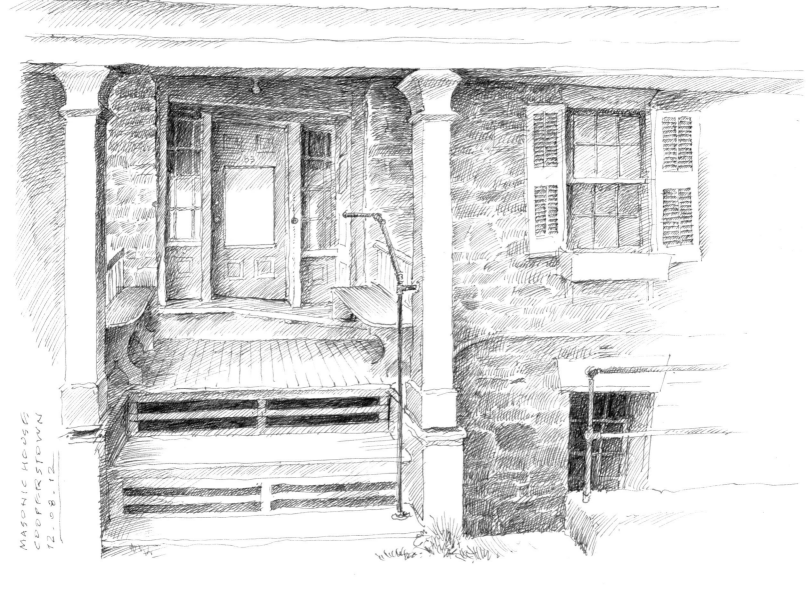

1825

MASONIC HOUSE
COOPERSTOWN
12.08.12

Scott McKowen,
Alex & Ika, ink, 2012.

Alex & Ika is our favourite hangout in Cooperstown. The bar is made from the wooden floor of an old bowling alley (their previous premises in the nearby village of Cherry Valley). I can't even count the ellipses — it's a loose sketch (and I was enjoying a cold beverage which made it into the foreground) so they are not perfect, but there's an overall pleasing harmony to the sketch.

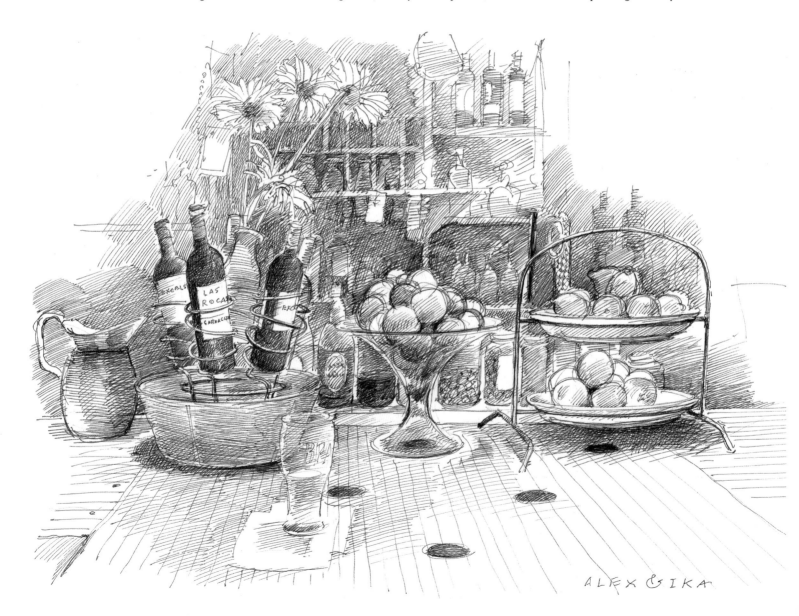

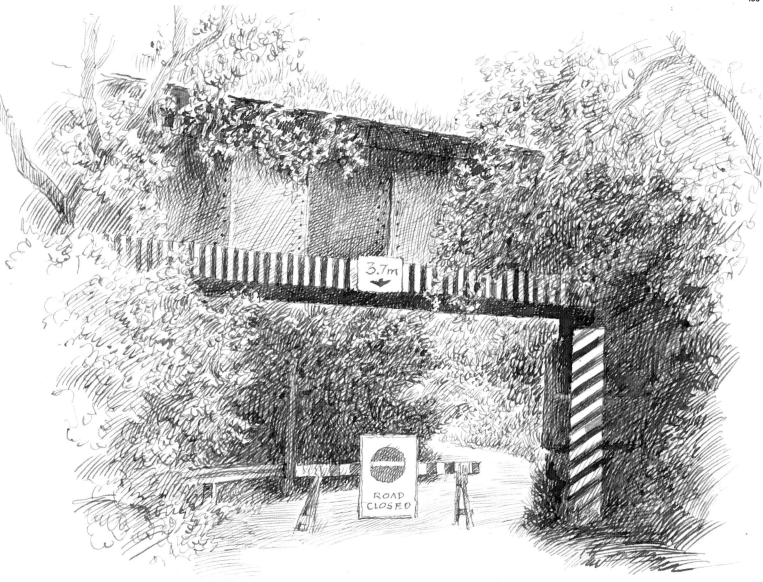

Scott McKowen, *T.J. Dolan Drive at the foot of St. David Street, Stratford, Ontario*, ink, 2020.

COVID-19 upended travel plans for everyone — and made me look for things to draw in my own backyard. This railway bridge in Stratford was as interesting a subject as anything I've ever seen in Europe. Rendering foliage can be a challenge — I want a sense of seeing around and through the leaves in the foreground; farther down the path, in the distance, it's about larger masses of texture defining trees and shrubs in highlight and shadow.

Scott McKowen, *St. Louis Cemetery, New Orleans*, ink, 1989.

Much of New Orleans is situated below sea level, which means that the city has no traditional cemeteries. I visited for a week in 1989 and explored Saint Louis Cemetery, near the French Quarter, established two centuries earlier in 1789. The graves are above-ground vaults; many are decorated with rocks, sea shells, coins, candles and flowers, reflecting the blend of Latin-Catholic and African cultural traditions. X marks inscribed with a piece of soft, red brick on the wall above a niche are said to invoke the spirit of the dead person. I was fascinated by this carefully constructed shrine to Amanda Dorsey Boswell Carroll, a Black woman who lived in the city from 1892 to 1945.

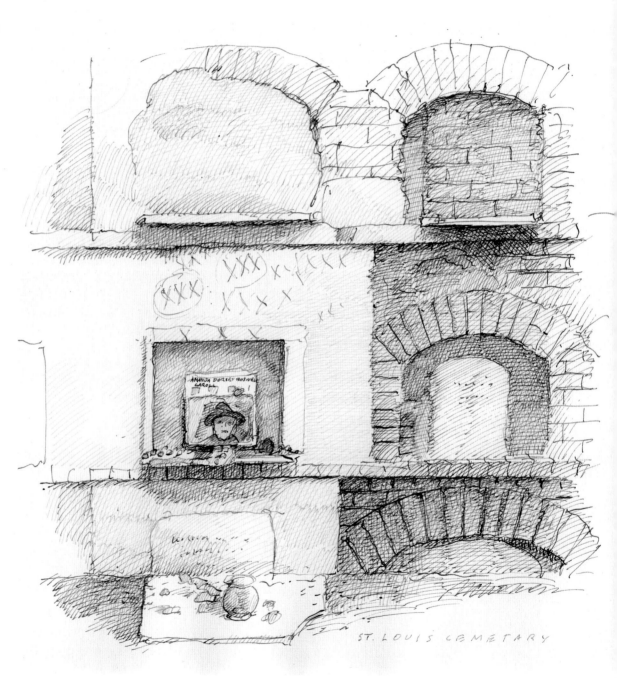

ST. LOUIS CEMETARY

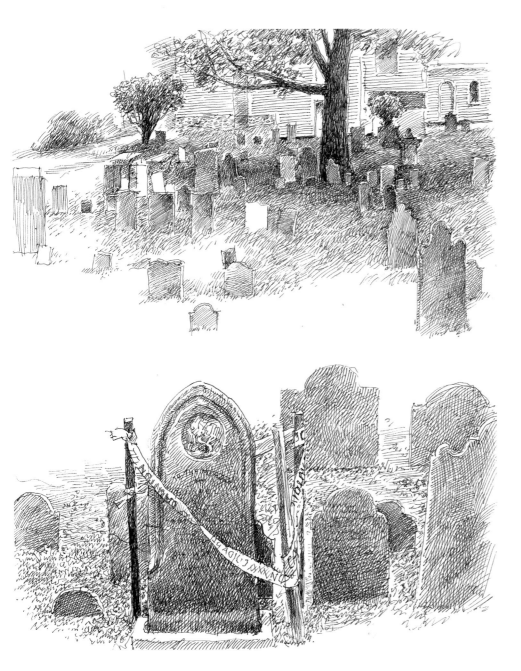

Clockwise from top: *Cooperstown Graveyard*, gel pen, 2014; *Abby Turner Winkler, 1858*, ink, 2018; *Circular Church Graveyard*, Charleston, gel pen, 2018.

Old graveyards always yield intriguing drawings; the shapes, sizes and textures of the memorials are as fascinating as the inscriptions. This churchyard in Cooperstown reminded me of the last act of Thornton Wilder's *Our Town*. The other two are from Charleston, South Carolina — Abby Turner Winkler (1824–1858) is buried in the graveyard of First Baptist Church. Circular Congregational Church dates back to 1681 — the churchyard is crowded with hundreds of memorials but this one jumped out at me, mysteriously roped off with yellow and black CAUTION tape tied around makeshift stakes.

HOP PRESS
FARMERS' MUSEUM
COOPERSTOWN

Scott McKowen, *Mary Geister Potter's Bathing Suit*,
Farmers' Museum, Cooperstown, ink, 2005.

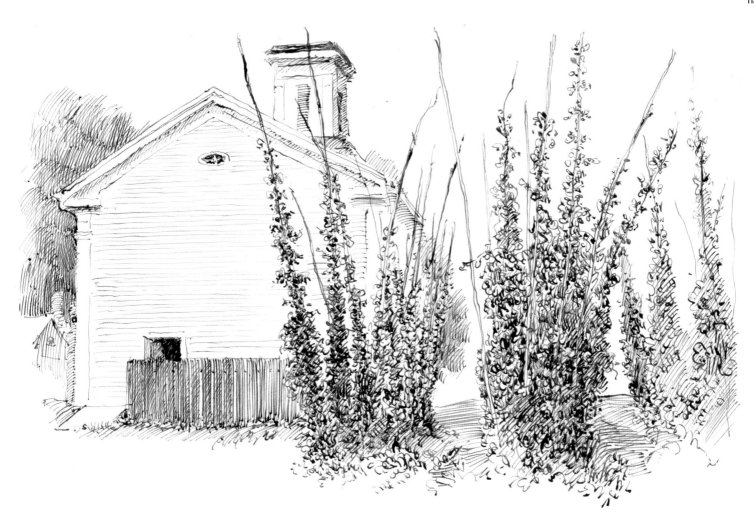

Scott McKowen, *Hop Press*, and *Growing Hops*, Cooperstown, ink, both 2005.

I made a pilgrimage to Cooperstown every summer for more than 25 years (for opera, not baseball). A great place to draw is the wonderful Farmers' Museum — a collection of historic buildings from across the region, reassembled to create the feeling of a little village. There's a blacksmith shop, a printing shop with working presses, a pharmacy, a tavern, barns and lots of animals. Costumed interpreters demonstrate period trades, crafts, cooking and farming. In the 19th century, New York grew more hops and brewed more beer than any other state in the country. The Museum's crop grows on traditional 18-foot hop poles. I was able to draw the green vines growing vertically, and then as they dry after harvesting in a nearby shed housing the hop press (on the facing page). The small, dark room was illuminated only by an open doorway — I recorded a sense of the light and shadow but omitted the details of the room.

Scott McKowen, *Old Plow*, Farmers' Museum, Cooperstown, ink, 2005.

I came across this plow on the same day that I drew the hops on the previous page — every time I turned around it seemed like there was another archaic farm implement to sketch (although I imagine this one is still in everyday use). I like this drawing because it conveys a contrast between hard and soft. The plow is a strong, sharp-edged metal machine — but the frame and the blades are all undulating curves. There's a nice variety of line weight; the hatching and shading keeps the metal surfaces feeling appropriately sharp, while the vegetation textures and the bricks are loose enough to feel organic and spontaneous.

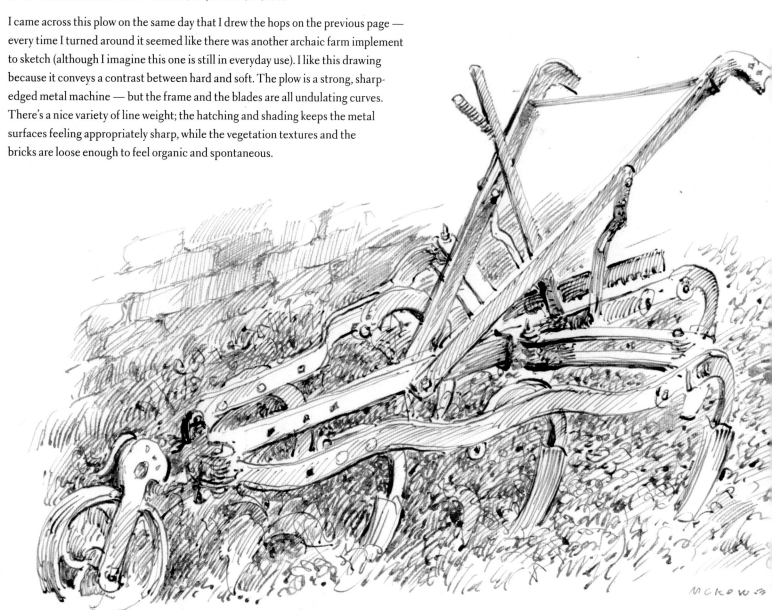

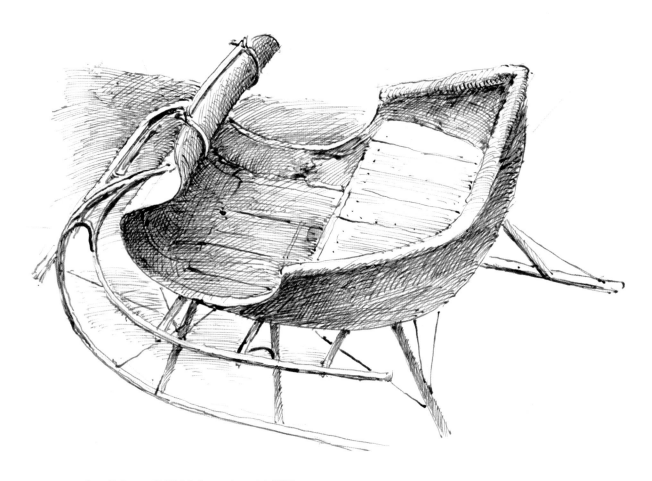

Scott McKowen, *Old Sleigh*, Cooperstown, ink, 2005.

Wood Bull Antiques was a regular stop on our annual visits to Cooperstown. It's an antique shop but it feels more like a crazy museum in a vast old barn. Three or four floors and mezzanine levels are connected by winding staircases. I spotted a fantastic Victorian drafting table on one visit, which I had to have (I use it to this day — I had to rent a van and return for it the following weekend because it was much too large to fit in our car). This sleigh was Wood Bull's centrepiece, suspended in mid-air between floors — it was high overhead as you entered on ground level, but you could look down into the boat-like interior from the upper balconies. Pen and ink lines suggested the woodgrain textures of the seat and floor, the wicker rail around the back of the seat and the graceful curves of the runners.

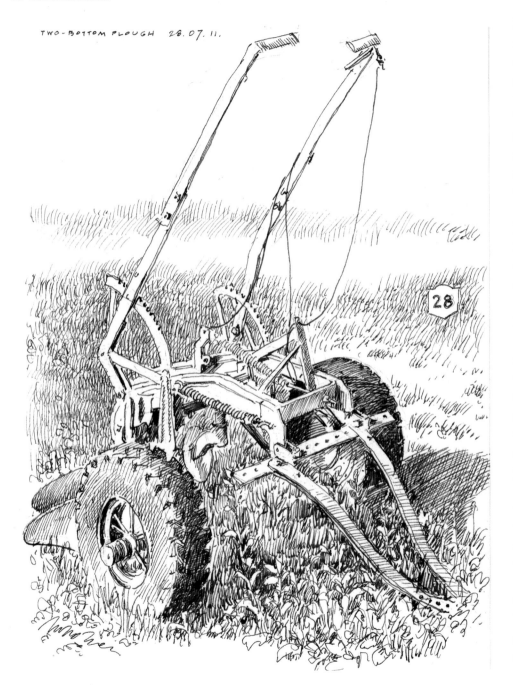

TWO-BOTTOM PLOUGH 28.07.11.

I love drawing old farm equipment — the structure of the machine is completely visible, so you can see how all the parts fit together. There's a sense of nostalgia for vintage agricultural traditions (although my friends Antony John and Tina Vanden Heuvel, pioneers in the organic farming movement in Ontario, prefer machines such as this because they are more reliable, more economical and can be repaired more easily than the high-tech, up-to-date equivalents).

I noticed this two-bottom plow on the front lawn of a farm on Route 28 near Cooperstown, New York. It was painted bright yellow but I had only a blue gel pen with me; I drew it from two different angles. At one point the owner came out to say hello, friendly but curious about what the heck I was doing standing on his lawn.

It's (mostly) bilaterally symmetrical — the metal beams are parallel to each other in space — which makes it easier to map the structure in perspective. The right wheel is offset 18 or 20 inches in front of the left wheel. I picked my angle and I worked out everything as a light block-in before adding any shading (you can still see some faint pencil lines here that did not quite get erased).

Next I started to indicate shadows cast by the light coming in from the left side. The grass texture on the lawn helps to give a sense of the environment, but more importantly some tone in the negative spaces adds the illusion of depth.

I moved closer to the front end of the plow for the drawing on the facing page, where I could see both sides of the curving metal blades. Now the sun was behind me (slightly over my right shoulder) so I used cast shadows to indicate front lighting.

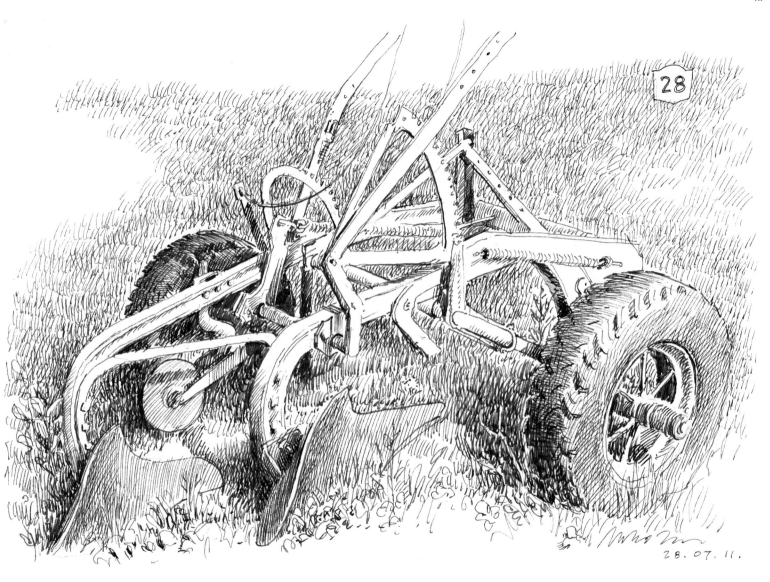

Scott McKowen, *Two-Bottom Plow on Route 28* (two views), gel pen, 2011.

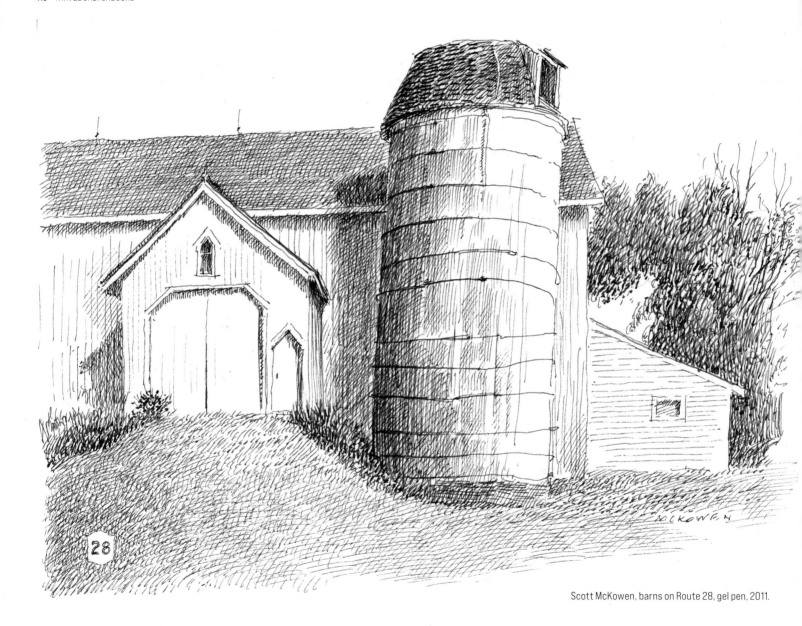

28

Scott McKowen, barns on Route 28, gel pen, 2011.

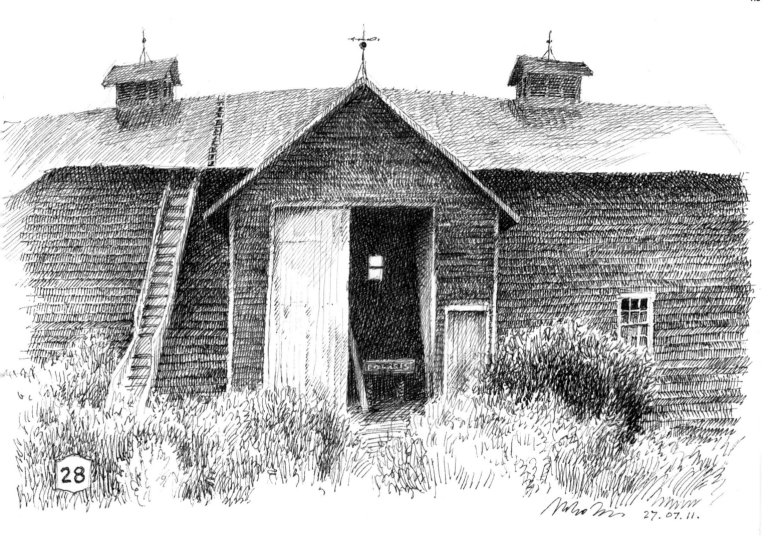

A little farther north on Route 28 from the plow on the preceding page are several interesting old barns. Some are clearly still in use on working farms, but they are part of a slowly vanishing way of life. We noticed on each visit to the area more and more barns abandoned and deteriorating until they collapsed completely. Barns make great drawings — they are often part of a grouping of interesting architectural shapes. Silos add vertical cylinders; if they are leaning or the roof is sagging, it adds character. I plotted out my compositions in light pencil, using doors and windows as units of measurement to make sure my proportions were accurate before starting to ink. I always try to think about what kind of lines best describe the contrasting textures of wood, stone, metal, shrubs and grasses.

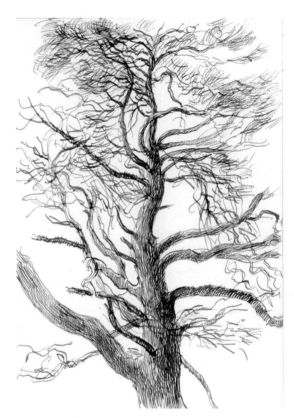

Scott McKowen, *Pine in the Old Grove, Stratford*, 2020, ink; *Cloven Pine*, 2014, Pigma Micron pen.

Pine trees are interesting subjects to draw from any angle or distance because the branches disappear into the semi-transparent layers of needles as they grow out from the trunk.

Attempting to prolong the life of an ancient tree on the grounds of the Prado Museum in Madrid, arborists had set up an elaborate system of cables and braces forming a kind of man-made cage supporting the ancient limbs. Red-and-white striped warning boots kept pedestrians from walking into the cables.

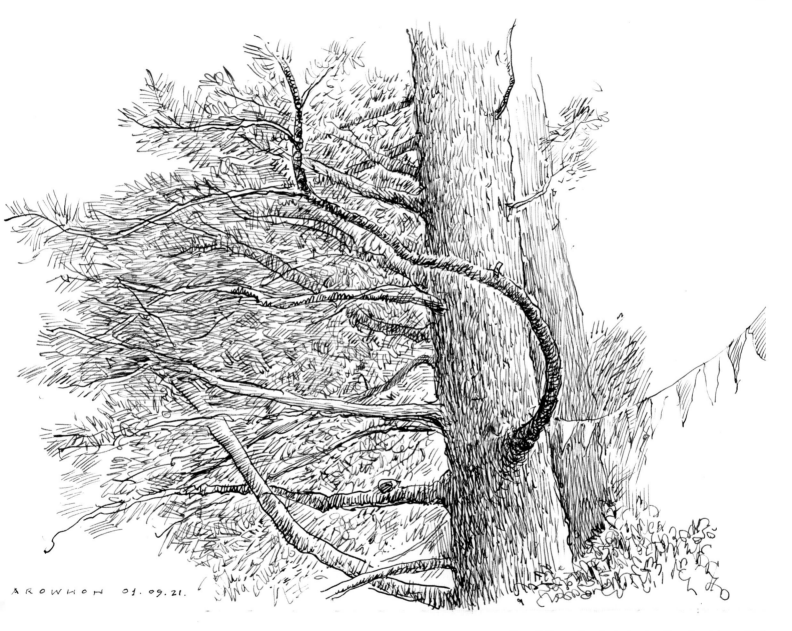

AROWHON 01.09.21.

Scott McKowen, *Tree Study,* Arowhon Pines, fountain pen, 2021.

Arowhon Pines is a resort in the middle of the vast wilderness of Algonquin Park in Northern Ontario. There are moose crossing warning signs along the highway. The air and water are pristine; the forest is silent except for loons calling. The rustic, six-sided dining hall was built in 1940 — local woodsmen selected the trees, hewed the logs and built the stone pillars and metalwork for the chimney. If you visit in September when the days turn cooler, a table near the fireplace is a treat. The structure of the log beams silhouetted by the cupola windows made for an irresistible drawing challenge.

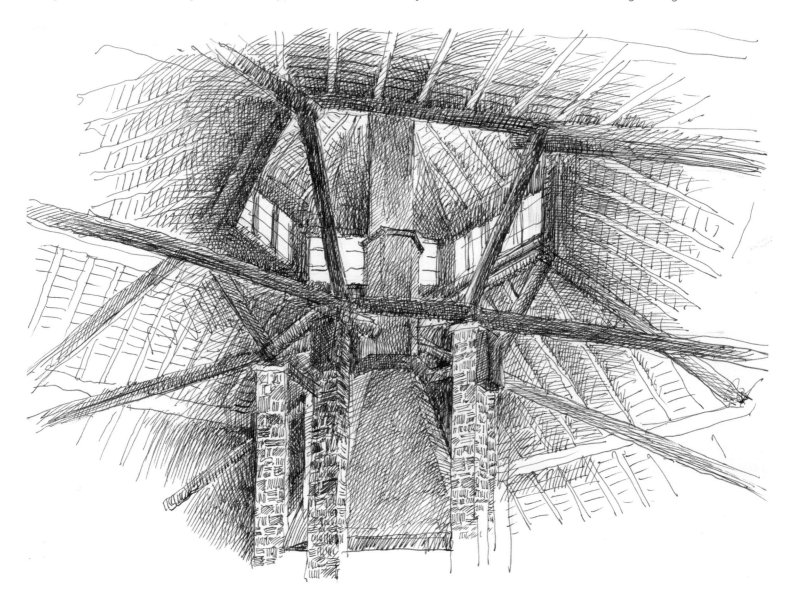

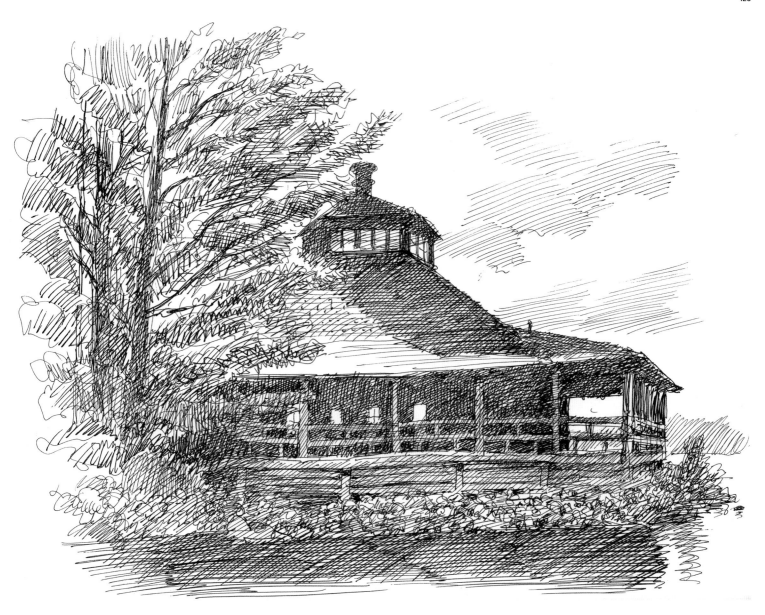

Scott McKowen, interior and
exterior views of the Dining
Hall at Arowhon Pines, 2021.

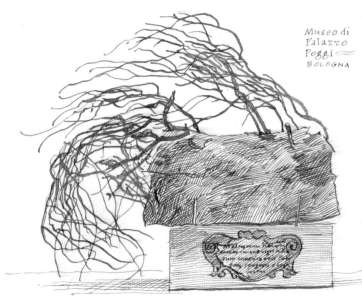

Museo di Palazzo Poggi BOLOGNA

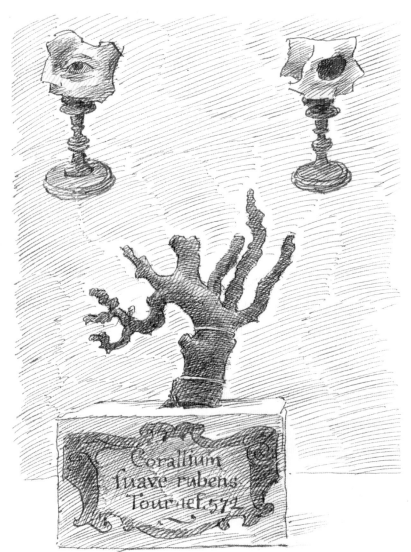

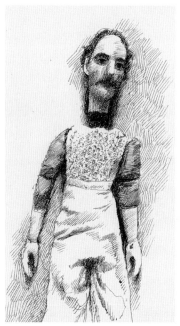

Scott McKowen, two sepia sketches made at the Museo di Palazzo Poggi, an eclectic collection of science and natural history specimens at the University of Bologna, in 2015; violin templates in a luthier's workshop; Victorian puppet from the Till Marionette Collection, 2021. Opposite: display cabinet and birdcage in an antique shop; more puppets from the Till Marionette Collection, 2021.

CABINET OF CURIOSITIES

Cabinets of Curiosities were collections of objects from natural history, geology, ethnography and archaeology, religious or historical relics and antiquities dating back to the 16th century. They were the precursors to museums — "Cabinet" originally meant a room rather than a piece of furniture. For the purposes of drawing, I'm happy to go with either configuration — any collection of eccentric objects is worth capturing on paper!

I have a coffee table in my living room that fits the description: two old wooden type cases — compartmentalized drawers for storage of the individual metal letters and ligatures — bolted together and covered with a sheet of glass. The compartments are perfect for all manner of tiny treasures — fossils, shells, a seahorse, birds' eggs, coins, keys, Boy Scout medals, embroidery scissors, antique sewing notions in their original packaging, Edwardian boot hooks, collar studs and ivory buttons. Normally these would all be stashed away in drawers and forgotten, but our personal Cabinet of Curiosities allows us to enjoy them every day.

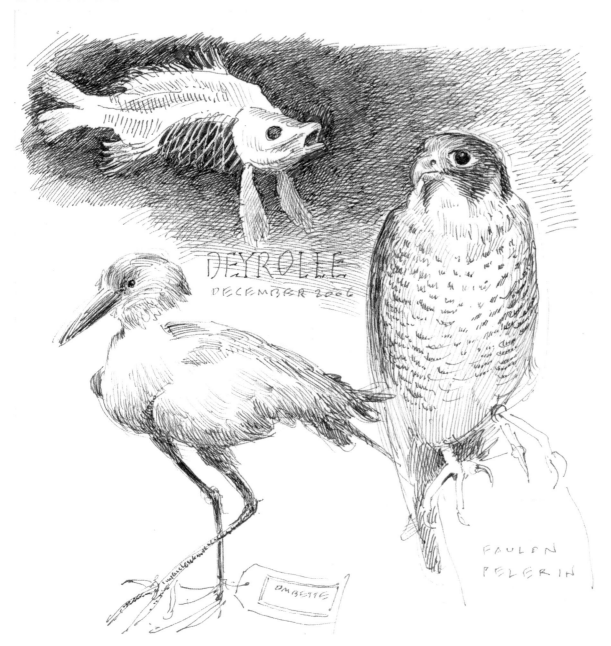

DEYROLLE

DECEMBER 2006

OMBETTE

FAULON
PELERIN

Scott McKowen, ink sketches made at Deyrolle, 2006 and 2004; charcoal studies of an Oryx skeleton, 2007.

I first discovered Deyrolle, the extraordinary shop on Rue du Bac in Paris specializing, since 1831, in *taxidermie, entomologie* and *curiosités naturelles* when I was working on a suite of illustrations for *Alice's Adventures in Wonderland* in 2004. The interior of the shop inspired my cover for the Sterling Classics edition of Lewis Carroll's classic. The shelves at Deyrolle are crowded with a surreal menagerie of stuffed birds and mammals, butterflies, fossils and skeletons. I have returned on subsequent visits to Paris to draw lions, polar bears, pelicans, flamingos, zebras, a moose and a giraffe peeking around the upper corner of a ten-foot doorway.

The two drawings of an Oryx pelvis (front and back) were made across town, in the Hall of Comparative Anatomy at the Jardin des plantes, where you can walk among a thousand animal skeletons and note the subtle differences between similar species.

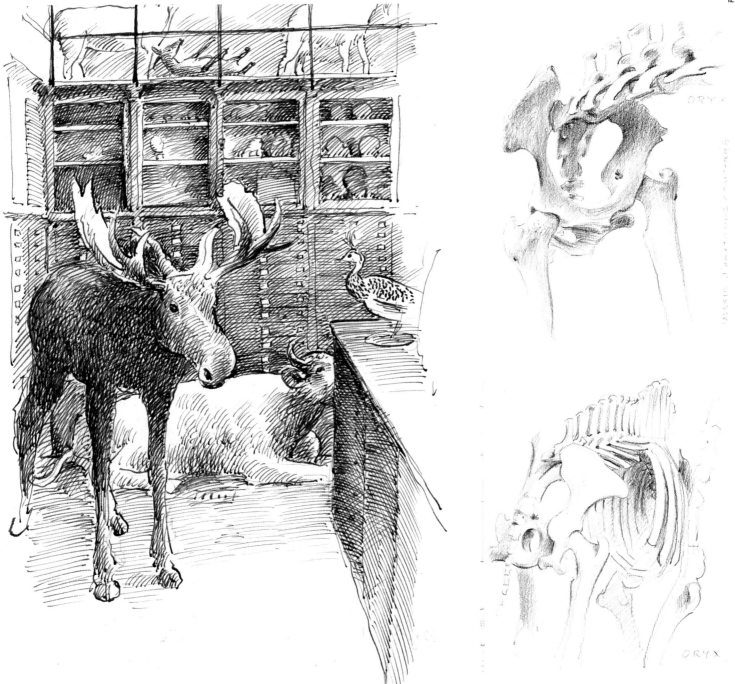

ORYX

ORYX

MUSEO DAVIA
BARGELLINI
BOLOGNA

We were the only visitors on the morning we showed up at
the Palazzo Bargellini. It's a Civic Museum of Industrial Art
with an eclectic collection of "functional ornamentation and
curiosities of old Bologna." Among the ceramics, iron grill-
work, furniture, liturgical robes and a gilded carriage, I was
delighted to find a room full of 18th-century marionettes. I have
loved puppets since I was a kid. Here were dozens of wonderful,
superbly detailed characters, in excellent condition for their
age. I drew them for a couple of hours — pure bliss!

MUSEO DAVIA
BARGELLINI
BOLOGNA

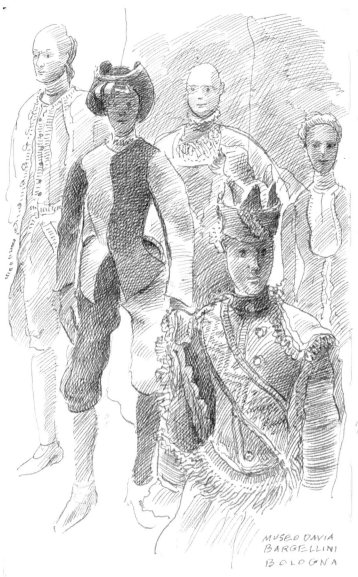

MUSEO DAVIA
BARGELLINI
BOLOGNA

Scott McKowen, *Puppets at the
Museo Davia Bargellini, Bologna*
(four sketchbook pages), ink, 2015.

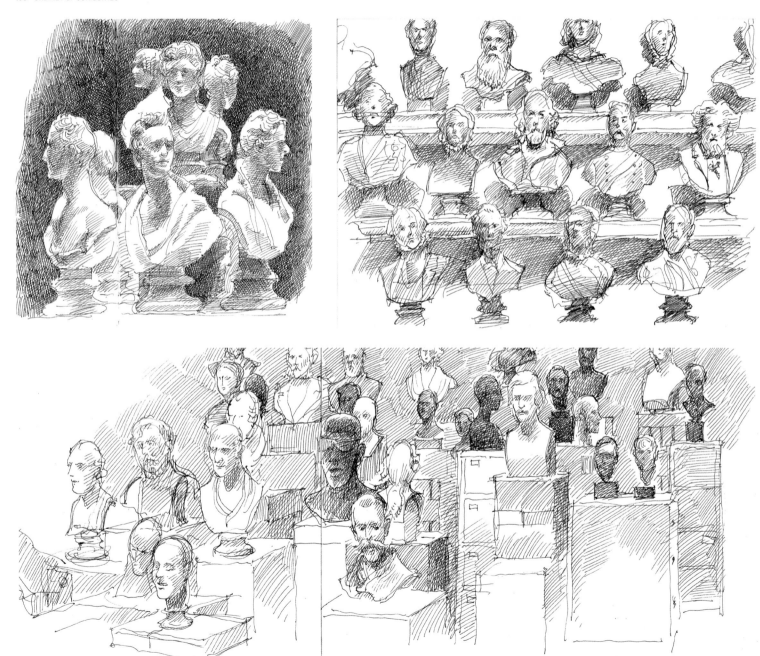

Everyone visits the Academia in Florence to see Michelangelo's *David*, but just down the corridor is the incredible Gipsoteca Bartolini filled with hundreds of 19th-century plaster portrait busts. Because they are life-size and three-dimensional, they seem like a crowd of real people — it's easy to imagine them whispering amongst themselves about their visitors. A temporary exhibition of Royal Academy portrait busts (on the facing page) spanned 300 years — 17th-century marble busts and 18th-century terra cotta portraits juxtaposed with contemporary sculptures in metals and plastics.

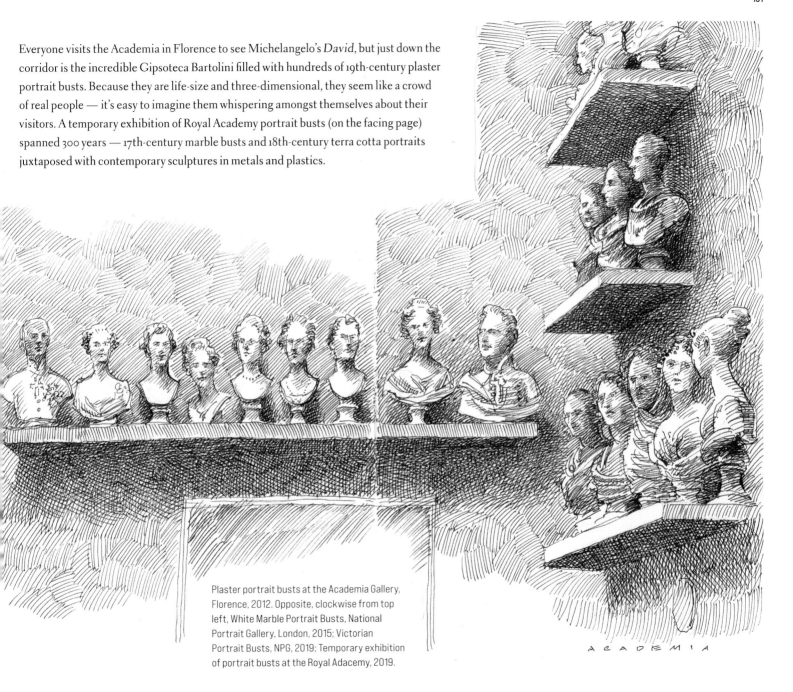

Plaster portrait busts at the Academia Gallery, Florence, 2012. Opposite, clockwise from top left, White Marble Portrait Busts, National Portrait Gallery, London, 2015; Victorian Portrait Busts, NPG, 2019; Temporary exhibition of portrait busts at the Royal Adacemy, 2019.

ACADEMIA

EAST WING
PAINTING FROM
1700 TO 1900

Scott McKowen,
East Wing, ink, 2003.

This quick sketch is the entry foyer at the National Gallery in London, designed by Sir John Taylor in the 1880s (the familiar portico facing Trafalgar Square goes back to the 1830s). The enormous leather sofas seem to be arranged in a different configuration every time I visit, but they are always full of exhausted, happy art lovers of all ages.

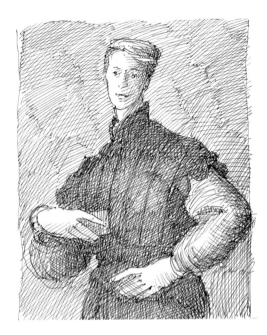

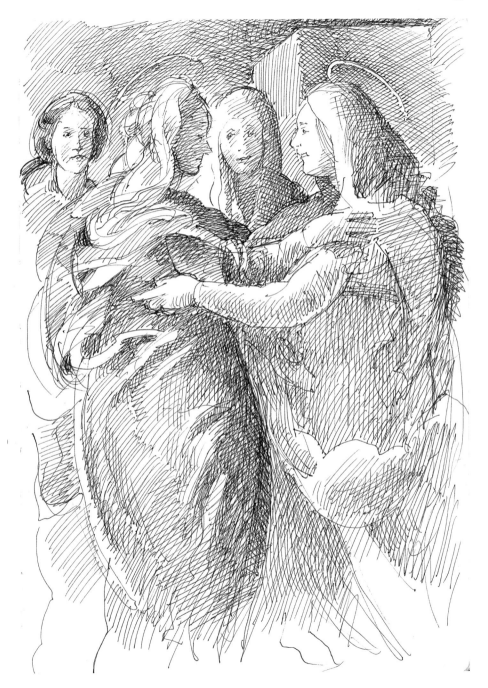

Art galleries and museums are top of my agenda when I travel, and I always try to have a sketchbook with me. Sometimes it's for practical reasons. In 2018, the Morgan Library in New York presented a tiny blockbuster show entitled "Miraculous Encounters," paintings and drawings by Jacopo da Pontormo including *Visitation*, an altarpiece from the late 1520s with larger-than-life-size figures, which had never before been seen in the United States, and *Young Man in a Red Cap*. Photography was strictly prohibited — a vigilant guard enforced that rule, tossing out anyone who tried to sneak a cell phone photo like a bouncer in a nightclub — but I was able to sit and study both paintings for over an hour while drawing them. I can't think of a better way to become familiar with a painting than by making a copy of it.

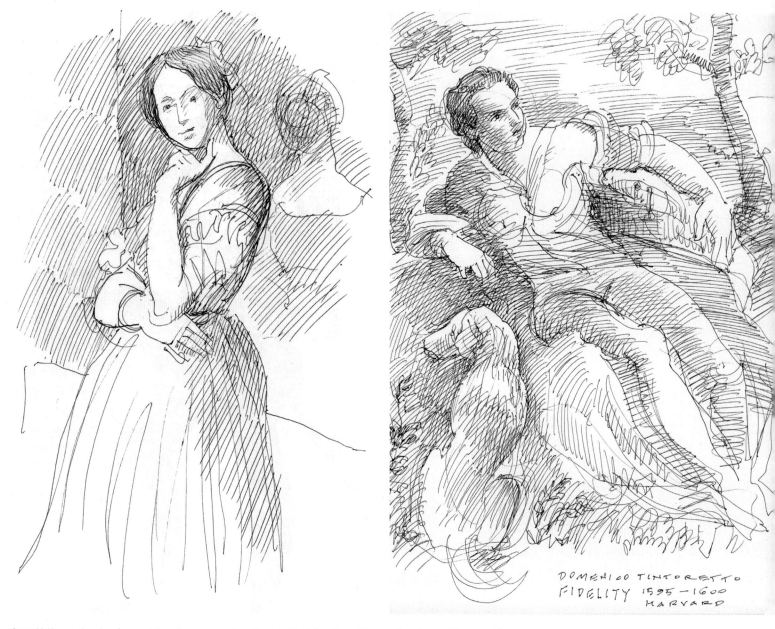

DOMENICO TINTORETTO
FIDELITY 1595 – 1600
HARVARD

Scott McKowen sketches from paintings in museums: Jean-Auguste-Dominique Ingres' famous *Comptesse d'Haussonville*,
1845, at The Frick; *Fidelity*, a drawing by Tintoretto in a 2018 exhibition at the Morgan Library; Moroni's *Il Sarto* (The Tailor),
1570; *Thalia*, the ancient Greek Muse of Comedy (she's admiring a jester's head), by Hendrick Goltzius, 1592.

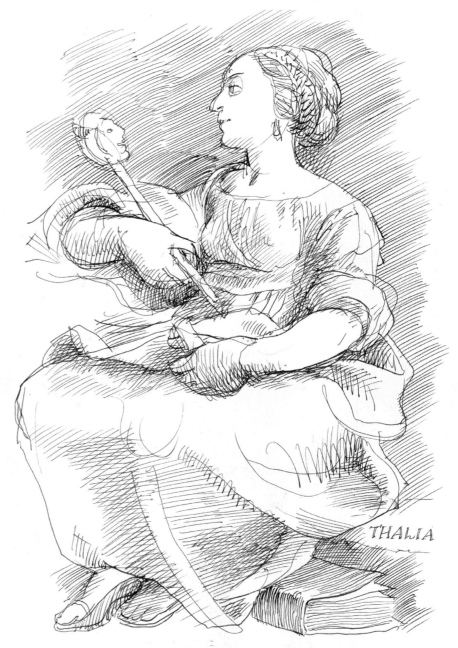

THALIA

I often get illustration assignments with historical subjects so I'm always interested in studying drawings and paintings from other eras. I look specifically at engravings because I learn so much about creating the illusion of tone from closely spaced lines, which I can apply to my scratchboard illustrations. I have five of a set of *Nine Muses* published by Hendrick Goltzius in 1592, which are most instructive — those ancient Greek muses still inspire across the millennia.

We planned a 2019 trip to New York around an exhibition of paintings by Giovanni Battista Moroni (1520–1678) at The Frick Collection. As at the Pontormo exhibition at The Morgan, photography was strictly prohibited — so I pulled out my sketchbook to make visual notes.

ROUND BRAIDING MACHINE 1786

AEROPLANE DE CLEMENT ADER DIT »AVION 3« 1893-97

La Gellieyne

L'HÉLICA
CAR WITH
PROPELLER
LESTAT, 1921

An 18th-century Rope-Making Machine; *Avion III*, a steam-powered aircraft with bat-shaped wings; and a propeller-driven race car — all from a visit to the Musée des Arts et Métiers in Paris, 2006. Opposite: bodices from an exhibit at the Museo del Traje, Madrid, 2014.

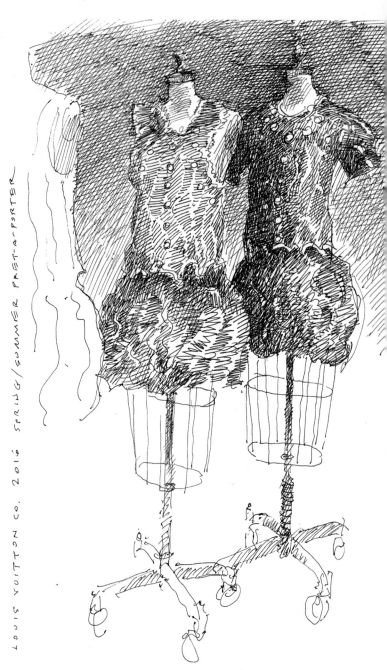

Scott McKowen, sketches from the exhibition *Manus x Machina: Fashion in an Age of Technology*, Metropolitan Museum of Art, New York, gel pen, 2016.

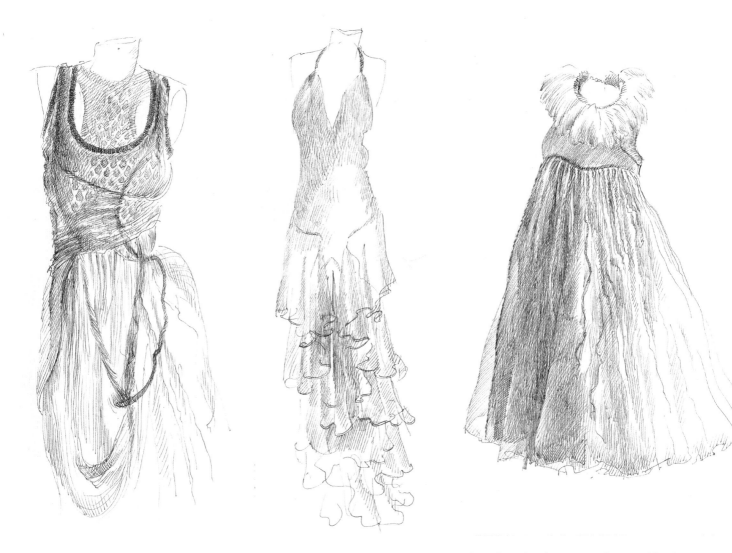

The Met's Costume Institute shows at are always top of our list because of Christina's professional interest, but *Manus x Machina: Fashion in an Age of Technology* was particularly spectacular. The show traced the influence of cutting-edge technology on *haute couture* as it evolved over a century — from Fortuny to Alexander McQueen. The textures of the machine-made fabrics were interesting to try to capture. Pen and ink was impractical in a crowded exhibition so I used a 0.25 Prussian blue Muji gel pen.

These three sketches were made one cold night in 2007 on Oxford Street in London. Selfridges' windows were brightly lit, and I was taken by these couture dresses displayed on clear acrylic mannequins, which enhanced the translucency of the fabrics by creating a see-through effect. They are, left to right, Bora Aksu, Alexander McQueen and Osman Yousefzada.

ALMA MATER
STUDIORUM
UNIVERSITA
DI BOLOGNA

MUSEO DELLE
CERE
ANATOMICHE
L. CATTANEO

T9·242

LaSpecola FIRENZE

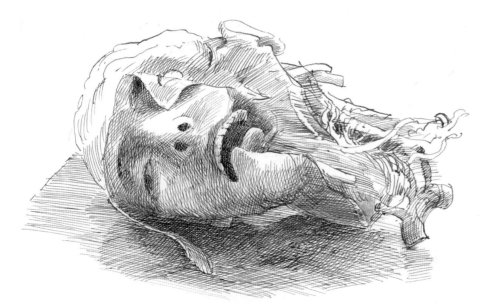

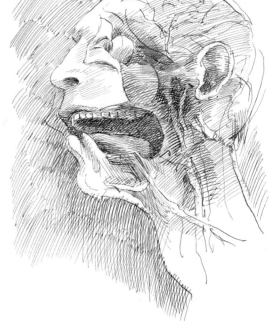

Scott McKowen, wax mannequins at the Museo delle Cere Anatomiche
(Universita di Bologna) and at *La Specola* in Florence, ink, 2015.

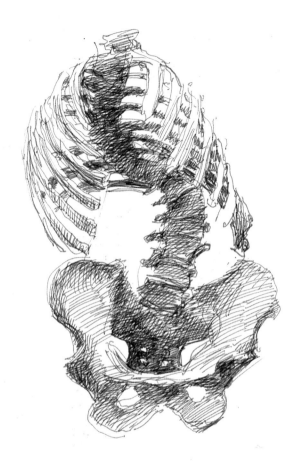

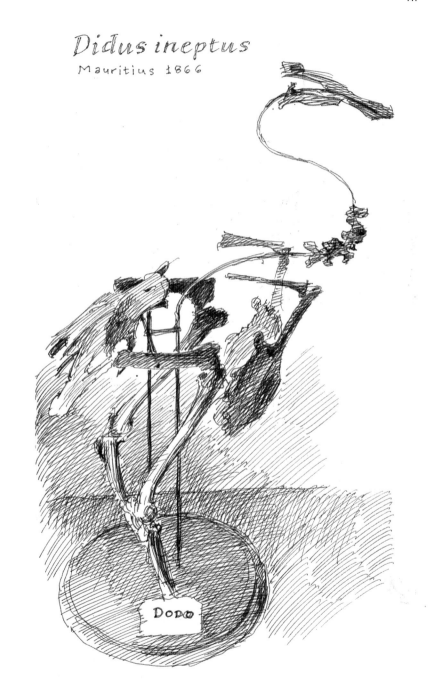

Didus ineptus
Mauritius 1866

DODO

Anatomy is a fundamental study for both artists and scientists. The University of Bologna (the oldest university in the world) and *La Specola* in Florence both display extraordinary collections of 18th-century wax anatomical models, which were used in teaching medical students.

The sketches on this page are from the Hunterian Museum, part of the Royal College of Surgeons in London. The human skeleton with a combination of scoliosis — sideways curvature of the spine — and kyphosis, which causes the curved back that we might call "hunchback," found its way into a 2016 poster illustration for Shakespeare's *Richard III*. And how often do you get to draw a dodo skeleton — I adore its Latin name!

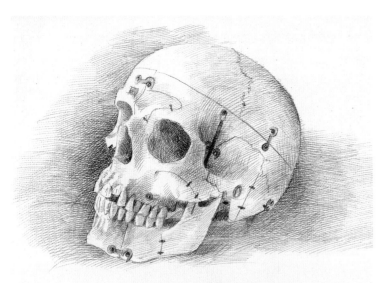

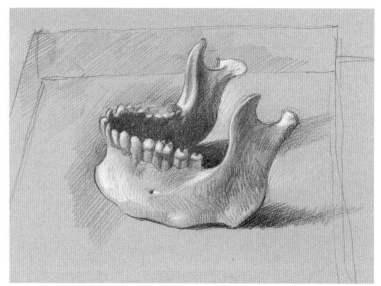

Scott McKowen,
studies of skulls
in various media,
2020 and 2021.

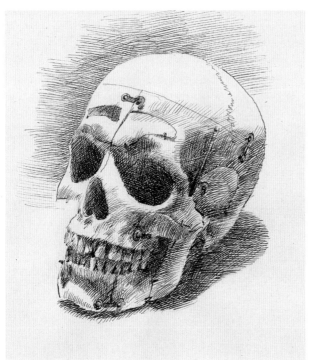

The skull is the most complex, subtle and sophisticated bone in the body, and no two are exactly alike. It determines the shape and structure of the face — integral to facial expression because it's so close to the surface of skin and muscle. The skull is an ancient symbol of death (the emblem I drew on pirate flags as a kid) — but also of the vital life force contained in the head. In art history, skulls symbolize the vanity of worldly things; with a cross they symbolize eternal life after Christ's death on Golgotha, the "place of the skull," where Adam's skull was said to be buried.

Scott McKowen, *Suzanne au bain*, 1813, by Pierre Nicholas Beauvallet, and *Les trois Grâces*, 1831, Musée du Louvre, Paris, charcoal pencil, 2007.

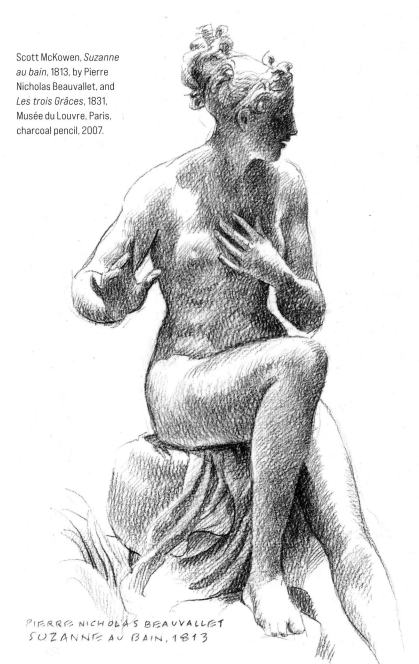

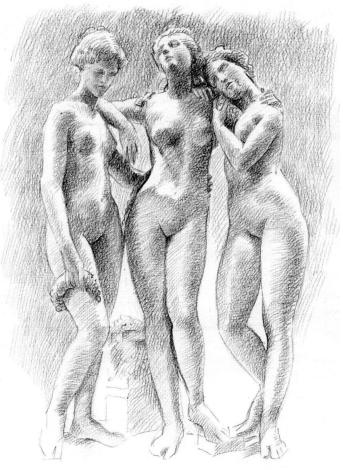

Scott McKowen, *L'Amour*, 1817, by Antonie-Denis Chaudet, Musée du Louvre, Paris, charcoal pencil, 2007.

As noted in the introduction to this book, any aspiring artist in the 19th century would have travelled to Paris to learn painting and drawing in the classical Academic tradition. First-year students entering an atelier were not allowed to draw from live models — you had to spend your first year mastering fundamentals of anatomy and proportion by drawing from plaster casts of classical statuary.

There was no such rule when I was studying at the University of Michigan School of Art in the mid-1970s — we drew from live models from day one — but the massive old plaster casts were still displayed, incongruously, throughout the corridors of the school.

Because I skipped this step of my basic training, I felt I should at least give it a try. On a visit to Paris in 2007, I spent a full day drawing statues at the Louvre (the originals, not plaster casts). Anyone can draw at the Louvre, but you have to remain standing — the guards will shoo you along if you sit. But if you apply in advance for permission, they give you a folding stool, and the guards leave you alone to focus on your work.

Inset on the facing page is my officially signed and stamped permit from the Louvre's *Bureau des copistes*. Painters can obtain permission from this same office to bring an easel and portable supplies to make copies directly from the masterworks hanging in the museum.

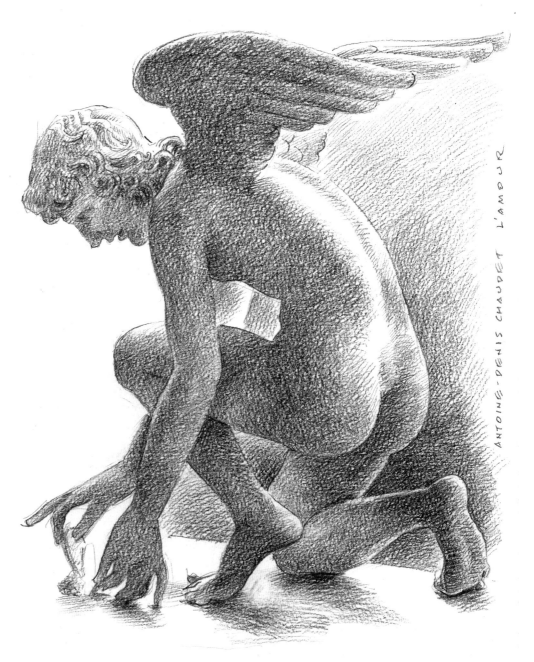

ANTOINE - DENIS CHAUDET *L'AMOUR*

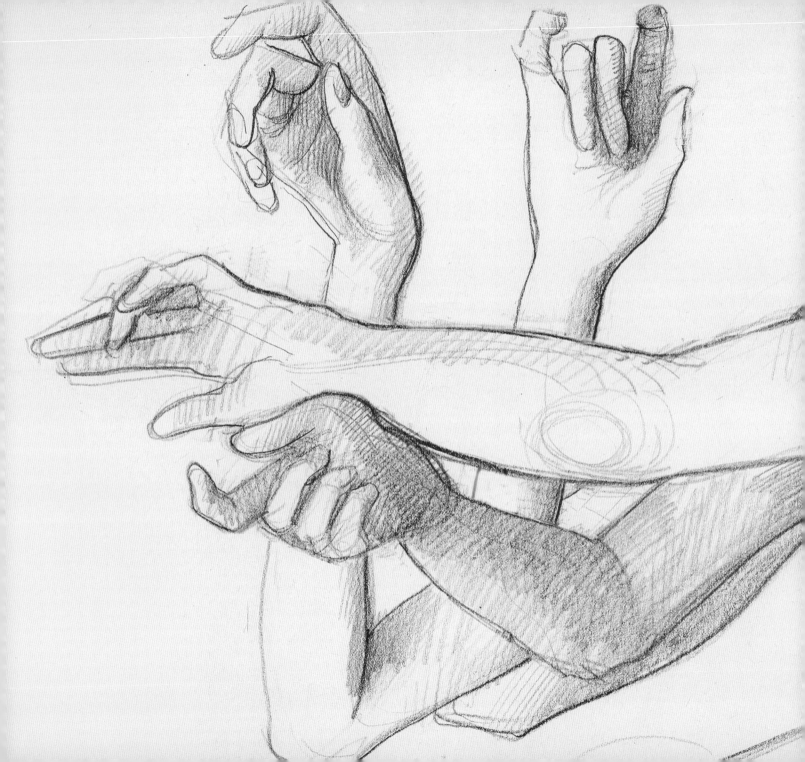

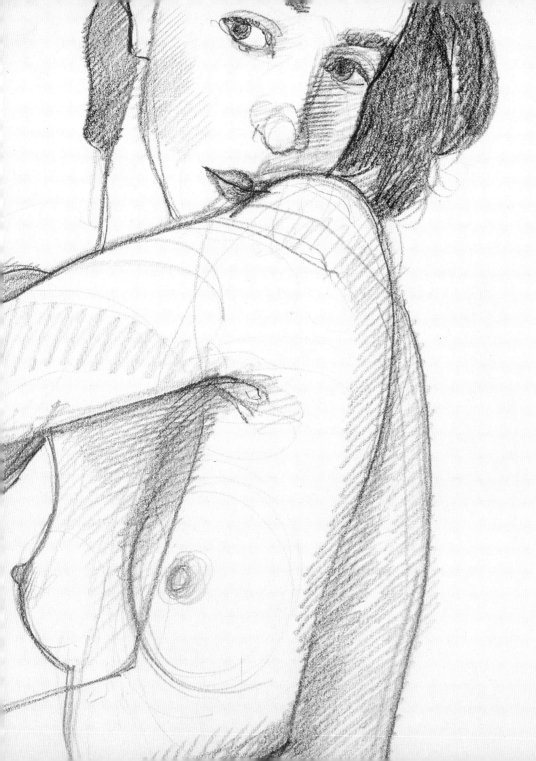

LIFE
Drawing

Scott McKowen, *Olja's Pantomime*, coloured
pencil, from a live Zoom session, 2021. The
pose is based on *Pantomime 12 "Letting Go"*
by Ukrainian painter Denis Sarazhin (b.1982).
The multiple sets of arms and hands were
modelled separately for 12 or 15 minutes each;
Olja challenged us to assemble the pieces into
a finished composite drawing. More of her
Sarazhin poses appear on pages 158–159.

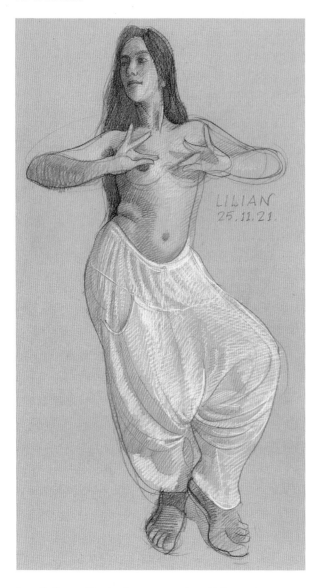

Scott McKowen, *Lilian*, in a live Zoom session of classical Indian dance poses from Bangalore, coloured pencil, 2021.

Scott McKowen, *Andrea*, in a live Zoom session from Rome, coloured pencil, 2022.

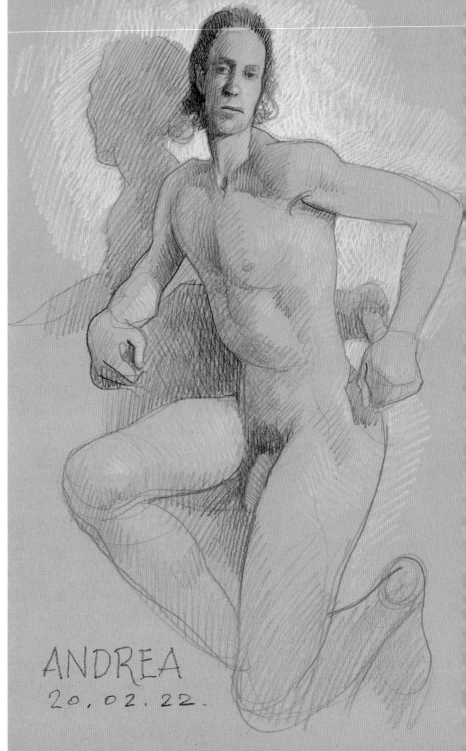

Rudolph Arnheim, author of *Visual Thinking* and *Toward a Psychology of Art* (and incidentally my first Art History professor at university) observed that "the human body is a particularly complex pattern, not easily reduced to the simplicity of shape and motion. The body transmits compelling expressions. Also, it is overloaded with non-visual associations. The human figure is the most difficult vehicle of artistic expression." I have been agreeing with Arnheim for over four decades now, as I try to master this discipline.

We increase our knowledge of drawing the longer we practise it. We learn to squint, which eliminates some of the detail and helps to simplify the forms. We memorize that the basic proportions of faces divide equally into thirds — hairline-to-eyebrow, eyebrow-to-tip of the nose, nose-to-chin — see page 155. Eyes always space out to one eye-width apart. Almost everyone has the same two eyes, two ears, a nose and a mouth — but no two faces are ever the same so every portrait drawing is a fresh challenge.

Peter Steinhart thinks that "we return to our drawing groups week after week, happy to see one another, grateful for our shared complicity in a doubtful activity. It is doubtful because its most noticeable attributes are nudity, desire, effort and failure. It's all funneled through a kind of meditative state that is internal and private, for the most part incommunicable except in the drawings themselves. It is by turns erotic and puritanical, social and narcissistic, uplifting and depressing."

Life drawing as a formal discipline originated in the Renaissance, but the inspiration for studying anatomy by drawing from nude models came from the art of the classical world. Renaissance artists realized from the naturalistic yet idealized forms of Greek and Roman statuary that direct observation of the human body was

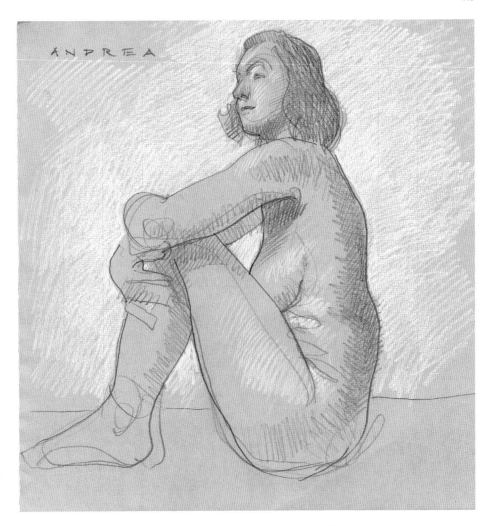

Scott McKowen, *Andrea*, in a live Zoom session from Edmonton, coloured pencil, 2021.

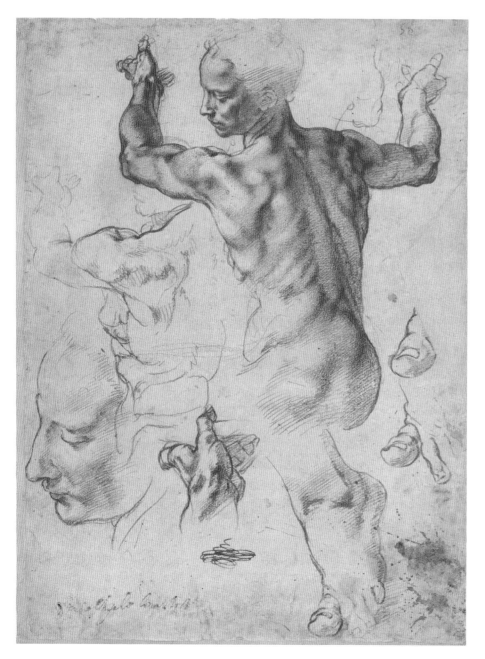

Michelangelo Buonarroti, *Studies for the Libyan Sibyl*, c.1510–11 (Metropolitan Museum of Art, New York).

the key to depicting figures. Michelangelo, a compulsive draughtsman, asserted, "Design, which by another name is called drawing… is the fount and body of painting and sculpture and architecture and of every other kind of painting and the root of all sciences."

The first formal art "academy" was established by Griorgio Vasari in Florence in 1563. It was patronized by the Medicis and was the model for the Académie Royale de Peinture et Sculpture in Paris (later the École des Beaux-Arts), established by Louis XIV in 1648. The Royal Academy of Arts in London was founded in 1768 along the same lines as the continental academies, and its school is still going strong.

The vintage drawings on the facing page are from the extraordinary collection of Ken Nutt, who has run our weekly life drawing sessions here in Stratford for four decades. William Strang (1859–1921) enrolled at the Slade School of Art in London in 1876, at age 17. His professor was Alphonse Legros (1837–1911), who insisted that his students learn to shade with line only — no smudging or tonal blending (stumping). Legros was a leading member of the etching revival in France so lines were his primary vocabulary. Strang became one of Legros' star pupils, and went on to establish himself as a leading portrait artist in the Edwardian period. Equally skilled but less famous was Mary L. Davis, a member of the "Saturday Sketch Club, Buffalo, 1911."

Life drawing today is less about trying to achieve a classical ideal. It's still an exploration of the human form, to be sure, but there's an added dimension that embraces an awareness of the human condition — the individual, the quirky, the vulnerable. As Henry Moore put it: "You can't understand life drawing without being emotionally involved… It really is a deep, long struggle to understand oneself."

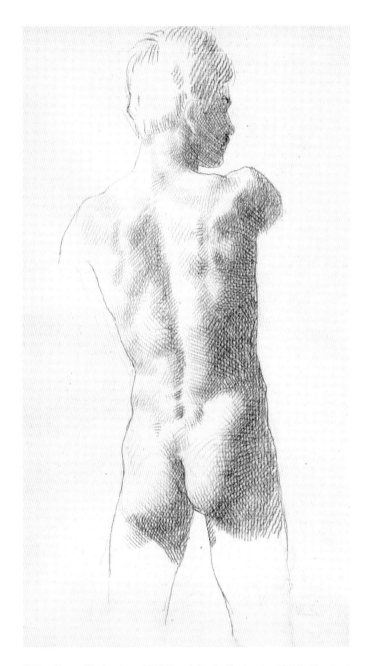

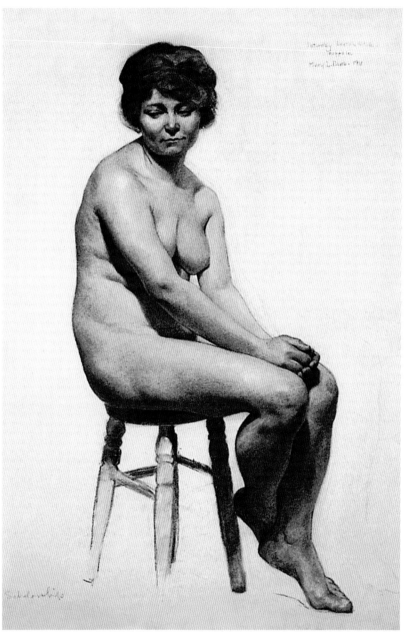

William Strang, life drawing, c.1880; Mary L. Davis, life drawing, 1911 (both collection of Ken Nutt).

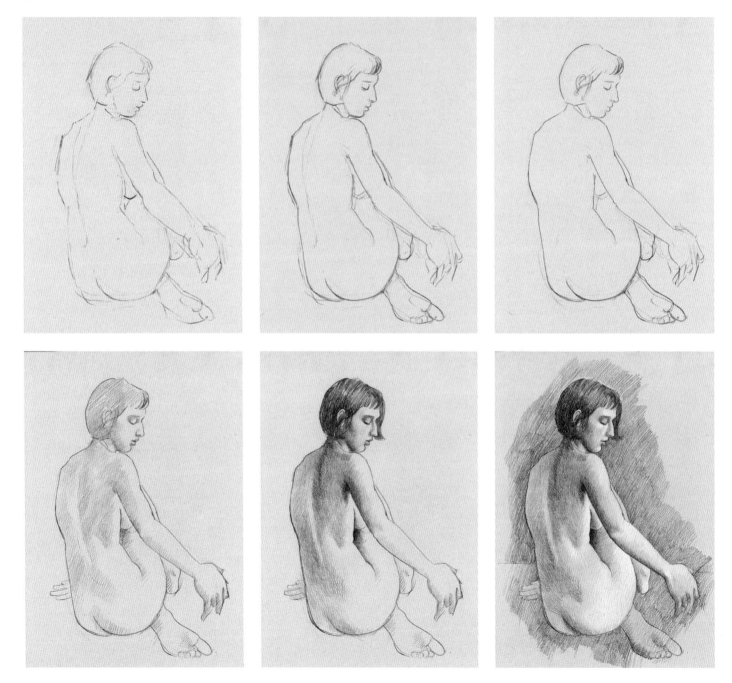

I scanned a drawing at several stages to show the steps of a block-in. This was a two-hour pose so there was plenty of time to measure and make adjustments.

Step one is very light lines using willow charcoal, which is completely pliable. I'm using my knitting needle to measure, and moving lines around as needed.

In step two, I have added a more definitive line over the charcoal — I'm still making minor corrections, deciding on which charcoal line is the correct one. Step three shows most of the charcoal wiped away with a cloth rag, leaving just the red line.

In steps four and five, I have started to add shading (I hadn't even noticed Nasim's left hand in the shadows until step four).

In step six, I have started to add highlights and suggest the dark background.

Scott McKowen, *Nasim*, coloured pencil, 2021.

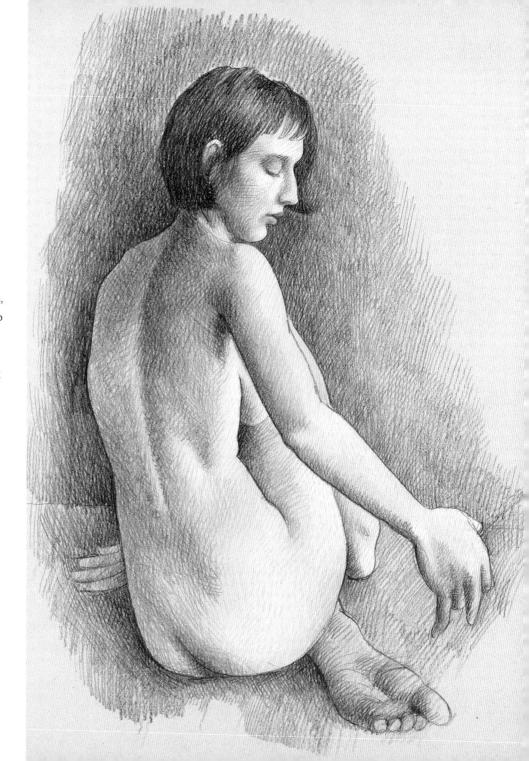

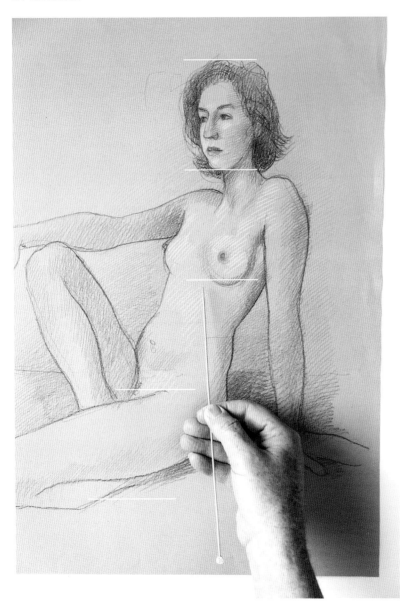

The most essential tool in my drawing kit is the ten-inch long knitting needle I'm holding in the photograph at left. I have talked about measuring as a key to ensuring accuracy in a drawing with architectural elements — let's look at how it works in life drawing.

The hatch-marks superimposed here represent my observations as I was studying Olja's pose. It's typical to use the height of the head as the unit of measurement. Marking the height of the head with my thumb, I stepped the needle vertically down the body, looking for visual landmarks. I noticed that the first unit located the bottom of the left breast, the second unit hit top of the right leg and the third showed me where the leg touched the floor. I made very light hatch-marks on my paper to serve as guideposts at the block-in stage, to check that I was drawing what I was actually seeing.

Using the same head-height unit, I rotated my needle horizontally to check for widths. The outside edges of Olja's hair, the overall width of her upraised leg and the distance between her right breast and the inside edge of her left arm each conveniently measured one unit.

I can hold the head of the knitting needle between my fingers and let it hang vertically as a plumb-line. In a standing pose, the side of the head might align vertically with the inside of a foot. That foot is at the bottom of the page so it's hard to see that relationship accurately — checking against a plumb-line shows you exactly where it belongs.

The needle helps to check the angles of legs and arms. Holding one end in each hand, I can compare those diagonal angles between the model and the drawing. If I am drawing an arm, a thigh and a torso, the easiest way to ensure that I have them in the right place is to focus on drawing the triangle of negative space between them — as highlighted in the inset on the facing page.

Almost all faces divide conveniently into equal thirds: the chin to the tip of the nose; nose to eyebrows; and eyebrows to hairline. The horizontal space between the eyes is one eye-width. These rules of thumb are useful to memorize — they work when you're looking at the face straight-on; if the model is looking up or down these landmarks shift and you have to measure based on the pose.

Scott McKowen, *Olja*,
coloured pencil, 2020.

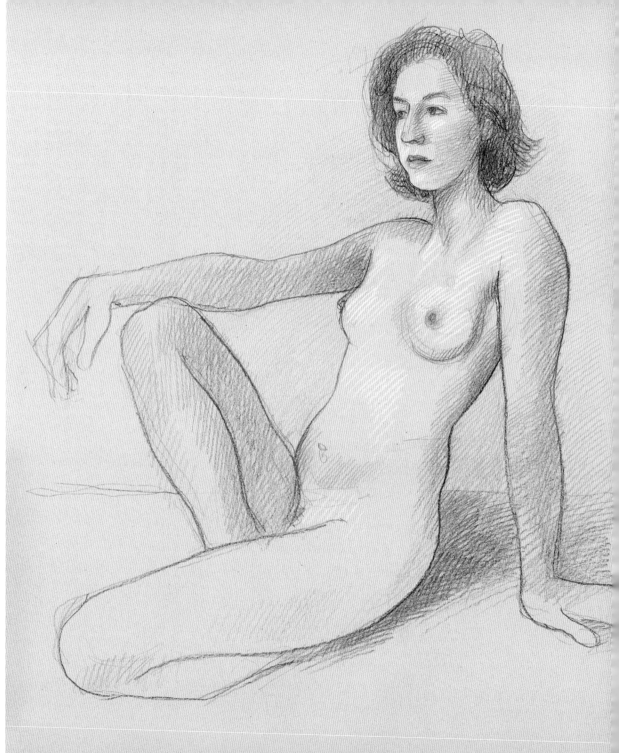

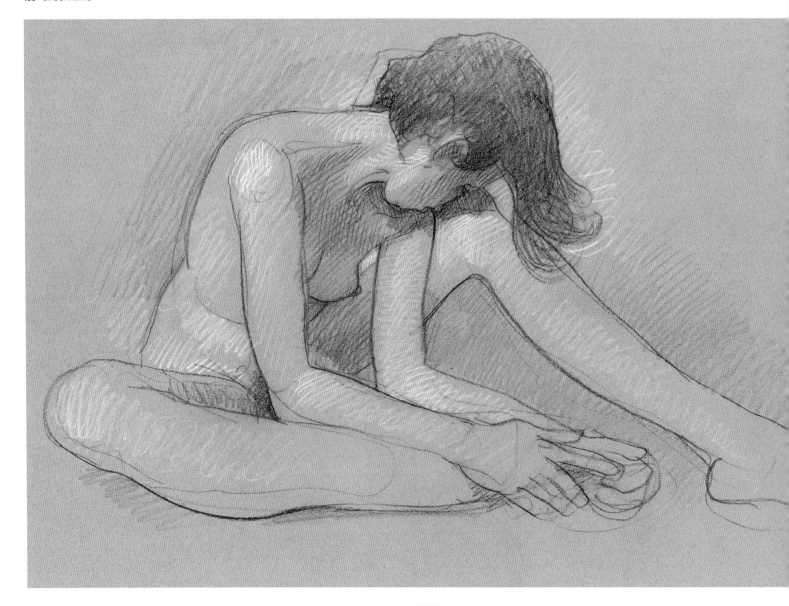

Scott McKowen, *Olja*, in a live Zoom session from Belgium, coloured pencil, 2021, inspired by *Seated Nude*, 2001, by American painter Jacob Collins. Collins is Adam Gopnik's tutor in "What I Learned When I Learned to Draw," on page 180.

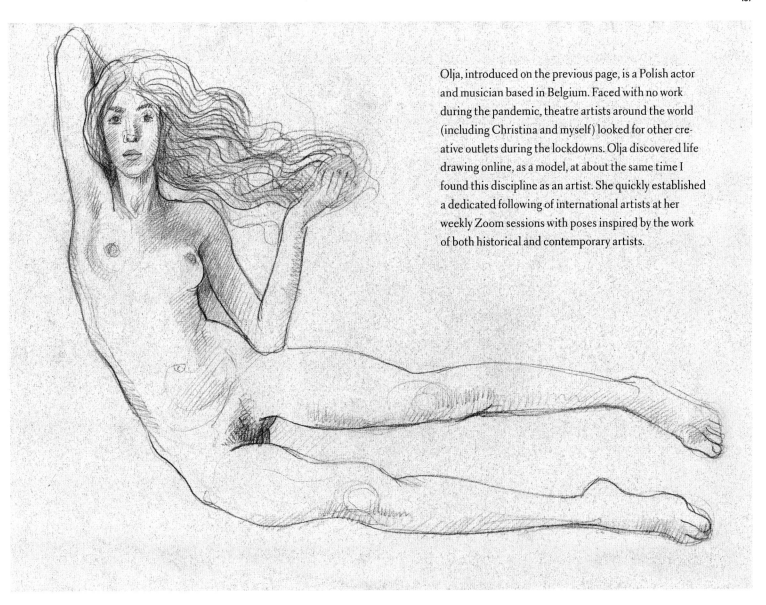

Olja, introduced on the previous page, is a Polish actor and musician based in Belgium. Faced with no work during the pandemic, theatre artists around the world (including Christina and myself) looked for other creative outlets during the lockdowns. Olja discovered life drawing online, as a model, at about the same time I found this discipline as an artist. She quickly established a dedicated following of international artists at her weekly Zoom sessions with poses inspired by the work of both historical and contemporary artists.

Scott McKowen, *Olja*, in a live Zoom session from Belgium, coloured pencil, 2021, inspired by *L'Aurore*, a small plaster sculpture made in 1963 by Riccardo Scarpa (1905–1999).

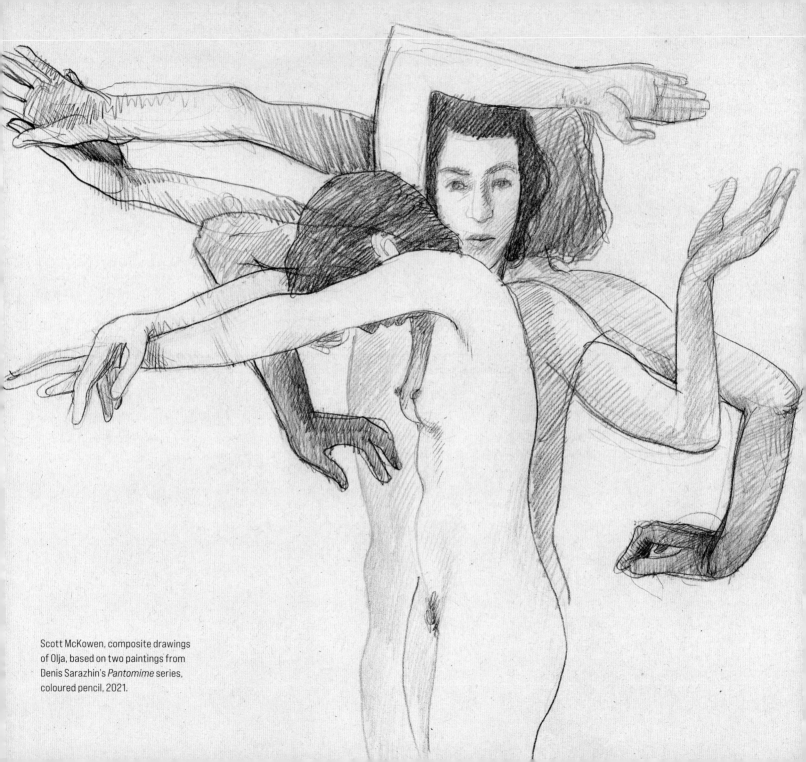

Scott McKowen, composite drawings
of Olja, based on two paintings from
Denis Sarazhin's *Pantomime* series,
coloured pencil, 2021.

Olja challenges artists in her Zoom sessions with little puzzles that we have to solve as we draw. Inspired by paintings of the Ukrainian artist Denis Sarazhin, she posed each of these multiple figures individually – 15 minutes each — asking us to assemble the grouping in a single drawing. I used a different colour for each figure to keep them straight. I'm always impressed by the preparation Olja puts into her sessions — and even more so by the fact that her outstretched arms never moved an inch during these difficult poses!

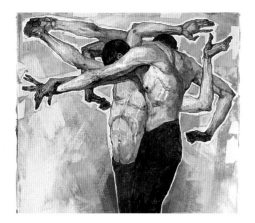

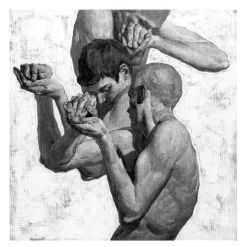

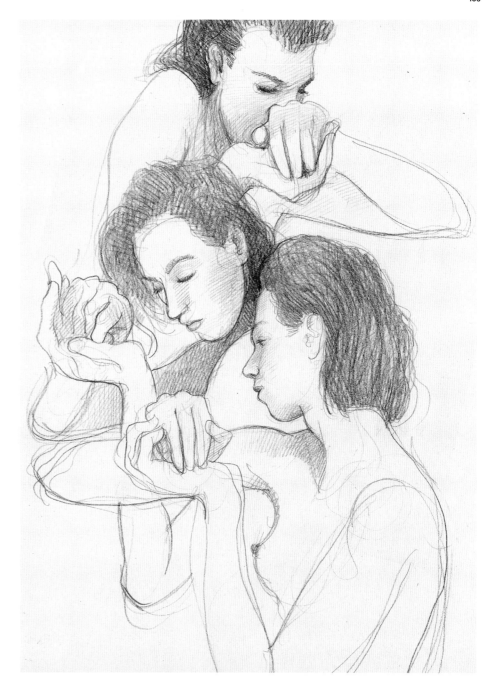

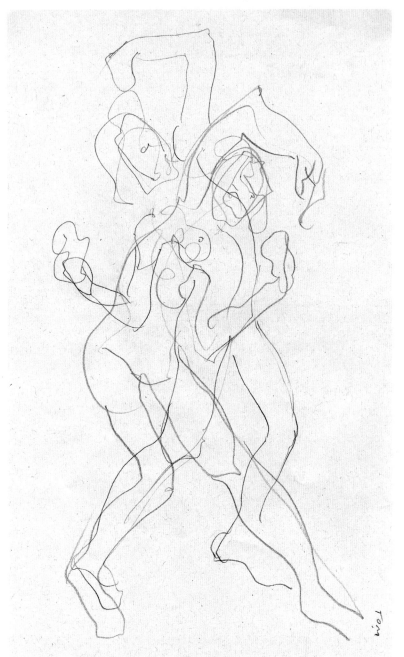

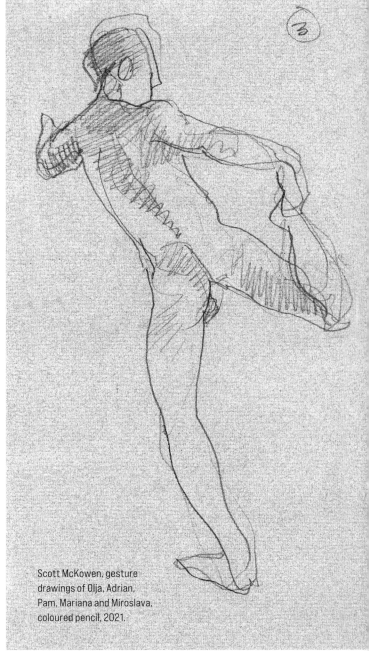

Scott McKowen, gesture
drawings of Olja, Adrian,
Pam, Mariana and Miroslava,
coloured pencil, 2021.

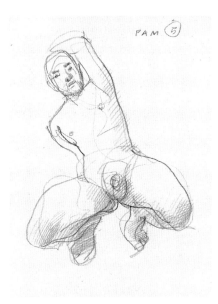

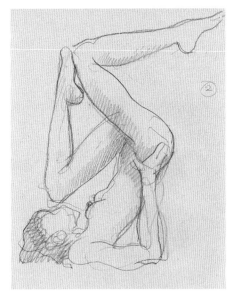

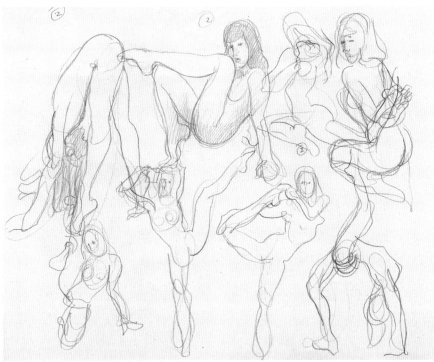

Many life drawing sessions begin with gesture drawings as "warm-ups." The quick, spontaneous poses tend to be more physical than longer poses — a model can hold a pose with a bend or a twist, with arms upraised or stand on their toes for a minute or two, which they could never hold for 10 or 15 minutes. You have to be on *your* toes and learn to be decisive. There's no time to be timid or even think about reaching for an eraser to make corrections. These poses come at you fast and furious.

Gesture drawing is the best way to teach yourself how to edit — how to simplify the figure to a few accurate lines. You quickly decide what's important to include and what can be omitted. I recently noticed an online class offering an hour of 60 one-minute poses, followed by a second hour of 30 two-minute poses. You'll complete a lot more drawings than you could with longer poses — this builds up what is known as "pencil mileage." Gestures are not meant to be finished drawings. I think of them as practice exercises to improve my eye for proportion and movement — to explore the contrast between tension and loose, flowing lines.

There's a technique called "blind drawing" in which you do gesture drawings without looking at your paper — think of your hand as an extension of your eye — and even if the lines don't quite match up, you'll be surprised at how well this can capture a sense of movement.

Another interesting exercise that I try from time to time is draw a warmup pose (say, three minutes) with your dominant hand — right hand, for me — and then draw the same pose again for the same length of time, with my left hand.

No pose on this spread was longer than five minutes; most were more like two minutes. Placing multiple gestures on a single page saves time (and paper) and, like frames of a film, underscores the sense of movement.

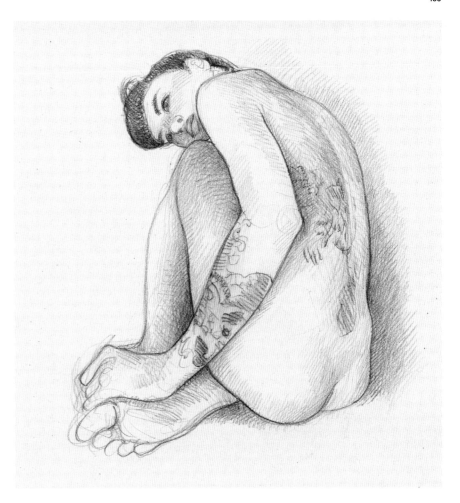

Scottish Borders Life Drawing Club sessions often attract more than a hundred artists from around the world. From a March 2020 session with Melina, a brilliant model in Buenos Aires, here are nine drawings of the same 20-minute pose. My drawing appears above; the other artists, clockwise from top left, are Kristin Van Houtte; Deryck Henley, who draws with charcoal pencil; Michael Duggan in Dublin; Pete Smith, who works digitally using Rebelle software; Annie Livesey, who made this drawing using Sharpie markers; Wayne Smith; Lisa Nolan in Western Australia; and Elena Briollet in Paris. Tattoos always present an additional degree of difficulty — I usually ignore them, but I had a couple of minutes before the end of this pose to give them a try.

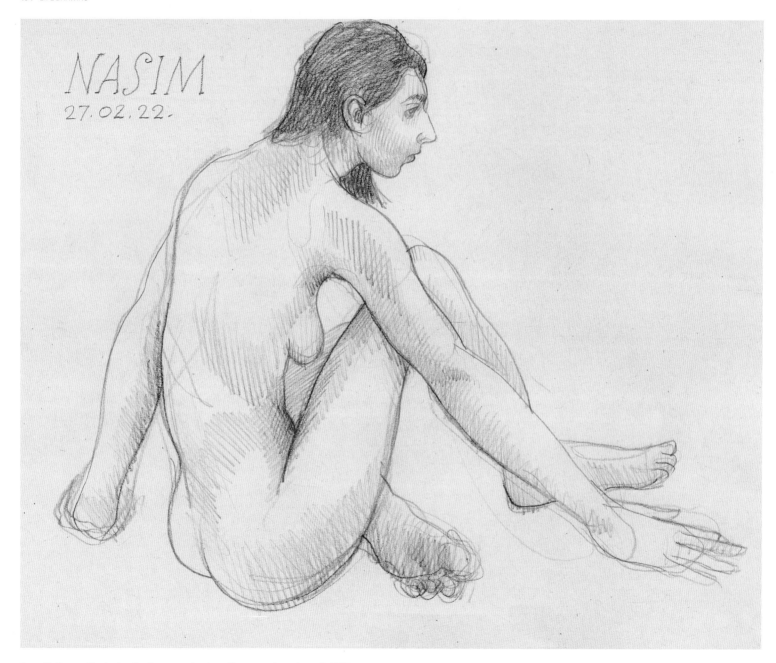

NASIM
27.02.22.

Scott McKowen, *Nasim*, in a live Zoom session from Glasgow, coloured pencil, 2022.

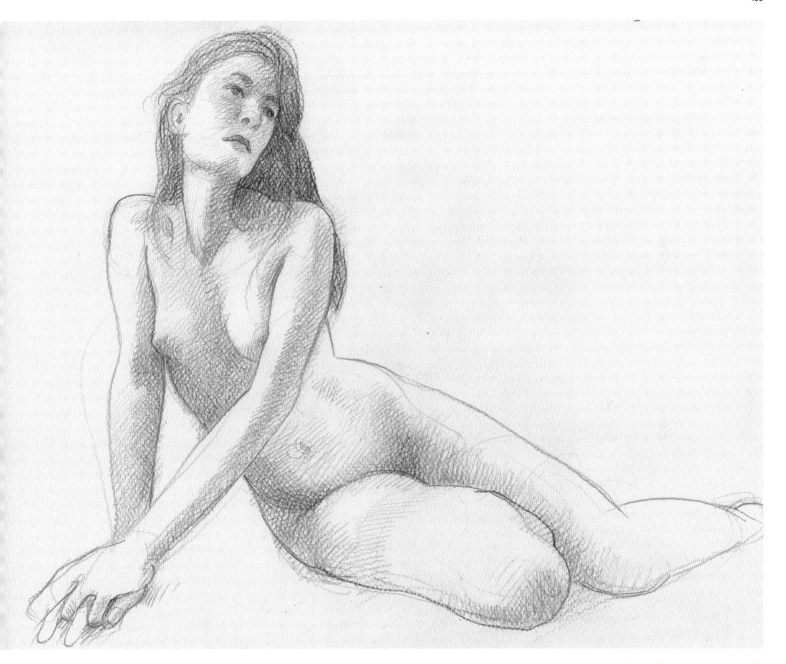

Scott McKowen, *Vilidian*, in live a Zoom sessions from Mexico City, coloured pencil, 2022.

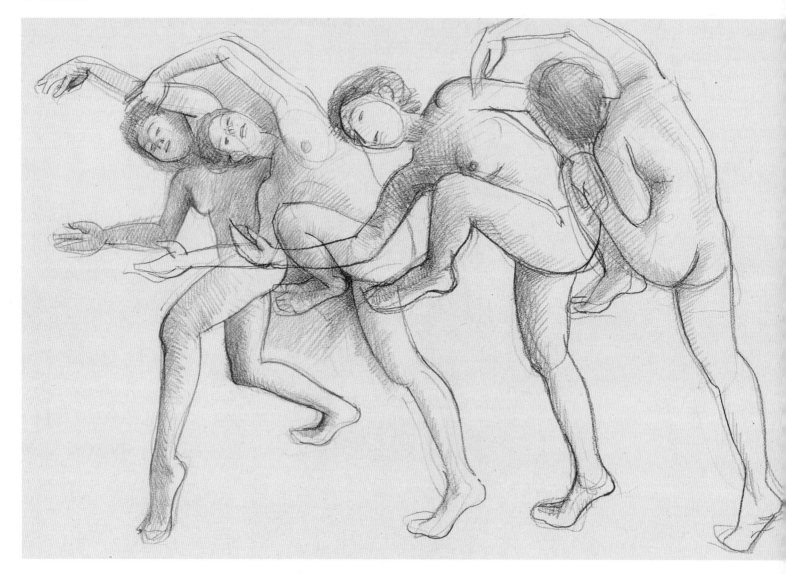

Scott McKowen, *Yoyo*, in a live Zoom session
from Taiwan, coloured pencil, 2022.

Scott McKowen, *Evie*, coloured pencil,
2021; *Caitlin*, China marker, 2014.

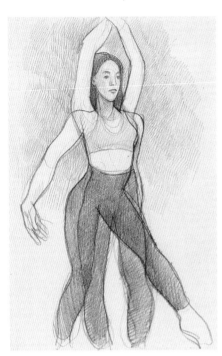

I love "sequential" poses in which a model moves through a series of related actions in slow motion. Yoyo performed a sequence of dance movements as if they were stop-motion animation — the drawings remind me of Eadweard Muybridge's photographic motion studies.

Both drawings on this page are from live sessions. Evie gave me a lovely "double exposure" dance pose. Caitlin took a simple seated pose for 15 minutes but moved her arms every 5 minutes. The finished drawing evokes the multi-armed Hindu deity Kali (or is it Durga?) — an impression enhanced by the harem pants and jewellery.

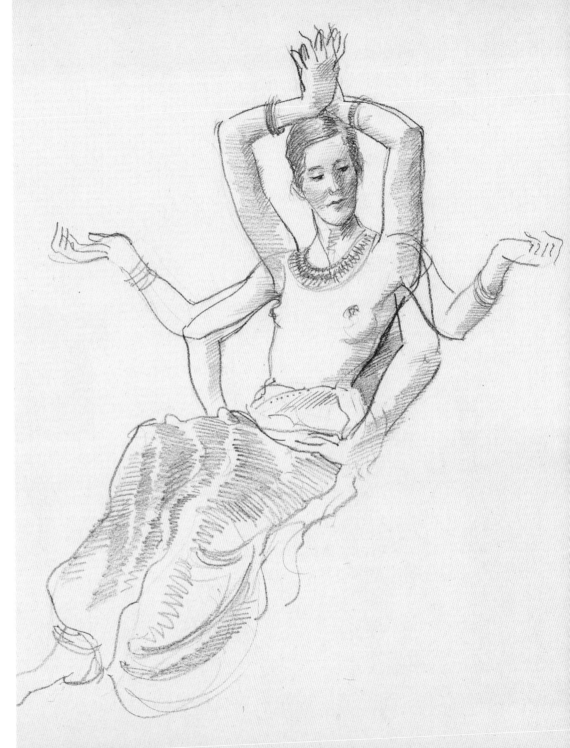

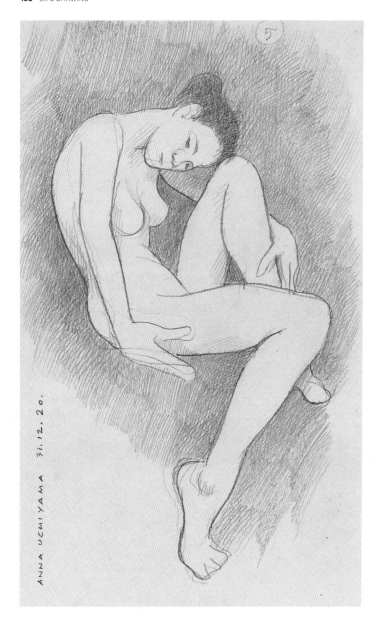

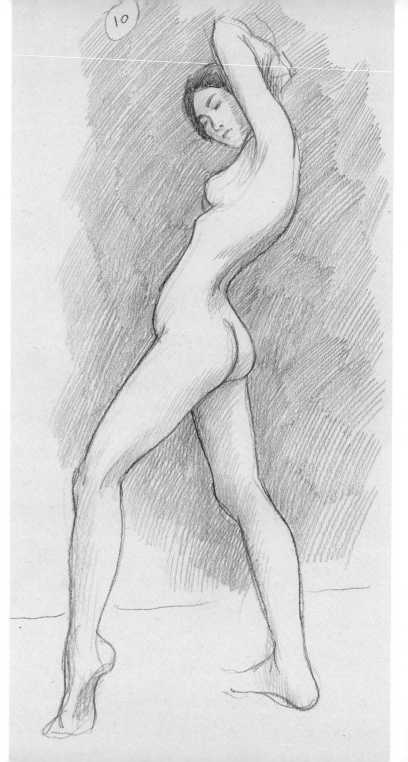

Scott McKowen, *Anna*, in live Zoom sessions from Tokyo, coloured pencil, 2021.

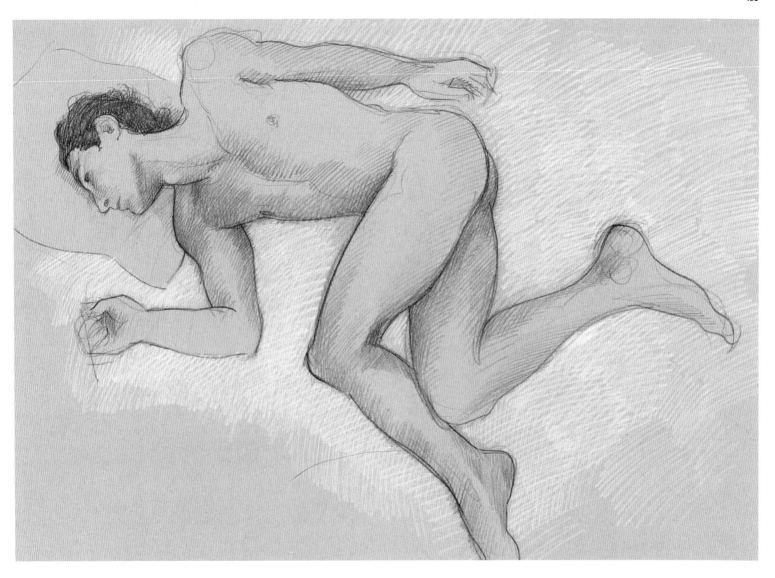

Online life drawing sessions afford opportunities for interesting or unexpected angles that would be impossible to capture "live in the room." Models sometimes place their cameras on the ceiling and stretch out (or curl up) on the floor below. Aerial views can be challenging — the drawings on the next few pages were 20-minute poses so there was time to do basic measuring. Drawing the negative spaces is always a very helpful way of checking proportions — see page 155.

Scott McKowen, *Alejandro*, in a live Zoom session from Paris, coloured pencil, 2021.

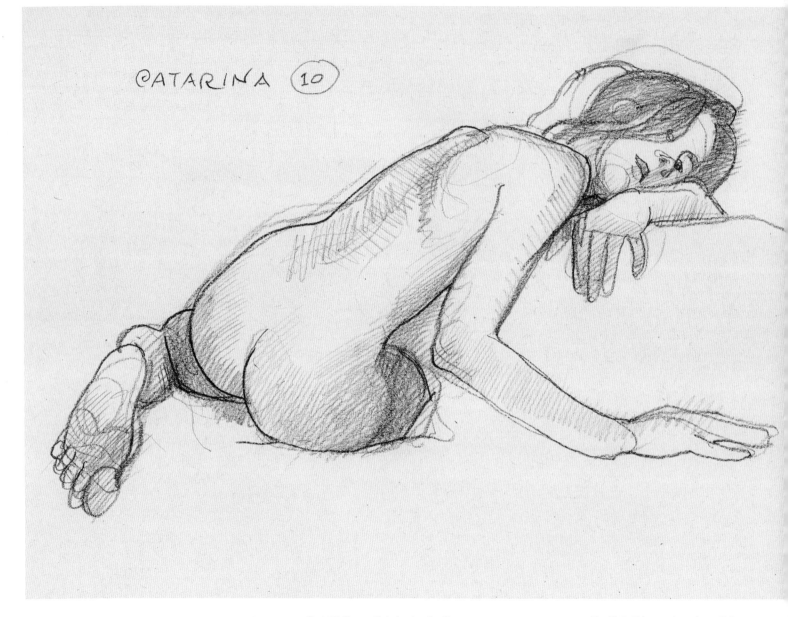

CATARINA (10)

Scott McKowen, *Catarina*, in a live Zoom
session from Portugal, coloured pencil, 2021.

Ken Nutt, *Falcon*, coloured pencil, from
a live-in-the-same-room session, 1998.

Live sessions vs. Zoom sessions

I have spent almost every Wednesday evening for four decades at a weekly Open Studio life drawing group here in Stratford. It's a friendly group — eight or ten local artists are "regulars"; sometimes as many as two dozen people show up to draw and you can barely find a place to sit. The sessions are run by my friend and master draughtsman Ken Nutt. Ken puts a huge amount of time into booking models and setting up the room, but he also devises "theme nights" inspired by artists throughout history. Everyone does poses inspired by Egon Schiele and Degas bathers, but Ken has an encyclopedic knowledge of art history and delves much deeper. We have had evenings inspired by the Swedish painter Anders Zorn (1860–1920), the Swiss painter Ferdinand Hodler (1853–1918) and the Italian Felice Casorati (1883–1963). Ken introduced us to the work of Bernard Fleetwood-Walker (1893–1965) and the Ukrainian artist Zinaida Serebriakova (1884–1967).

We have had evenings devoted to sculptors Paul Manship (1885–1966), who blended a sophisticated appreciation of the art of the European Classical past with the sleek stylizations of the Jazz Age, Aristide Maillol (1861–1944) and Georg Kolbe (1877–1947). Ken sends out email introductions to each of these featured artists which include a well-researched bio and a portfolio of their life drawings — an art history refresher course in your inbox every week.

When I occasionally find myself in New York in the middle of the week, I attend the weekly life drawing sessions at the Society of Illustrators, at 63rd and Lexington. It's hard not to be inspired with original drawings by Howard Pyle, N.C. Wyeth and James Montgomery Flagg hanging on the walls around you. These sessions feature two or sometimes three models, live jazz and an open bar (don't drink and draw!) — you have to get there early because there are 50 or 60 artists crowding in, who all want a good seat!

When the covid pandemic hit, drawing groups everywhere were prevented from meeting in person. Some groups moved to online drawing sessions via Zoom. One such was the Scottish Borders Life Drawing Club run by Deryck Henley, a talented draughtsman and painter near Edinburgh. You receive the Zoom link when you make a donation. The three-hour sessions start with warmup poses and progresses to 10-, 15- and 20-minute poses, just like in a live class. Henley posts the timings in the chat box and quietly intones that we're "halfway through" or have "two minutes left." He even programs music — his own three-hour playlists are available to listen to anytime on Spotify. I have joined Scottish Borders sessions with over a hundred artists from all over the world, all drawing a model (or sometimes two) live in London, Lisbon, Buenos Aires, Tel Aviv, Tokyo or Chicago. It's not the same experience as drawing in the same room with a live model, obviously — but there are compensations and fresh perspectives. The camera might be mounted on the ceiling so you're looking straight down at the model reclining on the floor — a point of view you could never get in a live session.

"Thousands Turn to Online Life Drawing" proclaimed a January 2021 article by Sarah Johnson in *The Guardian*. Brixton Life Drawing attracted around 50 people every week before the pandemic. "When they were furloughed in the first lockdown, they moved their classes on to Zoom," Johnson reports. "Now, about 1500 people take part each week."

But if you're going to draw from a subject on a computer monitor, why not just work from photographs? They could provide more accurate anatomical reference and better image quality. I think it's because the spontaneity of live poses shines through. The model is breathing and moving, exploring and collaborating with the artists — and there's a clock counting down the time for each pose. Drawing from photographs is *nature morte* — or at best, reproducing someone else's vision.

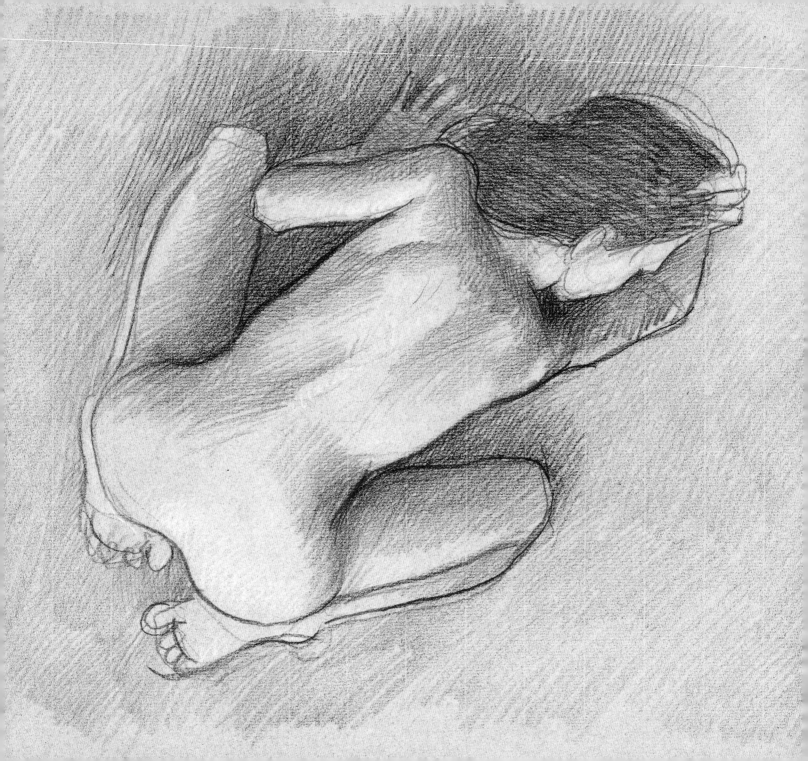

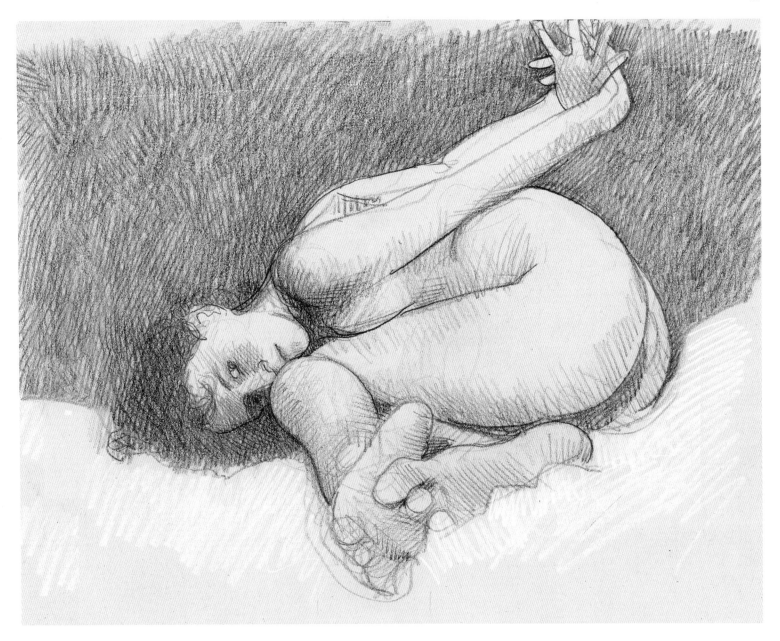

Scott McKowen, *Mariana*, in a live Zoom session
from Medellin, Colombia, coloured pencil, 2020.

Scott McKowen, *Nicole*, in a live Zoom session
from the Algarve, Portugal, coloured pencil, 2021.

Two models posing together raises the level of complexity and difficulty (especially if someone is upside-down!) — but the poses in a duo session are generally longer than in solo sessions to compensate. The camera in both of these sessions was on the ceiling, pointed down at the models.

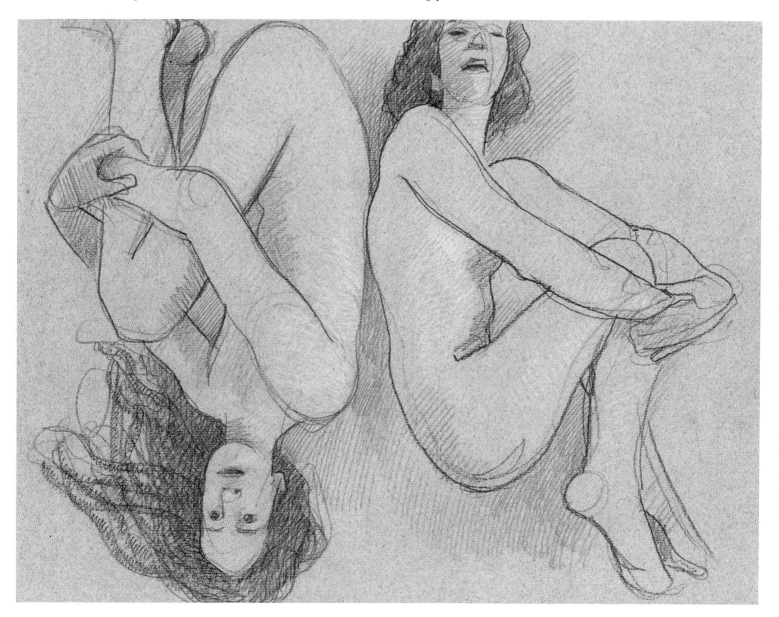

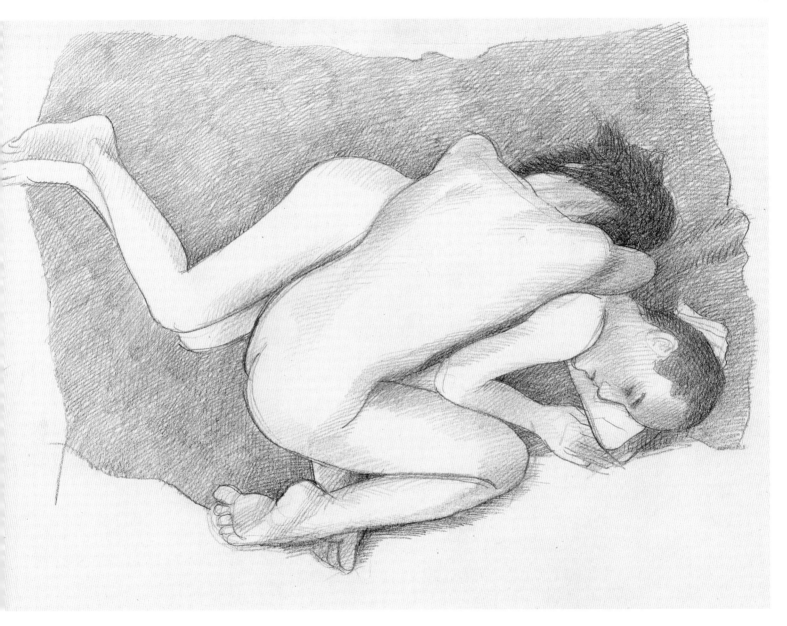

Scott McKowen, *Yolanda and Dorota*, in a live Zoom
session from Liverpool, U.K., coloured pencil, 2021.

Barbara and Helen, in a live Zoom session
from Portugal, coloured pencil, 2021.

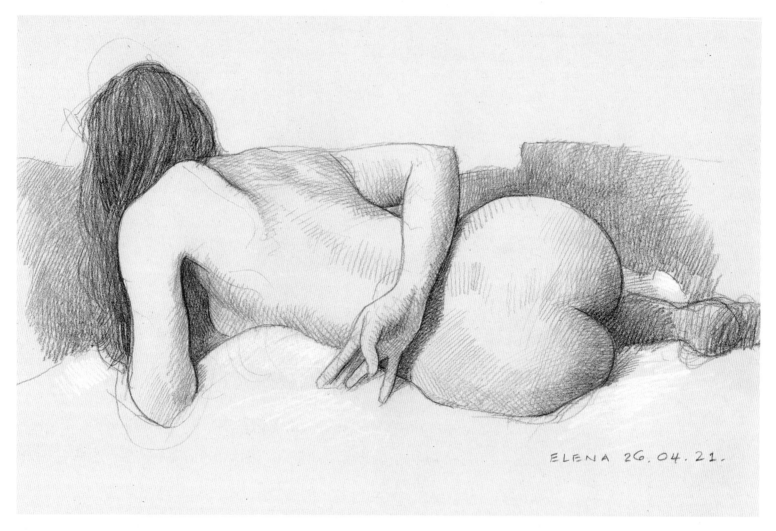

ELENA 26.04.21.

Scott McKowen, *Elena*, in a live Zoom session, coloured pencil, 2021.

Many of the best models I've worked with are also artists themselves. Elena is an artist and model based in Leipzig, Germany — she hosts her own sessions as well as organizing sessions featuring other models. She has presented sessions inspired by Auguste Rodin, Alice Neel, Tracey Emin, Hannah Höch, Cy Twombly, Helmut Newton (see page 198) and van Gogh's *De aardappeleters* (*The Potato Eaters*) to honour her Dutch heritage. These two drawings are 25-minute poses from a 2021 Zoom session.

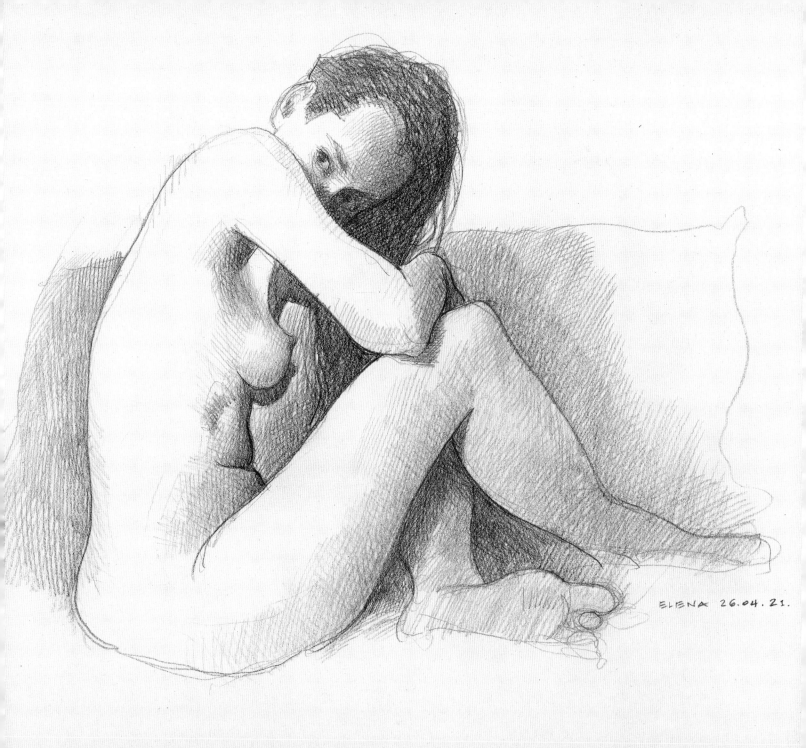
ELENA 26.04.21.

SASHA 20. 04. 21.

SASHA 20.04. 21.

SASHA @
EIGHT MONTHS

SASHA
&RUBY
19.10.21.

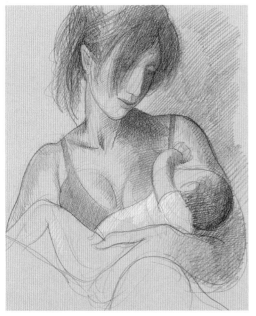

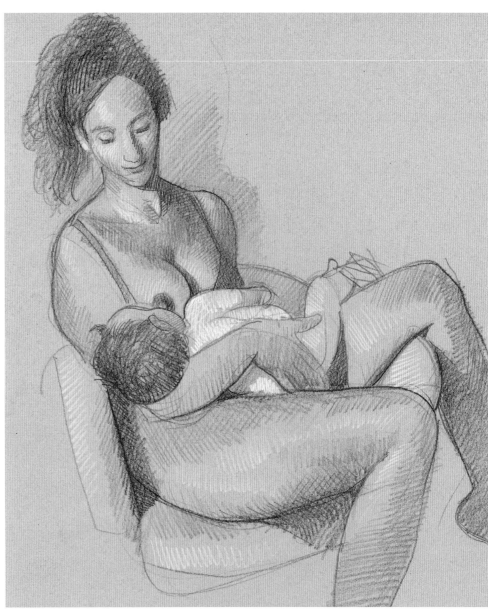

Scott McKowen, *Sasha*, in a live Zoom session from the U.K., eight months pregnant, coloured pencil, 2021. Sasha then returned in the fall to pose together with Ruby, her baby daughter.

"What I Learned When I Learned to Draw"

Adam Gopnik, the erudite essayist and critic at *The New Yorker*, wrote a long and insightful essay entitled "What I Learned when I Learned to Draw," published in the June 27, 2011, issue. It's worth reading but here's my precis. Gopnik finds himself at an interminable midweek dinner party. One of the other guests is Jacob Collins, an artist and drawing tutor; they have kids going to the same school and they strike up a conversation. Gopnik has a graduate degree in art history but has no real idea of how to draw. So when Collins mentions "I teach people how to draw," Adam asks "Would you teach me?"

They arrange to meet at Grand Central Academy of Art, where Collins teaches. Gopnik observes the students working at their easels: "Each hand moved, back and forth, up and down from the wrist, and the world seemed to flow onto the sketcher's paper like silver water taking the form of things seen, subtle gradations of gray and black that didn't just notate the things in an expressive shorthand but actually mirrored them, in a different medium and on a different scale."

Collins sets up an easel and gives Gopnik a plaster cast of an eye, three times life size, to see if he can make a copy of it. It does not go well. Gopnik tries repeatedly but each sketch is a disaster. "As I crossed Sixth Avenue two hours later, I was filled with feelings of helplessness and stupidity and impotence that I had not experienced since elementary school. Why was I so unable to do something so painfully simple?"

Gopnik tries to forget about the experience but his desire to learn to draw is still intact and, six months later, Collins says "Hey, if you're still interested, why don't you come around to my studio sometime and watch while I draw?"

Over the ensuing year, Gopnik becomes a regular Friday afternoon visitor to Collins' studio. "Jacob drew and drew and drew. His paintings had a sombre, melancholic cast, in the manner of Thomas Eakins. But his drawings were prestidigitations, magical evocations of the thing seen, pencil drawings as accurate as photographs but with the ability that a photograph lacks to distinguish the essentials."

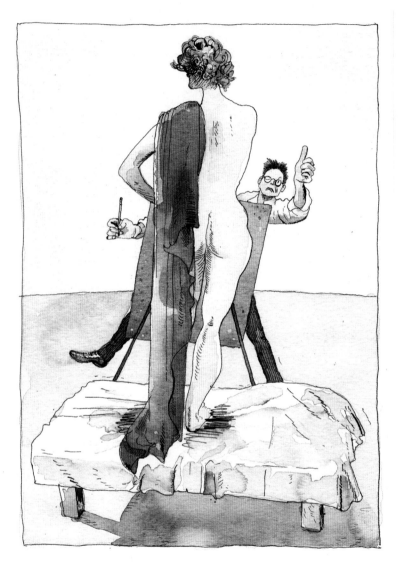

Barry Blitt's full-page illustration accompanying Adam Gopnik's essay "What I Learned when I Learned to Draw" in *The New Yorker*, June 2011.

I have loved Barry Blitt's *New Yorker* covers for years, with his brilliant caricatures of Obama and Trump. When I asked Barry for permission to reproduce his illustration here, I noted that it was a pretty good portrait of Gopnik. Blitt claims that any likeness was unintentional; either way, he caught the earnest trepidation of the art student, one eye closed to measure with his thumb, with delightful accuracy.

Gopnik listens and watches and begins again to try to draw from observation. Collins suggests Gopnik visualize an imaginary clock face on top of his drawing, which allows the artist to check the angle of a line — to see if it matches up with what you see. If it doesn't, then adjust it. Gopnik is gobsmacked that you can erase a line and correct it: "Nothing in a graduate degree in art history prepares you for the eloquence of the eraser."

Eventually there's a nude model in the studio — a perfectly muscled young man named Nate — and Gopnik starts drawing from life. He knows the basic approach but is still inexperienced and unsure. Collins suggests to "look into his torso and find a new form, another shape to draw. Something outside your skill set." Collins explains, "don't draw a chest or what you think a chest looks like... find something else in there to draw. Find a dog. The outline of some small African nation. A face... see there, right in the space beneath his breastbone, I see this kind of snooty-looking butler, his chin pointing out and his nose in the air." This is excellent advice — if you can let your imagination find unrelated shapes within the play of light and shade of the figure, it gives you alternate ways into the problem-solving process.

Gopnik has small epiphanies along the way — "I saw a kind of hamster with soft rabbit ears where his shoulder joined his arm, its blunt snout pressing toward the eyes, and I tentatively drew that. I was following the image, doing sight-system checking... rubbing out the weaker lines and letting the better ones bloom... and, miraculously, the outline of an arm appeared, and a shoulder, and it all looked more or less right."

Towards the end of their year together, Gopnik recalls arriving at the studio one Friday and there was a nude female model — an attractive woman named Anna. Using all the techniques he had learned, he tries to get her proportions right. Collins, coaching over his shoulder, points out little errors based on preconceptions and urges him, "look again." Gopnik makes some adjustments on his drawing and has a real breakthrough moment: "Suddenly, she was alive — right there on the page!"

That's a perfect description of my goal every time I start a new drawing.

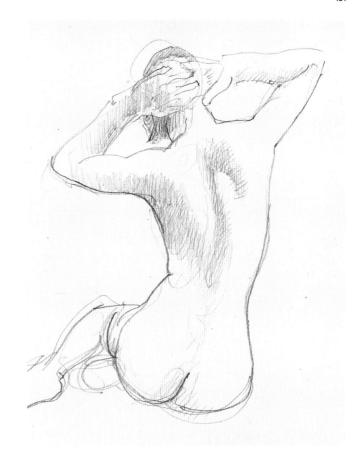

Scott McKowen, *Dorota*, in a Zoom session from Liverpool, U.K., 2021.

Here's an illustration of Jacob Collins' valuable tip to Adam Gopnik about visualizing non-related shapes. The light falling across Dorota's spine and shoulder blade created a shadow in which I could see the body, neck and head of a flamingo. You have to use a little imagination but, once you see it, right there in the middle of her back, it gives you another set of reference points to draw.

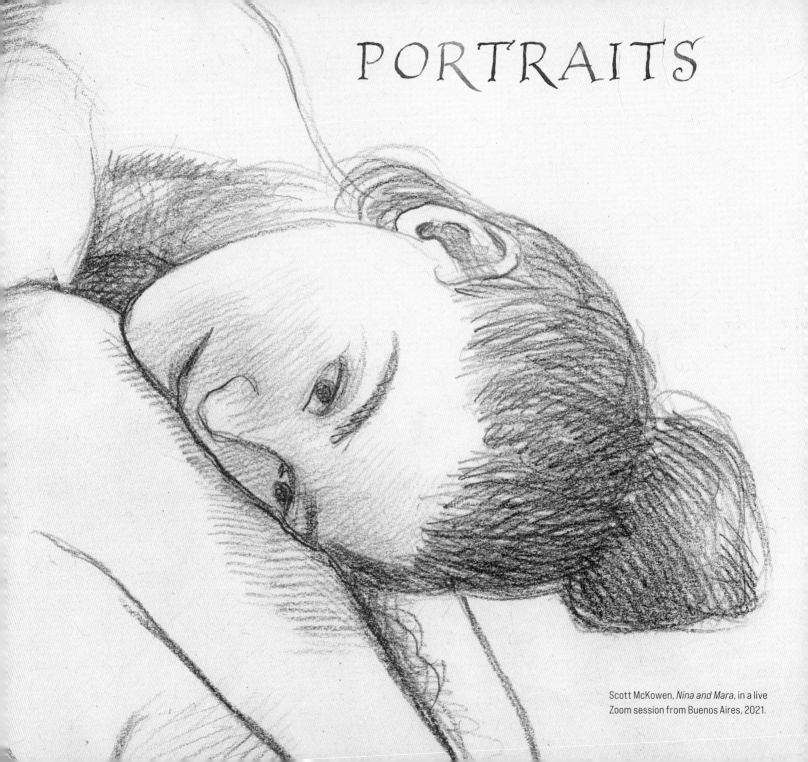

PORTRAITS

Scott McKowen, *Nina and Mara*, in a live
Zoom session from Buenos Aires, 2021.

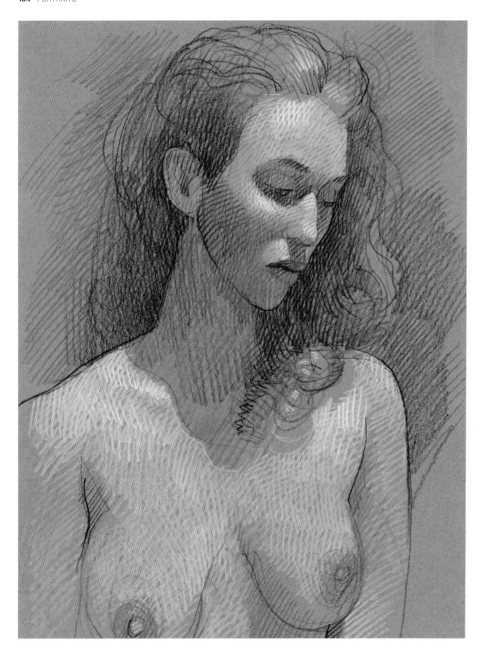

Scott McKowen, *Noa*, coloured pencil, 2022. Ten-minute portraits, clockwise from top left: *Astrid*, *Rodrigo*, *Henri*, *Cecilie*, *Barbara* and *Deandrea*, 2020–21.

One of the ten-minute poses in every Scottish Borders Life Drawing session is always a portrait. This is great practice because the human face is probably the most complex and challenging subject we ever attempt to draw. We all have a nose, a mouth, two eyes and two ears, but no two faces are the same. There's often extra pressure when drawing a close friend or loved one — we know the nuances of their features and the subtleties of their expressions, and we want to capture them perfectly. I have drawn my wife Christina for 35 years now and a recent profile sketch on page 189 is the first time I think I've done her justice.

I am always interested in accuracy in drawing — hopefully that's obvious by this point in the book. I'm not sure there's any formula for achieving a likeness other than practise, practise, practise. It helps to draw a person multiple times, to gain familiarity with the specifics of their features. You can learn more from doing a dozen quick two-minute sketches of a person than you would spending that amount of time on a single portrait.

John Singer Sargent warned that it's impossible to repaint a head where the understructure is wrong. He's talking about tone more than line, but he could draw with facility that most of can only dream of — so getting the structure right is sage advice. Andrew Loomis, in his 1956 classic *Drawing the Head and Hands*, reminds us of the great variation in the differences in shapes of the skull itself. "There are round heads, square heads, heads with wide and flaring jaws, elongated heads, narrow heads, heads with receding jaws. There are heads with high domes and foreheads, those with low." Loomis

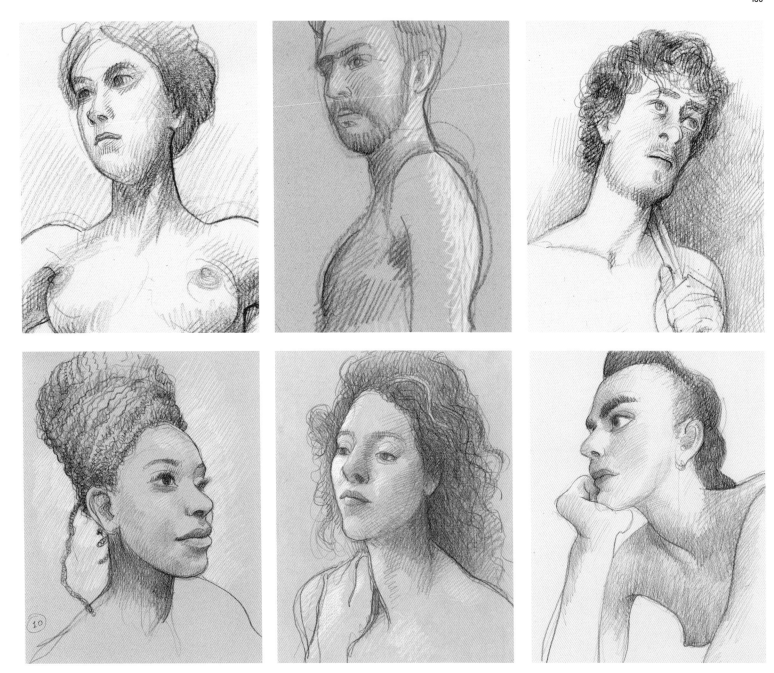

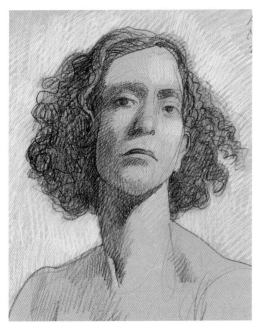
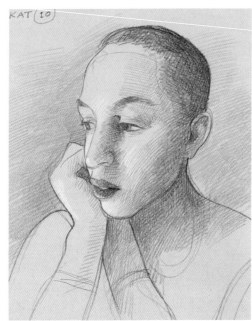
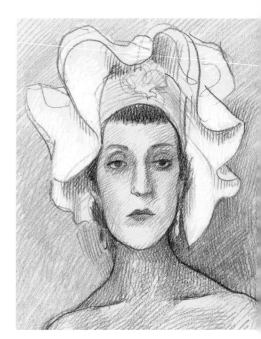
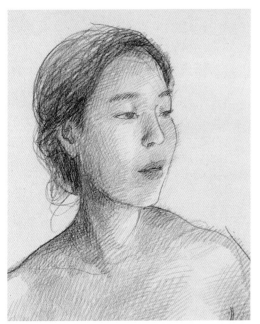
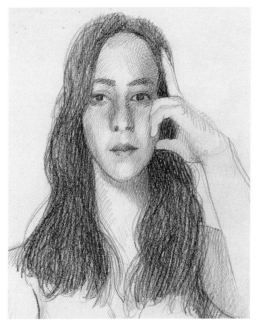
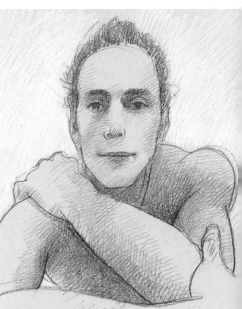

makes it sound so simple: "Drawing a head effectively is a matter of interpreting form correctly in its proportion, perspective and lighting."

I always check the proportional relationships down the central axis of the head — the distances between the hairline and the eyebrows, the eyebrows to the bottom of the nose and the nose to the chin are almost always equal (illustrated on page 155) unless the head is tilted. The line between the upper and lower lips is the most important shape to get right when drawing a mouth; similarly, the shapes of the eyebrow and the eyelid are distinguishing features. But it's the relationships between facial features that are key to likeness — the location of the eyes is more important than the shape of the eyes.

The great caricaturists from Daumier to Hirschfeld exaggerate facial features, either for humour or satire, but we have to recognize their subjects instantly — these artists know how to achieve a solid likeness before distorting it. Caricaturists pay particular attention to the shape of the skull, to get the basic bone structure right, before moving on to details of individual features.

This leads us to the threshold of big questions of individual style and expression. An expressionistic drawing can convey more about a person than a perfectly proportioned face. Great artists go beyond mere likeness to reveal psychological depth and character of the sitter. The stark, unnerving portraits of Lucien Freud, for example, hint at profound and disturbing feelings (no surprise, perhaps, as his grandfather was Sigmund Freud).

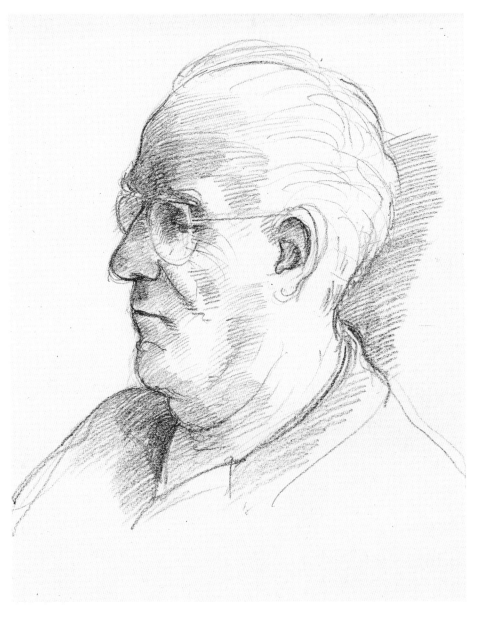

Scott McKowen, *Frank McKowen*, the artist's father, drawn from life at age 83, China marker, 2006.
Ten-minute portraits, clockwise from top left: *Andrea, Kat, Emily, Alex, Catarina* and *Yoyo*, 2020–21.

Life drawing lays a foundation for drawing the people around you every day. Drawing in public teaches you how to work quickly — you have only a few moments to capture gesture and likeness. I try to be inconspicuous — I don't want anyone to feel uncomfortable if they sense I'm watching them.

Scott McKowen, *Marge*, gel pen, 2015.

I drew my 86-year-old mother's hand, in mine, on the day she died.

Scott McKowen, *Christina*, drawn while she was at her easel working on a painting of her own, 2020; studies of customers browsing in a New York City book shop, 2017; a fellow passenger on a five-hour bus ride from Budapest to Trieste, 2017; Peter Sanagan, a young Toronto chef who had just opened a tiny butcher shop in Kensington Market in 2010.

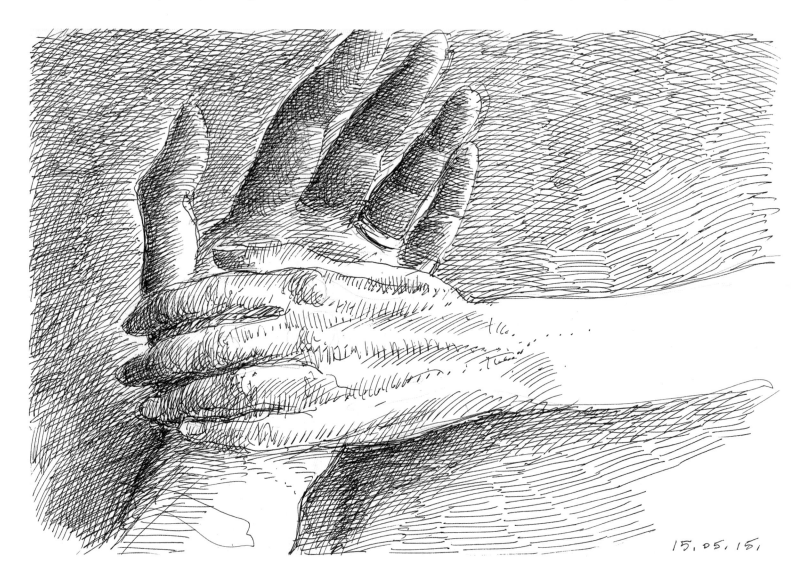

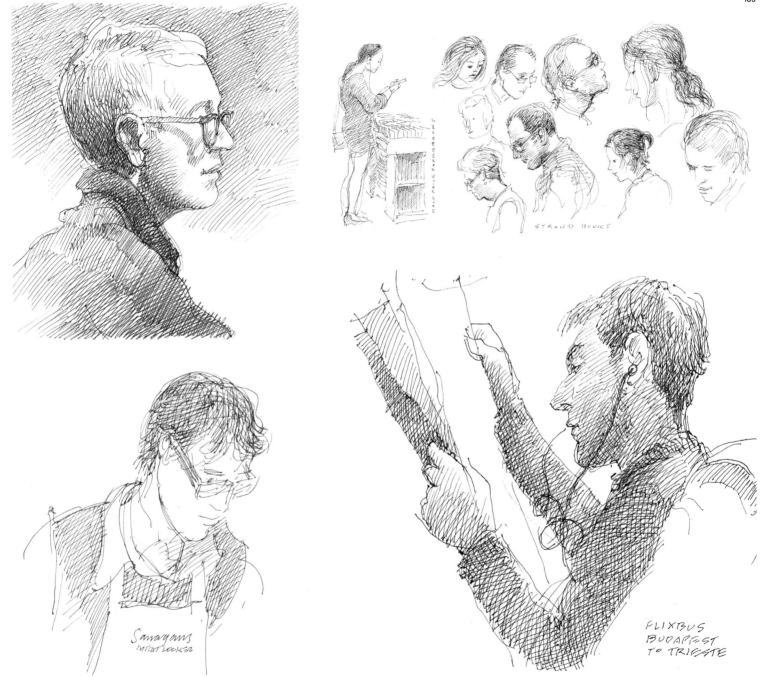

STRAND BOOKS

HALF PRICE PAPERBACKS

Samarans
MEAT LOCKER

FLIXBUS
BUDAPEST
TO TRIESTE

Scott McKowen, *Chess Corner*, Jardin du Luxembourg, ink, 1991.

Exploring the Luxembourg Gardens on my very first visit to Paris, I discovered "chess corner." The competitors were mostly older men, but this was serious blitz chess — there were time clocks. They were so intensely focused on their game that they paid absolutely no attention to a tourist drawing them.

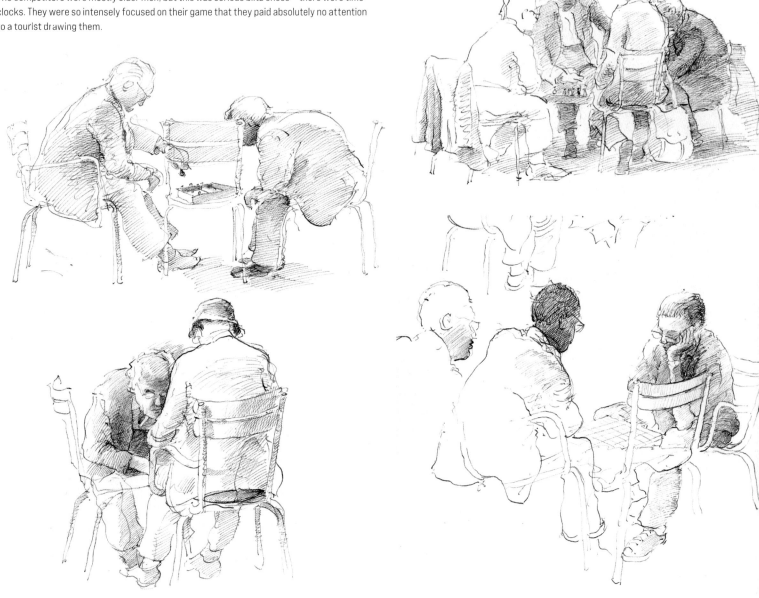

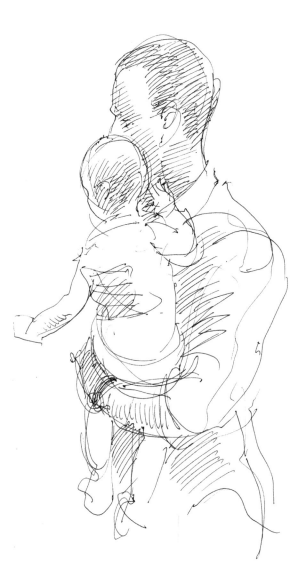

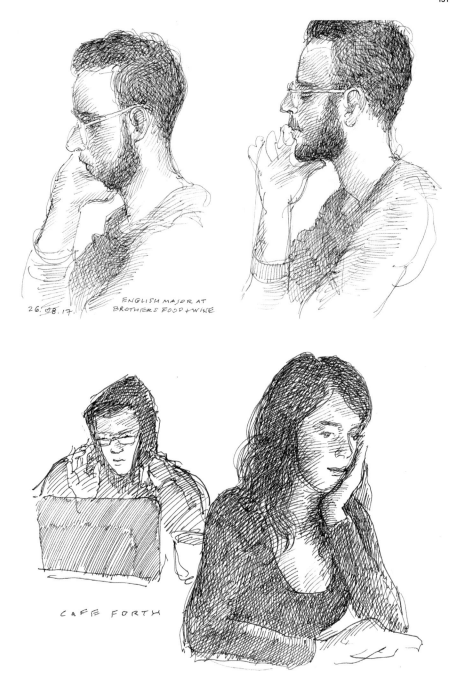

ENGLISH MAJOR AT
BROTHERS FOOD + WINE

26.08.17.

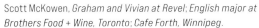

CAFE FORTH

Scott McKowen, *Graham and Vivian at Revel*; *English major at Brothers Food + Wine, Toronto*; *Cafe Forth, Winnipeg*.

A few surreptitious sketches made in hotel lobbies and cafés where it's easy to sit near people who are focused on a book or a phone or a conversation. I try to remain inconspicuous, but sometimes get caught — the couple at Cafe Forth in Winnipeg got up to leave and asked, "were you drawing us?" (They loved the drawing, thankfully.)

FOLGER CONSORT

AMHERST EARLY MUSIC FESTIVAL

ROBERT

sir Henry Umpton's Funeral John Dowland

Tobias Hume
POETICAL ~~DOUG~~ MUSICKE

DOUG

THE LOWEST TREES HAVE TOPS FROM DOWLAND'S THIRD AND LAST BOOKE OF SONGS OR AYRES

"TABLE BOOK"

Stingo, Or the Oyle of Barly

Longwayes for fix

OBERON THE FAIRY PRINCE MASQUES

TENOR

SOPRANO

BASS

To the Ingenius Reader

Scott McKowen, sketches and notes made during a lecture demonstration by musicians of the Folger Consort from Washington, D.C., gel pen, 2014. The Folger Consort performed in Stratford in 2014 to commemorate Shakespeare's 450th birthday.

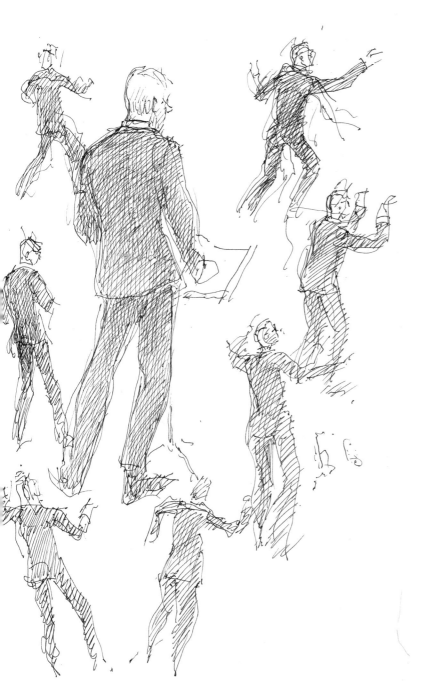

Scott McKowen, *Ivars Taurins*, gel pen, 2015; *Angela Hewitt*, gel pen, 2018.

Ivars Taurins is the conductor of the Tafelmusik Chamber Choir in Toronto, one of my very favourite ensembles. Ivars is a highly physical leader; his body language expresses a wide range of nuances that he is able to draw from his musicians — which makes him great fun to draw during concerts!

The great Canadian pianist Angela Hewitt played Bach's complete *Well-Tempered Clavier* in a concert presented by Stratford Summer Music.

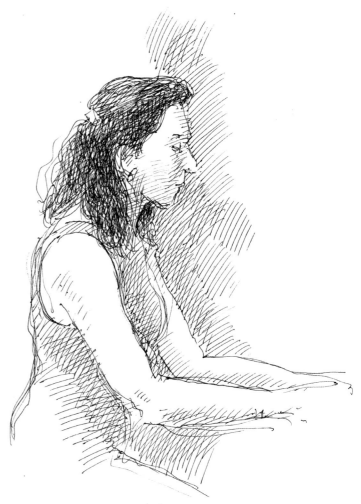

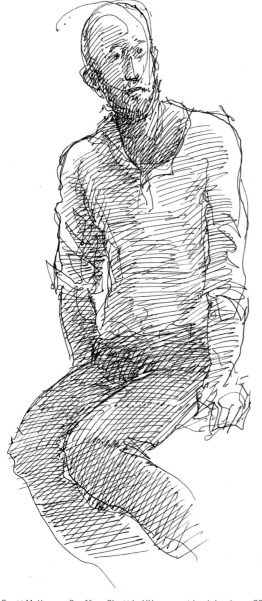

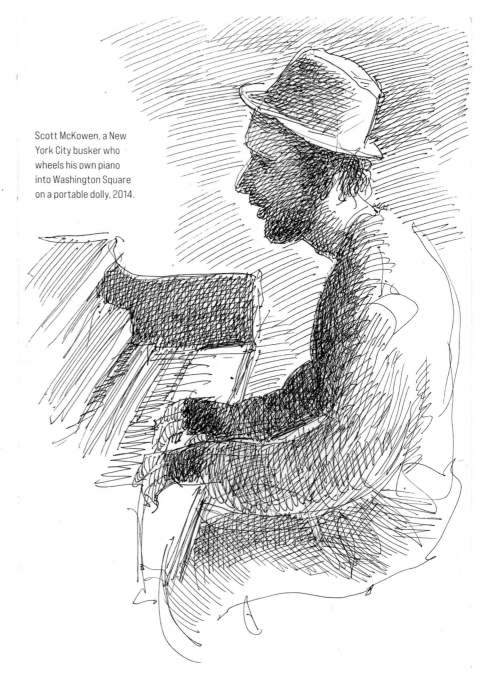

Scott McKowen, a New York City busker who wheels his own piano into Washington Square on a portable dolly, 2014.

Scott McKowen, Geoffrey Sirett in *L'Homme et le ciel*, gel pen, 2014.

Baritone Geoffrey Sirett performed in Stratford with Bicycle Opera Project, a company that tours contemporary opera across Ontario.

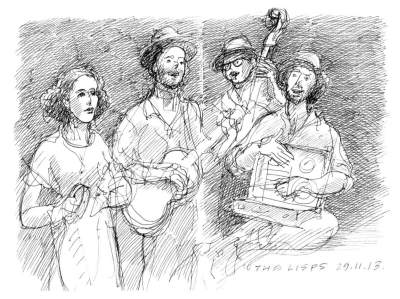

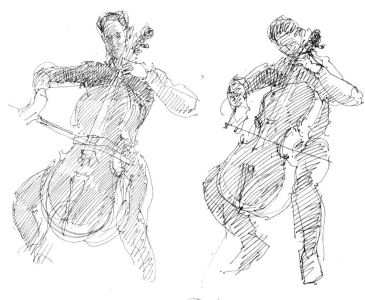

Scott McKowen, indie rock band The Lisps, who composed and performed music for the Public Theatre's 2013 production of Brecht's *The Good Person of Szechwan* in New York.

Scott McKowen, studies of cellist Stéphane Tétreault, in a 2017 Stratford Summer Music performance.

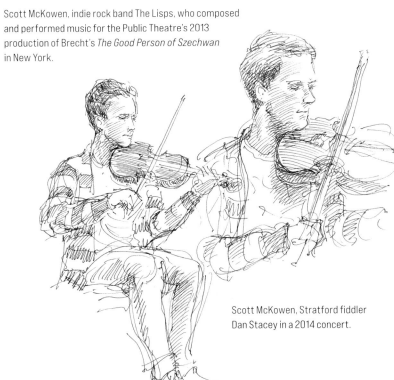

Scott McKowen, Stratford fiddler Dan Stacey in a 2014 concert.

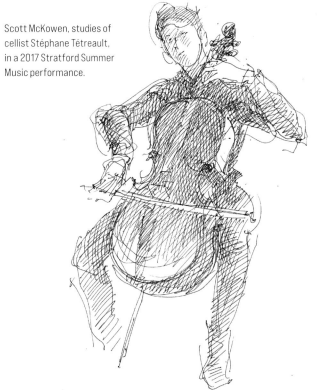

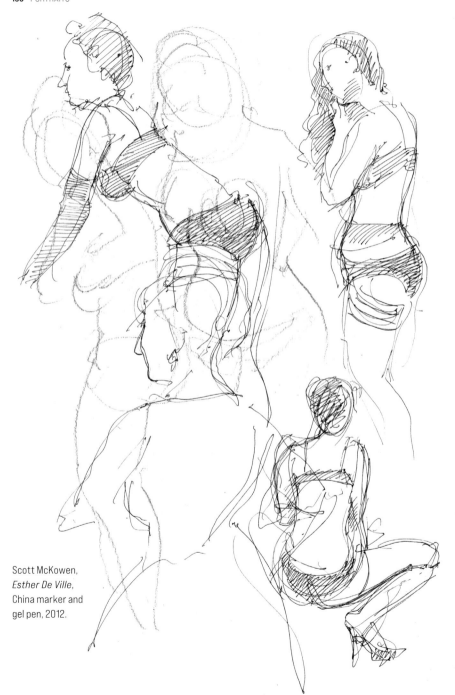

Scott McKowen,
Esther De Ville,
China marker and
gel pen, 2012.

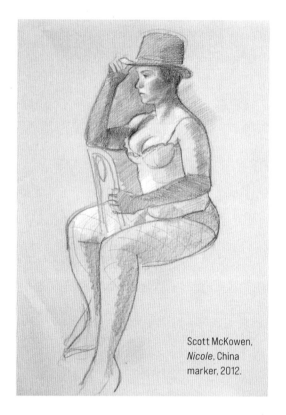

Scott McKowen,
Nicole, China
marker, 2012.

You have to be on your toes to draw live performers.
I asked and was given permission to draw backstage,
in the dressing room, during a burlesque show in
Stratford. It was a whirlwind — costumes thrown
on so quickly (to come off onstage) that I had only
moments to capture the behind-the-scenes buzz.

Anna Atkinson, a singer, songwriter and multi-
instrumentalist, played the title character in *Fiddler
on the Roof* at the Stratford Festival in 2013. I invited
her to the studio and draw her while they while she
played. I wondered about "freezing" the action of her
bow arm — but because bowing involves a limited,
repeated range of motion and I found that it was not
difficult to isolate a single point while she was playing.

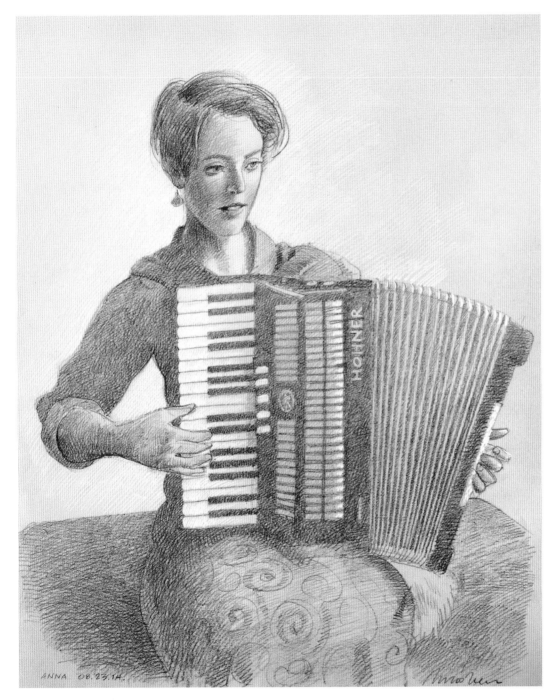

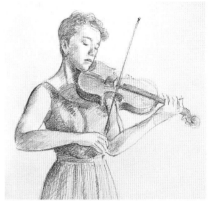

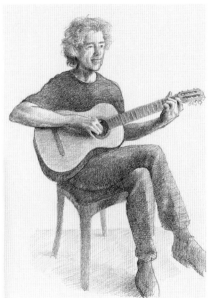

Scott McKowen, Anna Atkinson, accordion and viola; George Meanwell, guitar, China marker.

The accordion portrait, from 2014, was used as a poster for Stratford Summer Music's lunchtime concert series *Music at Rundles*, in which Anna was the featured artist.

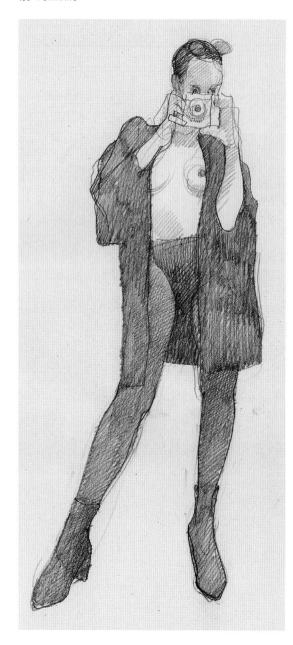
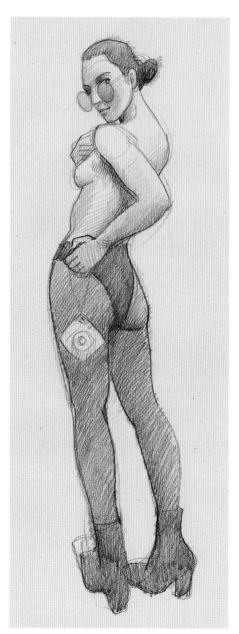
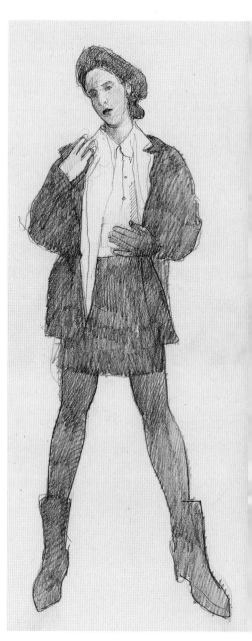

Scott McKowen, *Elena*, in a Zoom session inspired by the fashion photography of Helmut Newton, 2021.

Great life drawings can only happen with great life drawing models. The model doesn't guarantee the quality of the drawing, of course, but it's the prerequisite for a good collaboration. I like to know something about the person I'm drawing, but that's not always possible. I have a comfortable familiarity with the models I work with in my local live-in-the-same-room drawing group (and favourites, of course); as of this writing we're still on hiatus because of the pandemic. Drawing sessions via Zoom have provided incredible opportunities to work with the best models from around the world, but it's sometimes the first and last time you will draw this person.

Modelling obviously requires extraordinary body awareness and self-confidence — and a surprising amount of physical strength and stamina to hold a pose for 15 or 20 minutes or longer, especially if there's an upraised arm or leg or a twist to the body. Not surprisingly, the best models are often dancers or actors. I have drawn circus performers. I have drawn burlesque artists. Some models are full-time professionals who can make a living working for art schools and universities. Most are yoga instructors, carpenters, college students, hairdressers, mechanics or retired teachers. I have drawn models of all ages, colours, shapes and sizes — the common denominator seems to be an enviable sense of body positivity and an interest in creativity and being part of a creative process.

I know many models who are artists themselves, equally comfortable on either side of the easel. I'm sure that the two disciplines are complementary on some level — if you draw, you surely have an instinct for poses that make an interesting drawing.

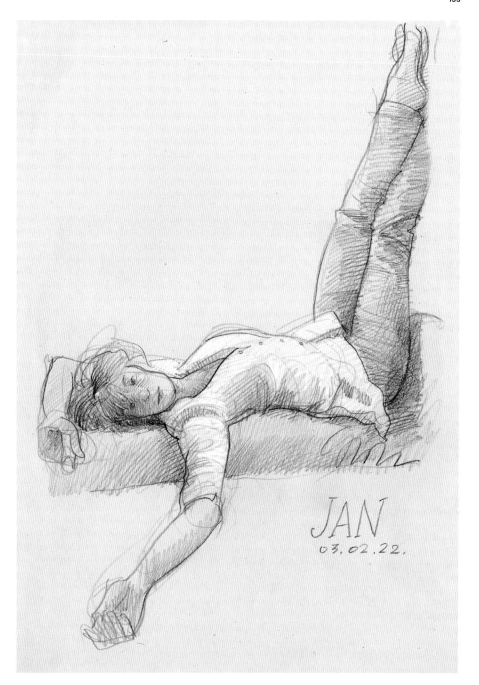

Scott McKowen, *Jan*, coloured pencil, 2022. This welcome sitting was one of my first, live in the same room with the model, after two years of the pandemic.

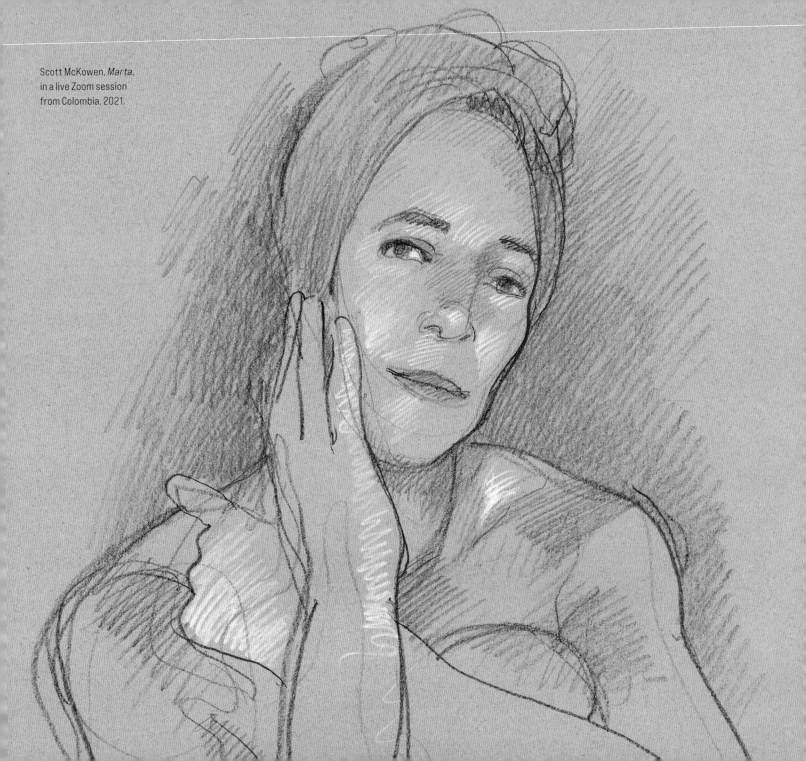

Scott McKowen, *Marta*,
in a live Zoom session
from Colombia, 2021.

Scott McKowen, *Big Sue*, coloured pencil, 2022.

Deryck Henley occasionally offers special portrait sessions for the Scottish Borders Life Drawing Club, outside of his regular three-hour Sunday sessions. In January 2022, we drew Sue Tilley in a live Zoom session from London — "Big Sue" famously modelled for Lucien Freud in several large-scale paintings. *Benefits Supervisor Sleeping* (1995) broke records when it was sold for over $33 million in 2008. We were encouraged to send Deryck questions for Sue, about working with Freud or other aspects of her colourful career. She is a fabulous raconteur and answered questions while we drew her — a few of her stories got animated enough that Deryck had to gently remind her not to move out of the pose!

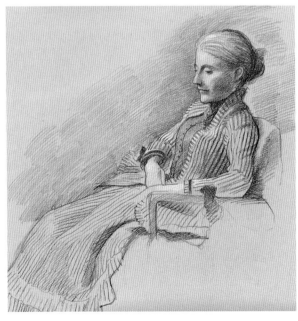

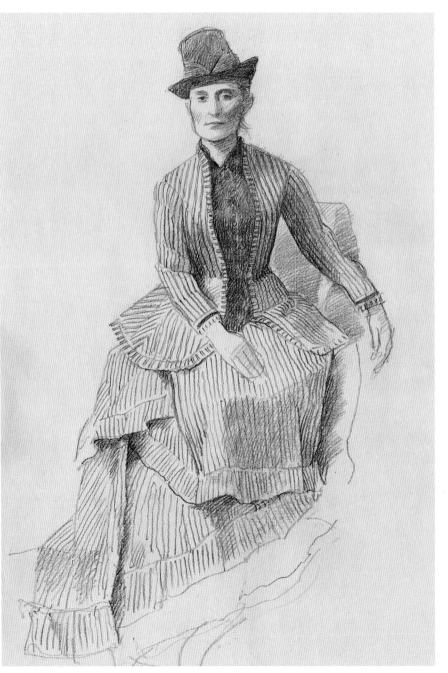

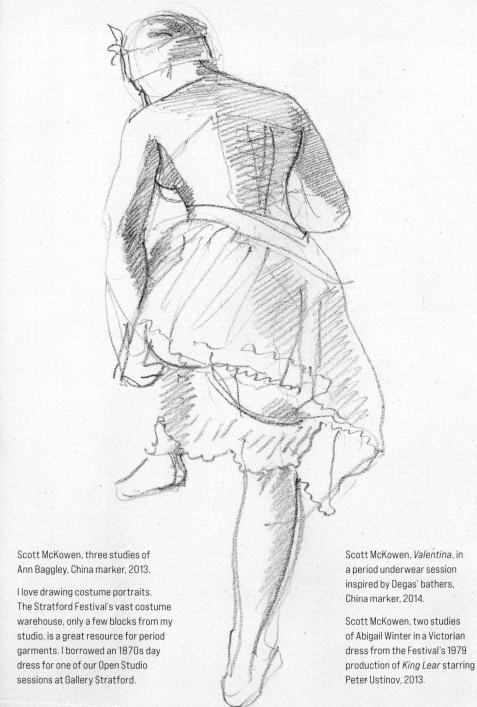

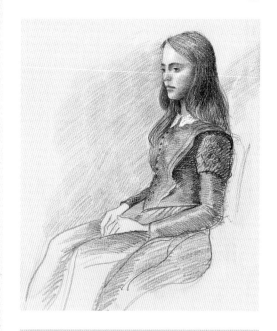

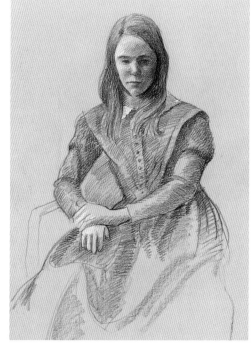

Scott McKowen, three studies of Ann Baggley, China marker, 2013.

I love drawing costume portraits. The Stratford Festival's vast costume warehouse, only a few blocks from my studio, is a great resource for period garments. I borrowed an 1870s day dress for one of our Open Studio sessions at Gallery Stratford.

Scott McKowen, *Valentina*, in a period underwear session inspired by Degas' bathers, China marker, 2014.

Scott McKowen, two studies of Abigail Winter in a Victorian dress from the Festival's 1979 production of *King Lear* starring Peter Ustinov, 2013.

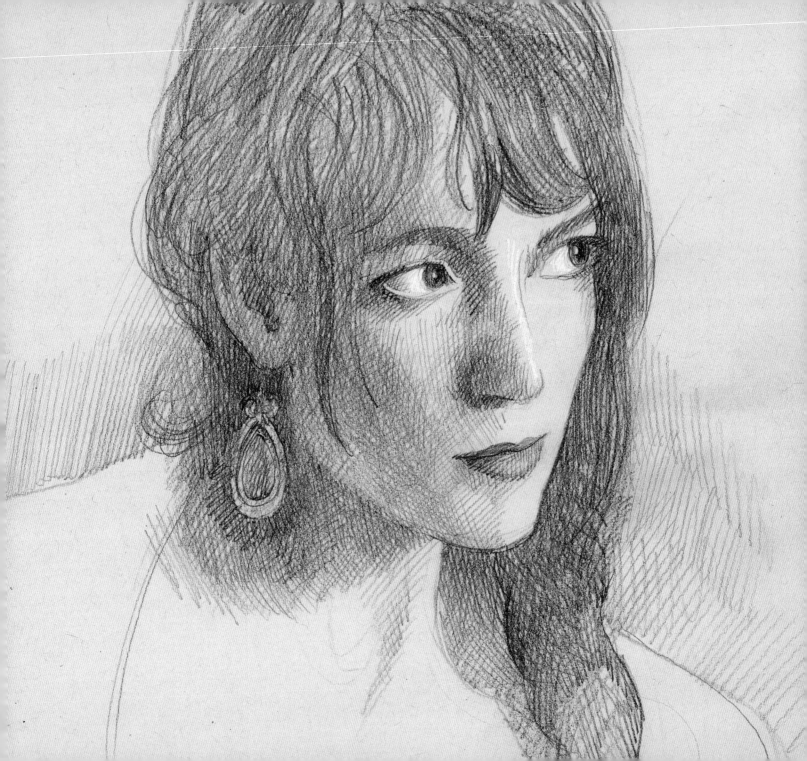

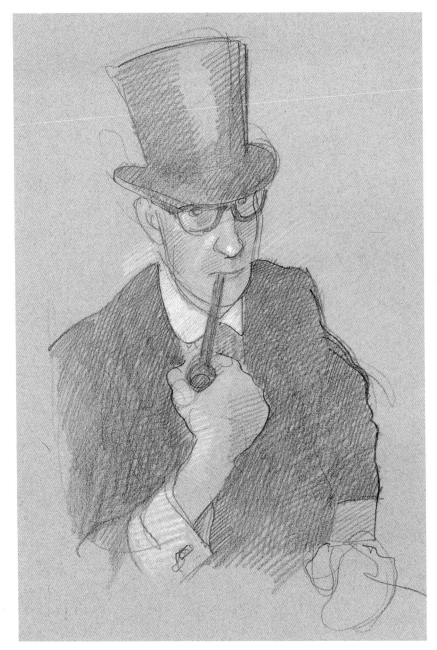

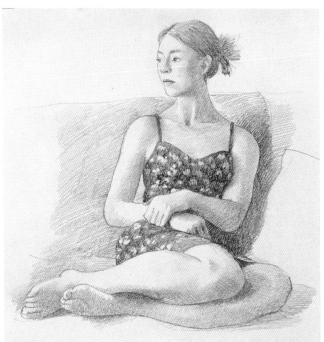

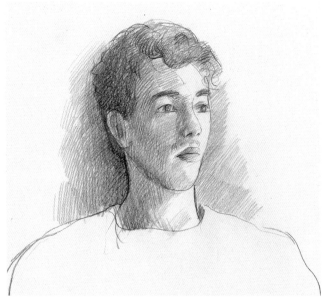

Scott McKowen, *Vilidian*, *Jerry*, *Evie* and *Sam*, coloured pencil, 2020–21.

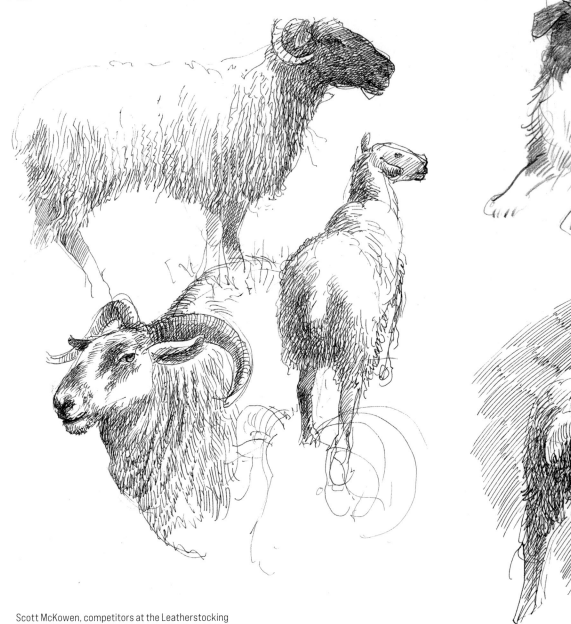
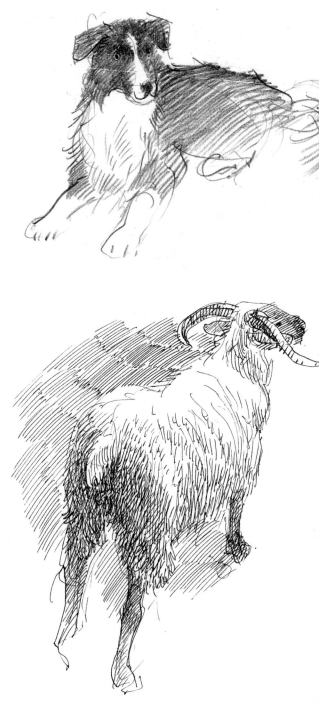

Scott McKowen, competitors at the Leatherstocking
Sheep Dog Trials, Cooperstown, gel pen and pencil, 2015.

Flora & Fauna

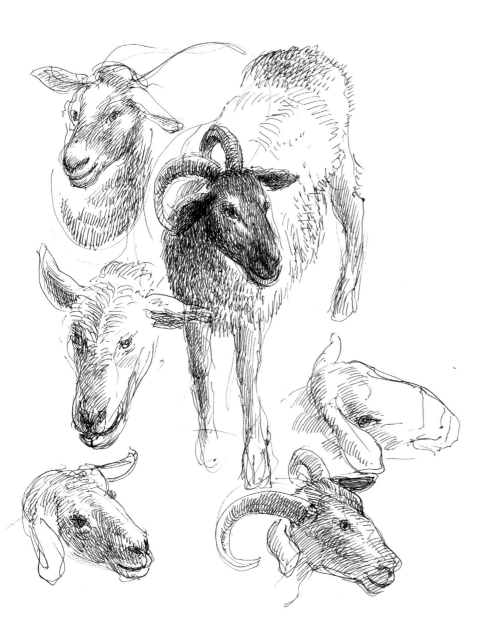

Henry Moore, *Head (Sheep Album)*, 1974, etching and drypoint (Art Gallery of Ontario).

We always tried to align our opera trips to Cooperstown, New York, with the weekend of the Leatherstocking Sheep Dog Trials. This is the Olympics for Border Collies from across the Northeastern U.S. and Canada — the dogs are required to herd a trio of sheep from the top of a hill, through an obstacle course of gates and posts and into a pen beside the dog's handler at the bottom of the meadow, all with a clock running.

While Christina cheered on these talented contestants, I found myself drawn to the sheep in their holding pens. I happily filled several sketchbook pages with Scottish Blackface sheep from various angles. I have an old Thames & Hudson facsimile edition of *Henry Moore's Sheep Sketchbook*, published in 1972. Moore's studio in Hertfordshire was surrounded by fields full of sheep. They would wander up close to the windows and Moore become fascinated by them. He could tap on the window and they would stop and look at him, "sheepishly" standing still for five minutes — long enough to draw them. Not surprisingly, many of the ewes and lambs in their various configurations resemble Moore sculptures.

LINK

Scott McKowen, *Link*, coloured pencil, 2021.

Link is a year-and-a-half-old English Mastiff who lives next door;
I have never quite trusted dogs that look as scary as Link but it turns
out that he's very well trained and a completely charming fellow.

Scott McKowen, studies from the Reptile House at the Jardin des Plantes in Paris: a Varan (Monitor Lizard); Tortoises; and a Crocodile du Nil, ink, 2004.

I adapted this fellow into a scratch-board illustration for the Crocodile in J.M. Barrie's *Peter Pan* — my pencil sketch for that version is reproduced on page 15, with the swallowed clock visible inside.

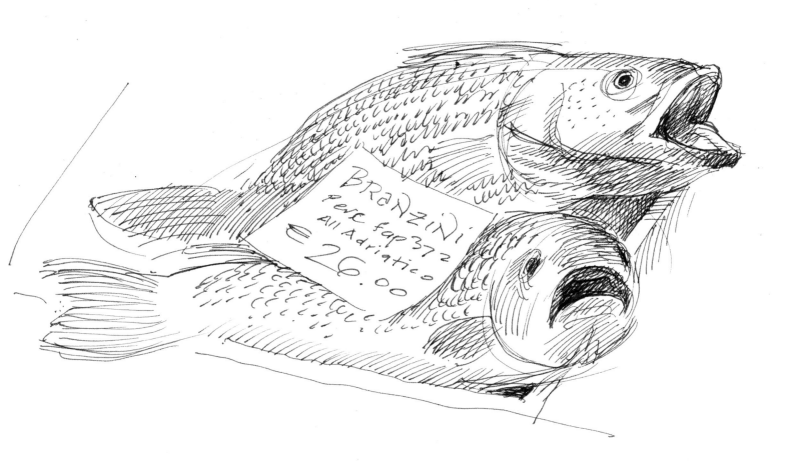

Scott McKowen, four sketches of fish in Italian markets, gel pen and Pigma Micron pen, 2012 and 2015.

Fish markets are full of great characters to draw — the busy fishmongers never stand still but their produce (on ice) are stationary, still with expressions of surprise on their little faces. These are quick sketches done standing up amidst crowds of shoppers — I'm balancing my sketchbook with one hand, so I use a portable marker rather than pen and ink. Shoppers are focused on their dinner menus and rarely notice a guy hovering nearby, drawing. I found the long, silver, ribbon-like *Sciabolao Bandiera*, known as a "Flagfish" (or sometimes a "Sabrefish"), at the Mercato Centrale in Florence. The blue *Sgombri* (Mackerel) and the *Branzini* were at the fish market in Venice, fresh out of the Adriatic that morning.

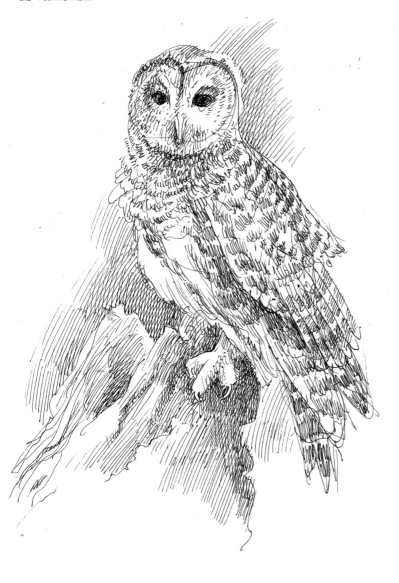

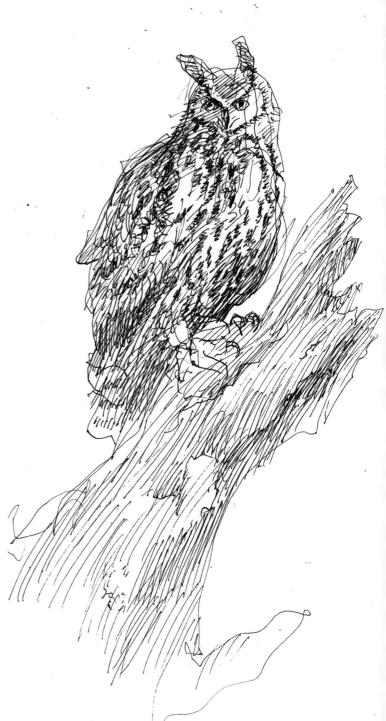

Scott McKowen, *Barred Owl* and *Eagle Owl*, sketched from life during a workshop for a small group of photographers at the Canadian Raptor Conservancy, gel pen, 2020.

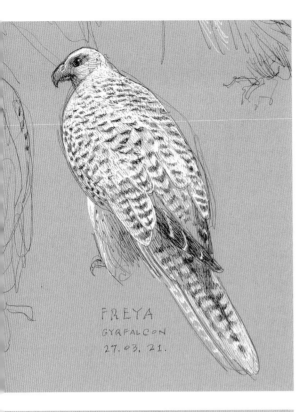

FREYA
GYRFALCON
27. 03. 21.

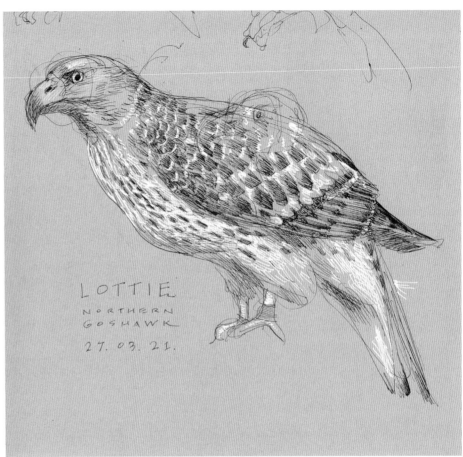

LOTTIE
NORTHERN
GOSHAWK
27. 03. 21.

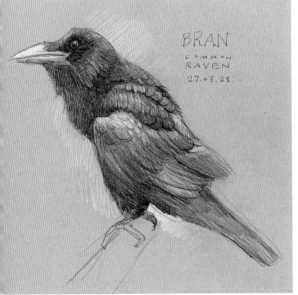

BRAN
Common
RAVEN
27. 03. 21.

Scott McKowen, *Freya*, a Gyrfalcon, *Lottie*,
a Northern Goshawk, and *Bran*, a Common
Raven, were the models in a live Zoom drawing
session from Lloyd and Rose Buck's bird
sanctuary near Bristol, in the U.K., 2021.

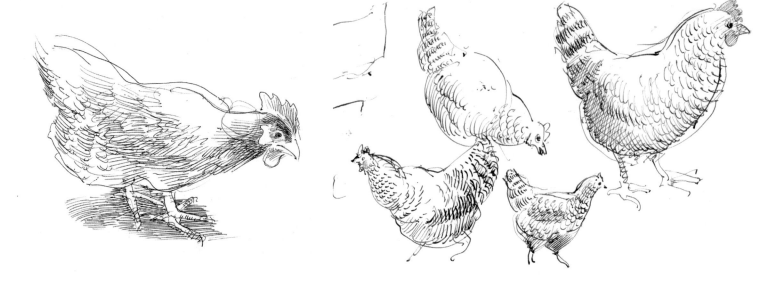

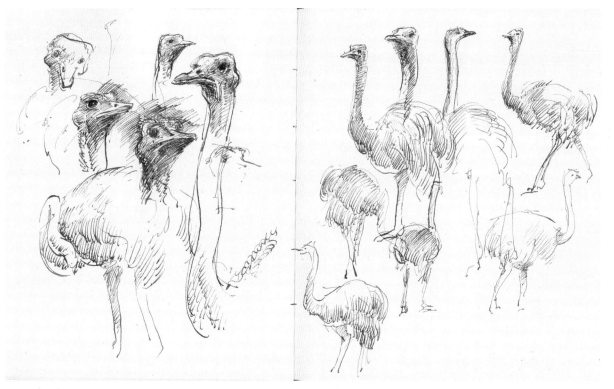

Scott McKowen, *Chickens*, Cooperstown, New York, 2005, and *Ostriches*, Jardin des Plantes, Paris, 2007.

I'm always sad to find a dead bird, but it's an opportunity to study them up close by drawing them. Shakespeare reminds us in *Hamlet*, "There is special providence in the fall of a sparrow." They are a *memento mori*. Here are a *Junco*, a *Bay-Breasted Warbler*, and two views of a *Swainson's Thrush*.

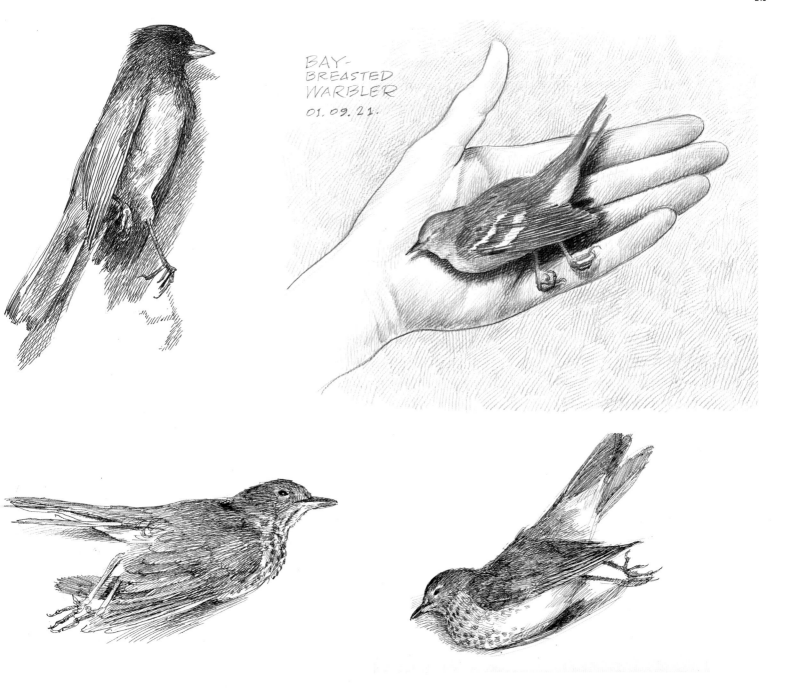

BAY-
BREASTED
WARBLER
01. 09. 21.

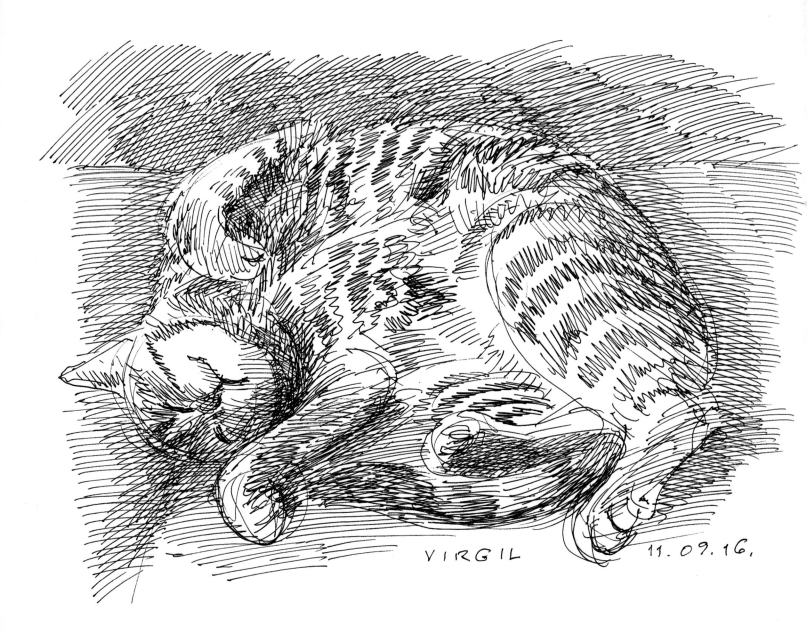

VIRGIL
11.09.16.

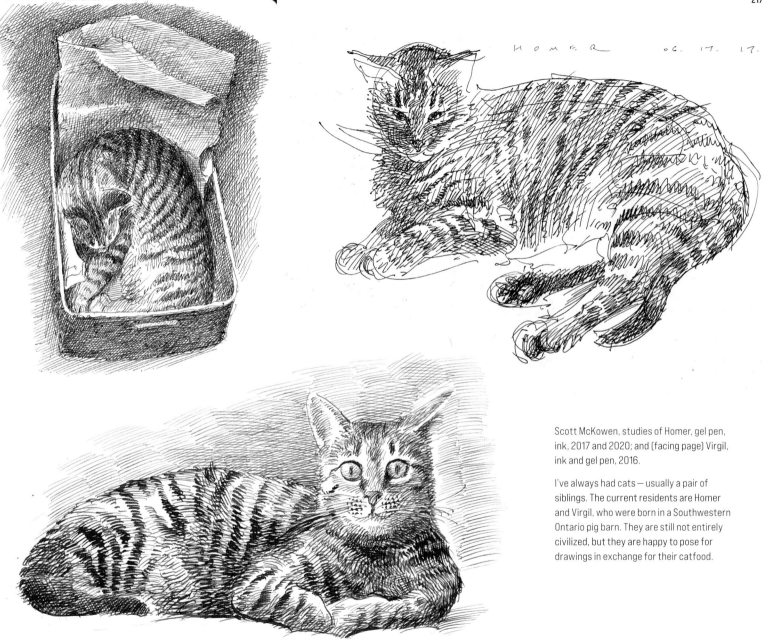

HOMER 06. 17. 17.

HOMER 06.06, 20.

Scott McKowen, studies of Homer, gel pen, ink, 2017 and 2020; and (facing page) Virgil, ink and gel pen, 2016.

I've always had cats — usually a pair of siblings. The current residents are Homer and Virgil, who were born in a Southwestern Ontario pig barn. They are still not entirely civilized, but they are happy to pose for drawings in exchange for their catfood.

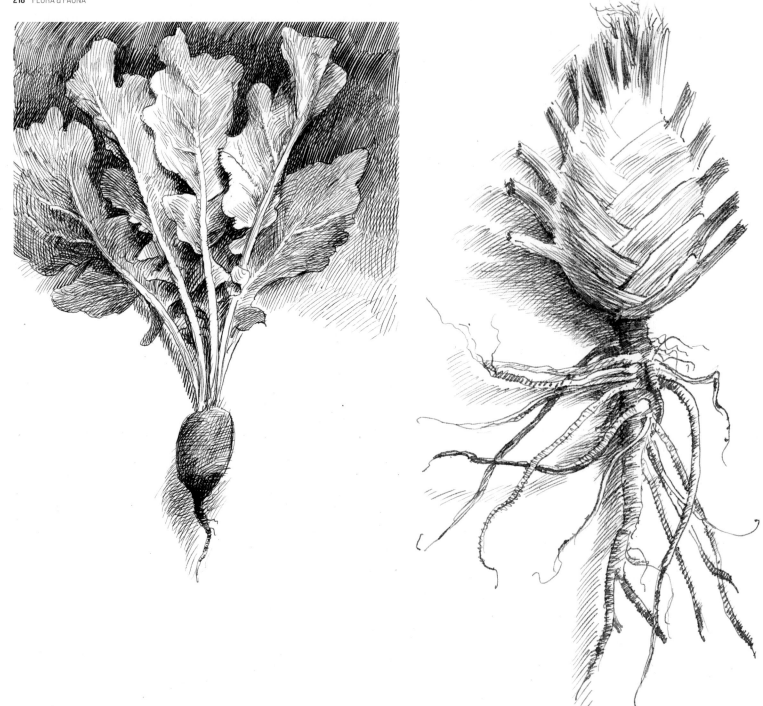

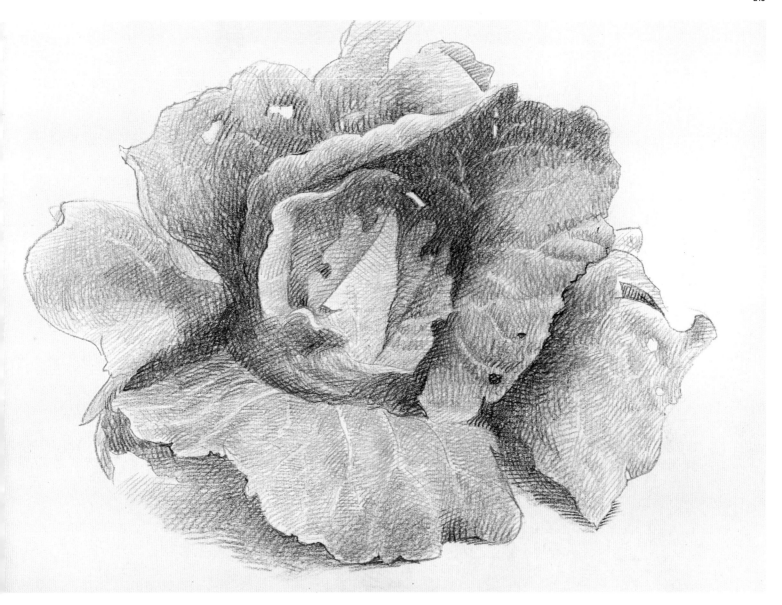

Scott McKowen, *Radish*, ink, 2020, and *Fennel*, ink, 2008.

We are blessed with abundant organic produce from our friends
Antony and Tina at Soiled Reputation, their farm north of Stratford.
Their vegetables are as beautiful to draw as they are to eat.

Scott McKowen, *Cabbage*,
China marker (two shades
of blue, and black), 2020.

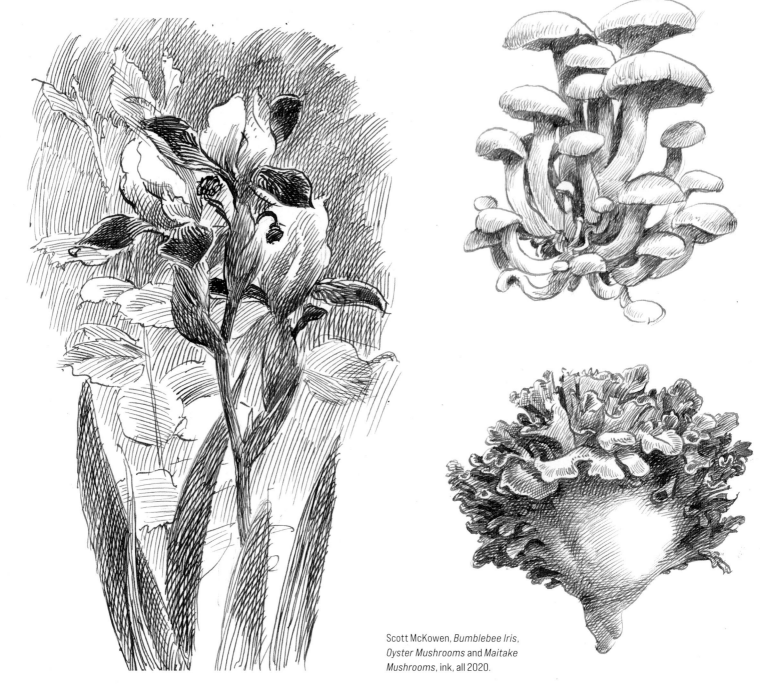

Scott McKowen, *Bumblebee Iris*, *Oyster Mushrooms* and *Maitake Mushrooms*, ink, all 2020.

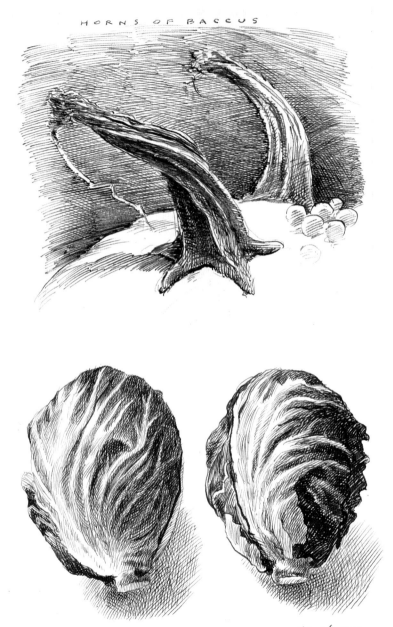

HORNS OF BACCUS

22.06.20.

Scott McKowen, *Radicchio*, ink, 2020.

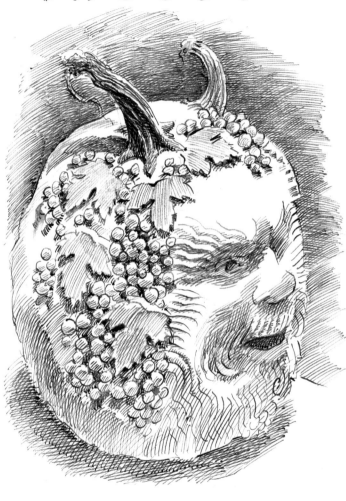

BACCUS

HALLOWEEN 2004

Scott McKowen, two ink drawings of my Halloween pumpkin, 2004. I carve features into the thick flesh of the pumpkin — *Baccus* was augmented with grapes made with a melon-baller and attached with toothpicks. The grape leaves were left with the dark orange skin of the pumpkin for contrast. I transplanted the stem of a second pumpkin in order to give him two "horns."

USE
POSTAL CODE
UTILISEZ LES
CODES POSTAUX

CHRISTINA
24 WELLINGTON
N.º 7
STRATFORD

428 DOWNIE STREET
STRATFORD ONTARIO
N5A 1X7

CHRISTINA
PODDUBIUK
CITADEL
THEATRE
98 28 101A
AVENUE
EDMONTON
ALBERTA
T5J 3C6

Christina
Poddubiuk
24 Wellington
Stratford, Ont.
Canada N5A 2L2

WILDLIFE CONSERVATION

UNITED STATES POSTAGE 3

PLEASE MAIL
EARLY FOR
CHRISTMAS

MISS CHRISTINA

Poddubiuk
469 RONCESVALLES
APT. N.º 302
TORONTO
ONTARIO
CANADA
M6R 2N4

CHRISTINA EMERGES UNSCATHED FROM ANCIENT ROME

JVLIVS CAESAR XVI. VIII. MMXVIII.

IT ONLY FEELS LIKE AN ETERNITY...

21 HAPPY YEARS

HAPPY ANNIVERSARY 22 JUNE 2007

EPHEMERA

CONGRATULATIONS DAAHLING!

XO — SOLOMON ISSACS

CHRISTINA MARIA QUEEN OF SCOTTS

Anno Domini 2007

WHEN WILL YOU EVER LEARN NOT TO LOOSE YOUR HEAD OVER WORK...

SOUL PEPPER PROPS DEPT.

HAPPY OPENING AND HAPPY BIRTHDAY

BE MINE!

HAPPY V-DAY 2013 LOVE S.

As a graphic designer I love printed ephemera — letters, cards, invitations and announcements, change of address notifications and especially Christmas cards. Christina has received a hand-drawn card on opening night of every show she designed since I've known her. Years ago I amused myself (and hopefully the recipients) with illustrated envelopes — often inspired by the stamp. Here are a few of these frivolities.

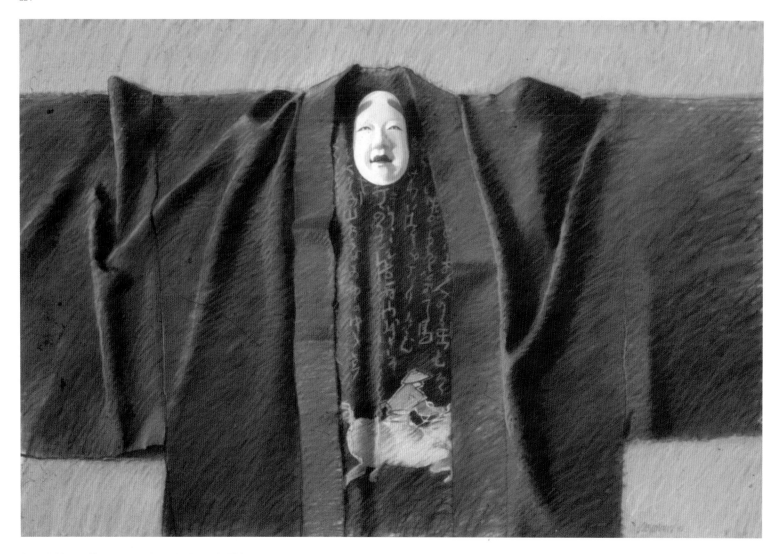

Scott McKowen, *Kimono and Noh Mask*, oil pastel, 1984.

THE ROAD AHEAD

I'm still trying to figure out my ideal drawing medium. I love scratchboard for illustration but it's rigourous and takes too long for spontaneous drawing. For the travel sketchbooks, I draw mainly with pen and ink. I prefer something softer and more flexible for life drawing; most of the examples in this book are coloured pencil — Prismacolor or Derwent, *Polychromos* pencils from Faber Castell or the excellent (and more expensive) Caran D'Ache pencils from Switzerland. But hatching in darker tone in the background with fine pencil lines takes too long. CarbOthello pastel pencils from Stabilo allow a quick block in areas of colour (still hatched lines but they are easily blended with a rag), but then there are compatibility issues — wax or oil based pencils don't blend well over chalk pastel. I like Cretacolor pencils from Austria — their *Sanguine* pencils come in dry or oily formulations. And there's conté in pencils and sticks and good old General's charcoal pencils. I'm almost embarrassed to admit that, for many years, I used China markers almost exclusively for life drawing — wax crayons wrapped in paper that peels away in spiral ribbons — they're dirt cheap, they sharpen beautifully and I can remember when it was easy to obtain three different shades of red. I like working on mid-toned paper because you can add both highlights and shadows to achieve subtle (or dramatic) lighting effects quickly and easily.

In the 1980s and '90s, I worked in oil pastel on larger paper. Many were poster illustrations but some were still life compositions set up from my modest collection of *objet d'art*. The kimono on the facing page is one of my favourite pieces from that period — the centre front opening reveals a glimpse of calligraphy and a monkey on horseback painted on the silk lining inside the garment. It's a large piece — as close to a painting as I've come — but it's still a drawing both in concept and execution. Every hatching line is still visible, even where I scumbled them together with a brush and some turpentine to build up areas of tone. I placed a very old and beautifully detailed ceramic *Noh* mask inside the jacket collar, which creates a surreal shift in scale. The head is far too small for this body, or else it's a coat made for a giant — either way it conveys an almost mythical sense of character. There are a couple of transformations here. The finished work has a physical presence greater than the sum of its parts. It somehow moves beyond a drawing exercise of a mask and an article of clothing and becomes art.

Looking back at *Kimono and Noh Mask* reminds me that I'm also still trying to figure how best to apply my drawing skills to projects that will give me the most satisfaction. My studio is constantly busy with illustration assignments — I'm 66 as I write this and truly gratified that my phone keeps ringing because there are so many younger, cooler illustrators out there. *Communication Arts* invited me to Palo Alto in 2012 to be a juror for their prestigious Illustration Annual — an experience that gave me a fresh appreciation for the depth of the talent pool in my field, and reminded me how much I enjoy being part of this community.

Someone recently asked what I would draw if I didn't have illustration deadlines — and I didn't have a ready answer. My finished drawings involve problem solving for assigned subjects; it's a different order of magnitude to make drawings that express your personal ideas and intentions. I need to figure out what the concepts are that I want to explore. One is limited only by one's imagination. And maybe by time. If there was a silver lining to the pandemic, it was having more time than usual to draw (with no graphic design work in the studio). I hate to lose the ground I've gained so I plan to wind down the design work, to make more time to focus on my drawing.

Where is the optimal balance between a loose, fluid drawing with a sense of freshness and vitality, and the tight, carefully observed shading that defines the nuances of surfaces — and can the two coexist in the same drawing? Why are some drawings beautiful, even though they are far from "correct" (in the sense of being accurate) — while others, carefully observed with eyes and nose perfectly placed, are mere exercises and kind of boring? Can a disciplined, controlled person be a great artist? There are no definitive answers, of course, but these are the types of questions that keep us replenishing our art supplies.

INSPIRATIONS

How *I* draw, I hope it's clear by now, is only one of many different approaches. Every artist has to develop their own visual language. In the past, there were established traditions that an artist could either embrace or rebel against. Artists today can do whatever they want — but figuring out influences that might be helpful depends on personal tastes and ambitions. This is a complex and evolving process, not without anxiety. It's very important to look at a range of other artists' drawings — not to copy, of course, but to learn from others' mistakes and successes. I wanted to acknowledge a few of the artists whose drawings have been a personal inspiration to me.

I often think my wife draws with more style and clarity than I do. CHRISTINA PODDUBIUK is a costume and set designer in theatre. Every visual element the audience sees on stage in one of her productions started out as a drawing. Her costume sketches communicate the shape, cut and historical period details to the cutter or tailor constructing the garment. A Shakespeare play can easily have over a hundred costumes — Christina gives each one a vivid sense of character on paper, as well as drafting scenery and drawing the furniture, masks, wigs and props required. She knows me better than anyone, and I'm enormously grateful for her patient help in editing both the visual and verbal content of this book.

I met KEN NUTT soon after moving to Stratford in 1980, at the weekly Open Studio life drawing group he had started that same year. We have been setting up our easels side by side every Wednesday evening for four decades now. Ken's brilliant draughtsmanship is central to his two parallel careers — fine artist and award-winning illustrator under the literary pseudonym Eric Beddows. His work is always astonishing both in its imagination

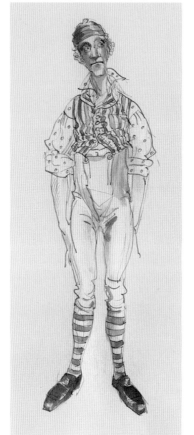

and its execution. I have always relied on his valuable advice, and I treasure his friendship and support .

I have dedicated this book to the memory of TONY URQUHART, one of Canada's most illustrious and prolific artists, who died in January 2022. His seven-decade career encompassed abstract painting, watercolour, collage and sculpture — from bronzes to his iconic boxes with complex hinges that open, close and allow the viewer to turn these three-dimensional spaces inside-out. Yet Urquhart acknowledged that his single constant over the years was drawing. When the MoMA reopened after its massive 2004 renovation with an exhibition revisiting and re-evaluating the permanent collection, they included Urquhart drawings purchased in 1961 — Tony was invited to the opening and they rolled out the red carpet for him. Tony's drawings combine meticulous classical draughtsmanship (his calligraphic precision makes me think of Dürer) with the abstract sensibility he brings to his paintings. Whatever the subject, Urquhart transformed it through his drawing into "something rich and strange." I have his drawings framed in every room in our house for daily inspiration. Tony, in his mid-eighties, had been suffering from dementia and his daughter, Emily Urquhart, has written a beautiful memoir about creativity in old age, *The Age of Creativity: Art, Memory, My Father, and Me.*

In my introduction to this book, I quoted Milton Glaser's wise observation that you have to learn to draw accurately before you can start to draw expressively. FRANK GAMBINO's drawings achieve a perfect synthesis of these two ways of working. He observes physical details with masterful authority (everything is in precisely the

Christina Poddubiuk, *The Fool*, costume
sketch for a production of *Robin Hood*
at the Citadel Theatre, Edmonton, 1991.

Ken Nutt, *OAX*, pencil
on paper, 1992.

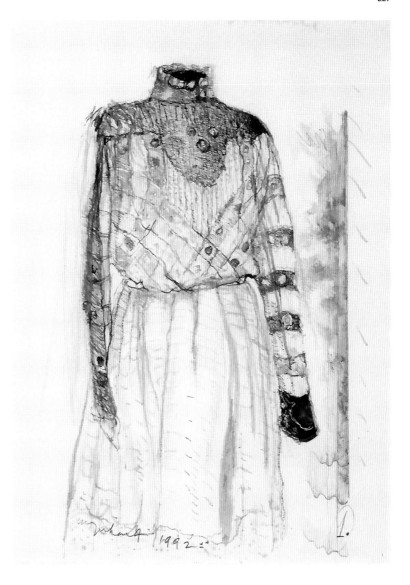

Tony Urquhart, *Grandmother's Dress*,
ink and ink wash on cream paper, 1992.

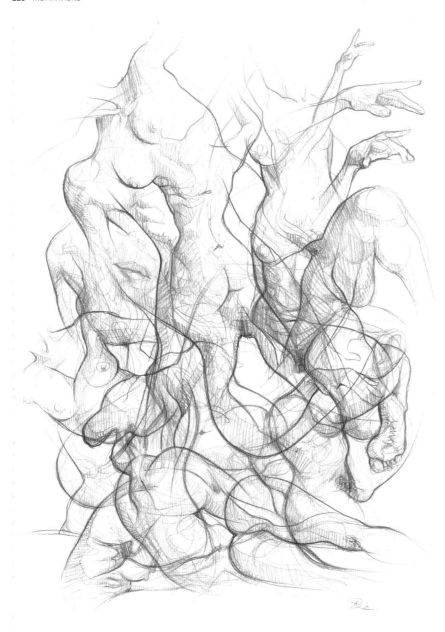

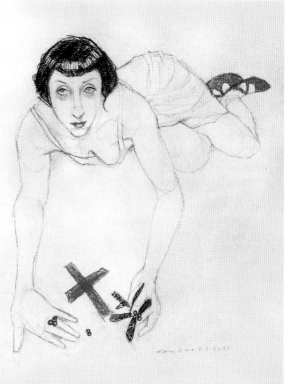

Sandro Kopp, *Bodyweb Daniela*, 2020; Curtis Holder, *George*, coloured pencil, 2020; Frank Gambino, *Emily Metalskin*, 2021.

right place), and at the same time he conveys a vivid sense of the personality of each model. Frank teaches drawing in London, U.K. I have watched a few of his online tutorials, which are full of great advice and useful techniques. In a recent interview, Frank noted that his students are often worried about making mistakes — yet it never occurs to them that "back to the drawing board," a phrase that sums up the familiar daily regimen of many artists, is all about trying again. "The problems are usually more from what's going on in your head than what you're doing with your hands." In other words, the mistakes are usually misunderstandings between what you see and what you think you see. Frank's goal as a teacher is to give students the confidence to see in their own drawings what is needed. "The work itself will tell you what to do."

I discovered Zoom life drawing sessions in 2020 when drawing from models who were in the same room became impossible. Everyone shares their work on social media and I soon noticed the exquisite draughtsmanship of SANDRO KOPP. It was appropriate to meet Sandro online because he had pioneered portrait painting and life drawing from videochat conversations over a decade ago — long before anyone else was doing it. In his 2015 show *FeedbackLoop*, Kopp painted portraits of his subjects over Skype; then repainted each portrait several times, capturing more pixel distortion in each step until the original portrait was completely abstracted. That exhibition was featured in *The New York Times* Style Magazine.

Sandro was born in Germany, trained in New Zealand and is now based in the Highlands of Scotland. He is a process-based artist who happens to work figuratively (rather than just a figurative artist with a passing interest in conceptual knacks). He exhibits all over the world. His assured, sensitive lines describe the planes of the body with calligraphic spontaneity — the delicate highlights and shadows feel completely accurate and alive. Sandro makes this look easy, but this level of virtuosity comes from looking carefully and understanding exactly how those forms are turning in space and how they catch the light. His paintings are superb, yet in a 2016 interview Sandro describes himself as more of a draughtsman than a painter. Many of us draw multiple poses on a single sheet but Sandro turns this exercise into brain teasing "macro-organismic" compositions of breathtaking complexity. You can get happily lost trying to figure out how many bodies you're looking at. I find Sandro's work hugely inspiring.

CURTIS HOLDER's drawings are strikingly individual. He builds up tone with layers of coloured lines that fade in and out, creating movement and vitality. Holder's drawings were a revelation when I first saw them — his lines are always fluid, dancing across the page, bringing forms alive with kinetic energy. Holder describes his process this way: "I prefer to start every drawing with a conversation, an opportunity to glimpse into the mind of the subject, make a connection and shape an idea. My goal is always to translate their emotions and the mood of our encounter onto paper, along with my own feelings and observations. The marks I make respond to the moment. Sometimes a simple continuous line says everything, other times I build tone and depth with complex layers of colour, injecting spontaneous lines to emphasize form or emotional intent. Life is never still, so I use multiple marks to create movement and energy or to correct what the eye has misjudged. I rarely erase lines; they are all part of the story." Holder was born in Leicester and is based in London. He won the Sky Arts Portrait Artist of the Year in 2020, a national competition across the U.K.

The work of these artists, and many others, reminds me how much I enjoy drawing, how much I value being part of this community and how much I have yet to learn.

Sandro Kopp, *Eye Portrait.*

ADDITIONAL READING

Aristides, Juliette. *The Classical Drawing Atelier: A Contemporary Guide to Traditional Studio Practices.* Watson-Guptill Publications, 2006.

Aristides, Juliette. *Lessons in Classical Drawing: Essential Techniques from Inside the Atelier.* Watson-Guptill Publications, 2011.

Arnheim, Rudolf. *Visual Thinking.* University of California Press, 1969.

Gillett, David. "Why I prefer to travel with a sketch-book instead of a camera," *The Globe and Mail,* May 19, 2016.

Glaser, Milton. *Drawing Is Thinking.* Overlook Duckworth, 2008.

Loomis, Andrew. *Drawing the Head and Hands.* The Viking Press, 1956.

McPhee, Constance C., & Orenstein, Nadine M. *Infinite Jest: Caricature and Satire from Leonardo to Levine.* Exhibition catalogue, The Metropolitan Museum of Art, New York, 2011.

Noble, Guy. *Drawing Masterclass: 100 Creative Techniques of Great Artists.* Prestel, 2017.

Scheinberger, Felix. *Dare to Sketch: A Guide to Drawing on the Go.* Watson-Guptill Publications, 2017.

Spicer, Jake. *How to Draw: Sketch and Draw Anything, Anywhere.* Ilex, 2018.

Steinhart, Peter. *The Undressed Art: Why We Draw.* Vintage Books, 2005.

Urquhart, Emily. *The Age of Creativity: Art, Memory, My Father, and Me.* House of Anansi Press, 2020.

Scott McKowen, @*a.werewolf.muse*, in a live Zoom marathon session to raise funds for Ukrainan charities, 2022.

INDEX

Scott McKowen, *Let Them Eat Cake*, ink, c.1985. Advertising illustration for a dessert café in Stratford (closed long ago).